21 Revolutions

21 Revolutions

New writing and prints inspired by
the collection at Glasgow Women's Library

Edited by Adele Patrick

First published in 2014 by Glasgow Women's Library and Freight Books.

Publication edited by Adele Patrick
Publication development by Helen de Main

Glasgow Women's Library
23 Landressy Street
Glasgow
G40 1BP
www.womenslibrary.org.uk

Freight Books
The Jacobean Building
49/53 Virginia Street
Glasgow
G1 1TS
www.freightbooks.co.uk

A CIP catalogue record for this title is available from the British Library.

ISBN 978-0-9522273-3-5

Typeset by Freight in FS Emeric
Printed and bound by PB Print UK in the Czech Republic

This publication was produced with the generous support of Creative Scotland,
Museums Galleries Scotland, Hope Scott Trust and individual backers via Kickstarter.

Glasgow Women's Library is an interactive artwork, rather than an archive. I coveted their signage and wanted to adapt it for the logo of *Feminist Times*. Now, I covet their contributors: *21 Revolutions* is full of amazing writing – Janice Galloway's essay on teen magazines is one personal highlight. I've never liked 'feminist fiction' but feel differently after reading 'Ernest Hemingway's Third Wife' by Denise Mina. *21 Revolutions* is Janus faced, looking into the past and future simultaneously. Like all great feminist projects, this collection has the potential to permanently shift our perspective.

Charlotte Raven, Editor in Chief, *Feminist Times*

21 Revolutions illuminates how much history and memories inform women's imagination and creativity, as well as their politics. A brilliant collage of artists' and writers' responses – sombre, poignant, quirky, funny and challenging – to the rich and varied collections of Glasgow Women's Library, this book is a revelatory and moving testimony to the interconnections between past and present.

Dr Esther Breitenbach, Research Fellow, University of Edinburgh and co-editor of *Out of Bounds – Women in Scottish Society 1800-1945*

21 Revolutions marks a turning point in the story of Glasgow Women's Library, showcasing its inspirational qualities for women of all artistic and creative temperaments. The diversity of women's experiences curated by GWL in its collections has acted as a spur to creativity with a feminist edge. From suffrage jewellery to knitting patterns, badges to banners, this rich archive documenting women's pasts has inspired and shaped some of Scotland's best artists to create celebratory works of immense depth and range. The silence and invisibility of the past has been given voice and illuminated by those who care enough to preserve, interpret and re-interpret lives worth remembering.

Lynn Abrams, Professor of Modern History, University of Glasgow

A beautiful and timely birthday present to mark the coming of age of Glasgow Women's Library, *21 Revolutions* is also a guiding star in the constellation of Scottish feminist history, art and literature. Buy it for your daughters, mother and grandmothers, but make sure your sons read it too. Created by Adele Patrick, a founder member of the Glasgow Women's Library, it makes the essence of the Library available between two covers. Every home should have a copy.

Dr Elspeth King, Director, Stirling Smith Art Gallery and Museum

Glasgow Women's Library is a place of research – and respite – for contemporary artists as much as writers and readers. *21 Revolutions* includes a fine selection of contemporary women artists who make a difference and, in the words of artist Ciara Phillips, "give a damn".

Moira Jeffrey, Arts Critic

21 Revolutions provides a detailed and inspiring insight into the vital work of Glasgow Women's Library since its inception in 1991. This covetable, lavishly illustrated book features new writings and prints inspired by the GWL collection by the leading luminaries of Scottish arts and letters, including writers A. L. Kennedy, Denise Mina and Louise Welsh and artists Sam Ainsley, Karla Black and Claire Barclay.

Dr Sarah Lowndes, writer, curator and author of *Social Sculpture: Rise of the Glasgow Art Scene*

When I first studied history it came as a shock to realise that history is not a straight line and that time passed does not always equate to 'progress'. *21 Revolutions* and this book capturing the legacies of the project, charts some of the changes to women's rights, but it also opens up the debate and raises awareness of the some of the challenges women face today. The book is a fantastic achievement that really captures what the Glasgow Women's Library is about. Margaret Elphinstone's piece 'We Thought We Were Going to Change the World' had particular resonance for me and I think this book shows we still need to and that we still can.

Joanne Orr, CEO of Museums Galleries Scotland

Contents

Revolutions and evolutions: the agency of artists and writers in the (re)making of Glasgow Women's Library

Dr Adele Patrick

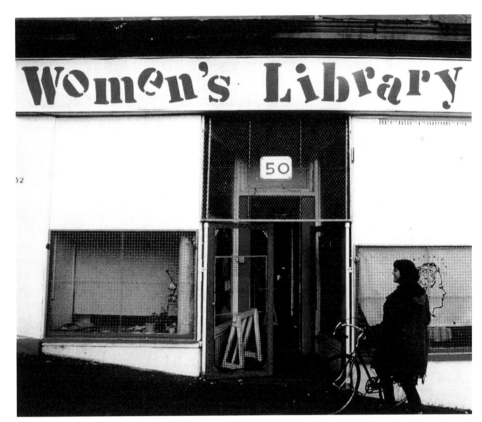

Façade of first Glasgow Women's Library premises, Hill Street, Garnethill, Glasgow, 1991.

'As an evolving movement, the struggle for women's rights has involved not one philosophy but many. Over the years it has comprised diverse fields of activity, each with its own intent and point of focus: the militant Suffragettes of the first wave of feminism; the collectives of the Women's Liberation Movement, the activists of America's [and Britain's] 'third wave' and many others. Their methods have also varied tremendously [...] yet all can be drawn together by a common bond: the will to change and improve the lives of women, and in doing so, to transform the lives of all.'

Suffragettes to She-Devils: Women's Liberation and Beyond, Liz McQuiston, 1997.

Glasgow Women's Library is unlike any other library and is unique in Scotland[1]. Informed by and connected with the international feminist art, library and archive projects that proliferated from the 1970s on, it was launched in Glasgow's Garnethill in 1991. It has developed into an organisation that crosses traditionally discrete territories, sitting at an axis between academic and community learning and the voluntary and the cultural sectors. It brings together women who have little cultural, social or economic capital with those who have had a wide range of creative experiences and educational opportunities. Its collections and materials are also unusually eclectic, being in the first instance entirely made up of donations that are reflective of the interests and passions of donors from a wide spectrum of backgrounds, ethnicities, ages and identifications. Just as there is no typical GWL user there are no typical texts or artefacts to be found amongst the Library's thousands of metres of shelving and in its hundreds of archive boxes. It is a rare example of a community grown library, museum and archive that has steadily built into a remarkable and varied collection that charts women's and equalities campaigns. It conserves, displays and makes accessible the mosaic of women's histories, creativity

1. The phenomenon of women's libraries, archives and museums is a global one; Glasgow Women's Library (GWL) is in a network of sister projects in India, Japan, South and Central America and across Europe and North America.

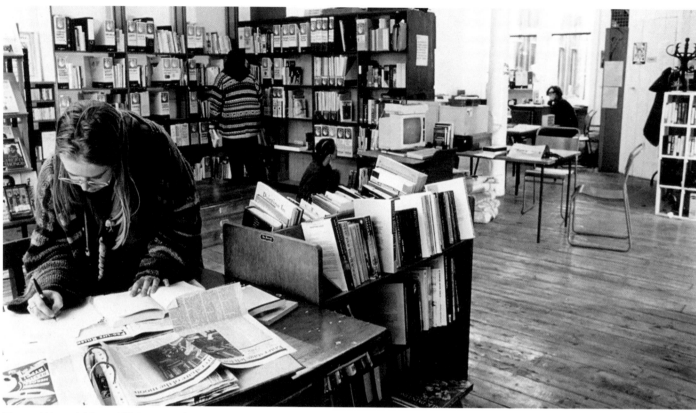

Glasgow Women's Library, 109 Trongate, Glasgow, 1994. Photo: Ruth Clark

and cultures, specialising in the lives and achievements of Scottish women but with a wealth of international texts and artefacts.

As a member of the team that gave rise to the Library and someone who has been either a volunteer or a worker throughout its history I have been witness to the agency of artists and writers in the Library's inception, and throughout its growth and development.[2] Although there are models of women's libraries, archives, and museums in the global women's library network led by artists and writers[3], there are few that have developed into fully accessible resources that make links with, and serve the needs of, users both within and outside the worlds of art and literature.

Those of us who took the bold step in 1991 of creating the Glasgow Women's Library (and somewhat presumptuously proclaiming our resource as the Archive of Scottish Women Artists and Writers) were, in the main, newly graduated or unemployed designers, artists, ceramicists, sculptors or (largely budding) writers, playwrights and poets; none of us were trained librarians or archivists.[4]

In 2007, a full fifteen years after I first started the process of labelling boxes and 'classifying' materials at GWL, I was a participant in a seminar series wherein Suzanne Lacy discussed the work of the feminist artists with whom she pioneered the influential second wave of feminist art practice in the US.[5] In particular she reflected on and tracked the arc of her engaged public art practice in Oakland, California. Here, her art programmes had critically interfaced with the work of council colleagues, academics, and other non-art partnerships. For the first time, I was forcibly struck by the idea that Glasgow Women's Library might be usefully considered and understood in this frame as an artwork in itself (re) generating and developing 'projects' since 1991 with its arts-trained management, and often arts-trained staff and volunteers, thus continually benefitting from a sequence of provocative and dynamic interventions and insights by artists, writers, photographers and filmmakers.

2. Glasgow Women's Library grew up from the roots of an earlier Glasgow women's project, Women in Profile, a multifaceted women's arts initiative triggered by the announcement that Glasgow would be the European City of Culture in 1990. Women in Profile staged a major festival of women's cultural and creative work in September of that year. The work and impact of Women in Profile and Glasgow Women's Library is discussed in *Social Sculpture: The Rise of the Glasgow Art Scene*, Sarah Lowndes, Luath Press, 2010.

3. For example, Bildwechsel, Hamburg, one of the European women's libraries that were an early inspiration to GWL.

4. GWL employed its first librarian in 2005. Our first archivist began work in 2009. My own background was as a graduate of Glasgow School of Art. After graduation I taught part-time for many years in the Historical and Critical Studies Department as the Glasgow Women's Library was growing two streets away in Garnethill.

5. The Working in Public seminar series: Art, Practice and Policy was a partnership between On the Edge Research and Public Art Resource and Research Scotland. It drew together artists, theorists, curators and arts administrators whose work engaged with issues relevant to social and cultural life, including policy. At the heart of the series was the work of Suzanne Lacy who was involved in a formal process of reflection into the Oakland Projects, California (1990-2000). http://www2.rgu.ac.uk/subj/ats/ontheedge2/workinginpublicseminars/intro.html

GWL learners at Barbara Kruger's exhibition, *Rule of Thumb: Contemporary Art and Human Rights*, Gallery of Modern Art, Glasgow, 2005.

Portrait by Rachel Thibbotumunwe, from a series of portraits commissioned by GWL part of the *Documenting 109* project, 2006.

Installation by Pam So, Glasgow Women's Library premises, 109 Trongate, 1998.

Like Lacy, our work has taken place 'on the front line' with the thousands of women who have visited us and/or used our resources. We have worked in creative and enquiring ways (typically using the tools and language of arts-trained colleagues and volunteers) across the cultural and social interfaces in dialogue with librarians, museums and archive staff, academics, voluntary, and public sector colleagues. Almost every milestone of the Library's evolution, environments and programmes reflect the aims of an organisation that is habitually keen to address issues and change creatively; to reflect on, (re)think and interrogate what a library might be and how it might be used and grow in collaboration with 'engaged audiences'.[6]

6. Even the GWL classification system is unique. It was developed in response to earlier feminist critiques of Dewey and the Library of Congress, reflecting the interrogative, theoretical and political work of international sister organisations who have developed feminist thesauri and classification systems (for example, *European Women's Thesaurus*, 1998, published by International Information Centre and Archives for the Women's Movement).

The Library has invited many artists and writers to work on projects and provide input into our programmes over the years (from US lesbian crime writer Mary Wings, artist Pam So, writers Manda Scott, Val McDermid, Magi Gibson and Raman Mundair and photographers and filmmakers including Rachel Thibbotumunwe and Jan Nimmo). However, *21 Revolutions*, triggered by the organisation's reflection on and celebration of its first two decades, offered us the opportunity to commission a new body of work from 42 practitioners, 21 writers and 21 artists, that directly referenced our collections. The *21 Revolutions* participants created distinct and powerful pieces through mining the library, archives and artefacts for inspiration. The resulting works are significant in their own right but importantly redirect viewers, audiences and readers back to the collections and the wider Library resources. The artists and writers had an open brief, to create work that drew inspiration from the Library. We asked for short pieces of creative writing or poetry from the writers and an edition of 20 art prints from the artists.

Their responses were fascinating and their processes illuminating to witness. The staff team had grown to appreciate the added value that having an artist or writer in a library can bring. This creative energy was evident throughout this period as campaign badges, knitting patterns, suffragette memorabilia, album covers, recipe books, feminist newsletters, our Women's Heritage Walk scripts and posters from the 'second wave' feminist movement became the focus of forensic attention by a newly constituted cohort of formidably talented makers.

21 Revolutions was an opportunity for some artists and writers to renew or sustain their relationship with the organisation and the collection, including artists Jacki Parry and Kate Davis who have had a longstanding connection with the Library. Claire Barclay and Sam Ainsley were active in the germination of GWL out of its precursor, Women in Profile. During 2009 and 2010 Shauna McMullan, Nicky Bird and Fiona Dean collaborated with GWL on a public art project, *Making Space*, and worked with the Library's diverse constituents including Black and Minority

Blue Spine, Shauna McMullan, 2011. This artwork, part of the GWL *Making Space* project, involved the artist working with hundreds of women who contributed a blue spined book, written by a woman to create a new, temporary collection. Photo: Alan Dimmick

Ethnic women, Adult Literacy learners and women facilitated by our National Lifelong Learning programme.[7] Writers Kirsty Logan, Louise Welsh, Jackie Kay and Zoë Strachan had collaborated on earlier projects and Denise Mina had cut her crime writing teeth at GWL workshops.[8] Practitioners who were discovering GWL for the first time on this project included artists Ellie Harrison,

Ciara Phillips and Corin Sworn and writers Jen Hadfield, Helen FitzGerald, Leela Soma, Zoë Wicomb and Laura Marney. All the participants, with their highly individual approaches, engaged with the brief with a commitment and enthusiasm that exceeded our expectations. Many reported that this work expanded their practice in unexpected ways and paved a route to further in-depth enquiries into our own and other collections.

Our aim with the *21 Revolutions* project, culminating in this publication, was to open up to the broadest audiences the gems from our library, archive and museum collection, interpreted through the lens of

forty-two of some of the most important women creatives working in Scotland today, but also to capture and reflect the essence of the innovative approach to the fields of social and women's history, feminism and equality that the Library has engendered. We hope that those who have contributed items to our collection over the past decades will feel as they leaf through *21 Revolutions* that their investment is validated and that those who have yet to visit will feel they know more about the 'special ingredients' we have to offer.

7. A video of the *Making Space* project can be viewed at http://vimeo.com/20838457

8. A GWL video podcast featuring Louise Welsh, Kirsty Logan and Zoë Strachan can be viewed at http://vimeo.com/29037304

Women's Work

Dr Fiona Bradley

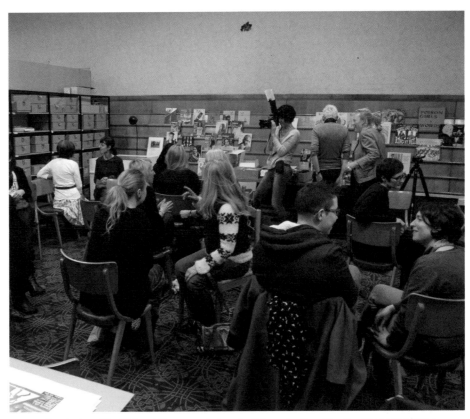

Inaugural gathering of the *21 Revolutions* commissioned artists and writers, Glasgow Women's Library, January 2012. The artist Claire Barclay, in conversation with Delphine Dallison is pictured bottom right.

On 12th April 2009, on the evening of the last day of Claire Barclay's exhibition *Openwide* at The Fruitmarket Gallery in Edinburgh, just after everyone else had gone home, I was privileged to be part of one of the most intelligent, exciting and inspiring conversations I have ever witnessed. I was with Claire Barclay and Louise Hopkins, one of the first artists I worked with in Scotland, whose Fruitmarket Gallery exhibition, *Freedom of Information,* took place in 2005. Louise had come with Claire to say goodbye to Claire's exhibition, and together look again at whether the idea to show small sculptures that had originally been part of other installations and exhibitions had been successful. It was a conversation about how objects behave; how they learn; how artists, curators and audiences learn; and it fearlessly interrogated the range of meanings at stake in the different activities of thinking, making, exhibiting and looking. I have always been interested in the questions artists dare to ask other artists, and in the particular quality of discussion that results. This conversation was

absolutely in that territory, and it seems to me that the *21 Revolutions* project is too, with 21 artists unearthing, questioning, appropriating and celebrating objects and ideas collected by Glasgow Women's Library over the last 21 years.

Claire Barclay's contribution to the project, *Untitled,* starts a conversation with the suffragette movement, bringing colours and forms familiar in Claire's practice (a fleshy pink, a tongue-like, geometrical shape, both strikingly reminiscent of the fabric elements in *Caught in Corners,* one of the two new installations she made for The Fruitmarket Gallery's exhibition) together with a slogan from the Social Purity Movement: 'wear the white flower of a blameless life'. Claire's work seems always to draw on both material and literary research and reference, and the collapse of the two seems particularly successful here. The prints display their creator's knowledge with a light touch: Claire's exhibiting career began with the 1990 *Womanhouse* Project in Castlemilk, itself part of the formation of Glasgow Women's Library, and an

Detail of *21 Revolutions* exhibition, Intermedia Gallery, Centre for Contemporary Art, Glasgow, 2012. Photo: Alan Dimmick

Artist Nicky Bird (foreground) with GWL volunteer Alice Andrews researching in the Glasgow Women's Library archive, Spring 2012.

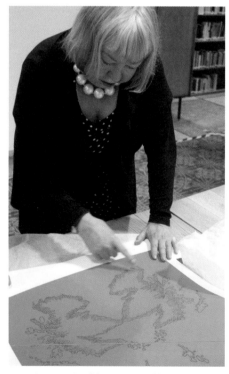

Artist Sam Ainsley delivering one of her prints *This Land is Your Land...* at Glasgow Women's Library, Summer 2012.

awareness of the history of the women's movement has long been embedded in her practice.

Several other artists engaged with the suffragettes. Elspeth Lamb starts with a yellow rose discovered at the centre of a pro-suffragette watch in the Library collection and makes a new banner for the movement, while Ashley Cook filters the militant cry 'we want what men have' through the imagery of a wonderful set of cards for the playing of the game *Panko* – a game, so the object's description tells us, 'based on similar rules to Happy Families' in which players collect sets of suffragists or anti-suffragists, drawn by a Punch cartoonist. In Ashley's dark yet luminous print, the imagery takes on something of the aura of the tarot.

A desire to take artefacts and ideas out of the seclusion of the Library and into the world and the popular imagination motivates many of the works. Delphine Dallison takes the Library's collection of political badges as the starting point for her army of mini-skirted, badge-headed modern feminist warriors, while Ciara Phillips enlists an advice-giving toucan to the cause, creating a poster in the spirit of the wonderful Chicago poster classic *Don't Call Me Girl!* Ciara's toucan reminds us that all is not yet won, and that we must still 'give a damn'. Magazines inspire Sarah Wright, Kate Gibson and Helen de Main: Helen's *21 Spare Ribs* sends me straight back to university, searching my memory for headlines from late 80s editions of the magazine.

Nicky Bird's work inspired by postcards by the Raging Dyke Network use one trope – the seaside postcard – to fuel another, proving the importance of making visible the often invisible and overlooked. Other artists too offer new spins on the potent politics of feminist concepts and ideologies. Sam Ainsley gives us a new map of Scotland, her red, white and blue prints taking us out of the union and re-inscribing our coastline with feminist wordplay.

Jacki Parry re-maps the Glasgow Women's Library's current and previous neighbourhoods, giving the city's iconic grid a feminist overlay. Particularly eloquent in this group of work is Shauna McMullan's more abstract print, which lets a marker of significance – the asterisk – stand not only

for all the starred passages she could find in the Library, but for all the women who were moved to star them.

The works in *21 Revolutions* move forwards and backwards between individual and collective memory and action, and between political and more poetic levels of engagement. Karla Black's *Necessity*, a variable edition of 50 small sculptures, prioritises, as does all her work, looking over thinking, and doing over speaking. Karla has in the past asked that we ask the question not what do her sculptures mean, but what do they do, how do they operate as objects in the world? These small objects operate like cards on a mantelpiece, or the little paper books that children make to bring early stories into the world – slightly abject, and completely appealing. They are made, again, as is all Karla's work, of materials that the artist has close to hand – sugar paper and body paint. Part of her use of cosmetics to colour her work has to do with a desire to rescue the gorgeousness of pastel-coloured powders, creams, pastes and gels from the consumerist context in which they more normally reside. But part of it is also to do with wanting to use materials that operate in the real world, stuff with which we all have a personal relationship.

Ruth Barker is perhaps working in a similar territory with her *Scarf for Glasgow Women's Library*. Not only because it's an artwork that takes the form of a scarf, but more particularly because Ruth wants to reference the material specificity of the Library's photocopies. I share her love of photocopied books and notes; the way a day's research can be gauged by the height of the stack of photocopies ready to be taken home. I still have sheaves of photocopies made more than twenty years ago that I cannot bear to throw away.

Several works in *21 Revolutions* sing the songs – unsung or sung too seldom – of individual women. You only have to watch Ellie Harrison's film *National Museum of Roller Derby* to be totally beguiled by her and her idea for an archive of Women's Flat Track Roller Derby. Elsewhere, women are commemorated in a proposed new monument (Sharon Thomas's *Mary Barbour Monument*); a botanical print and artist's book (Amanda Thomson's *Moneses Uniflora*, a homage to Mary McCallum

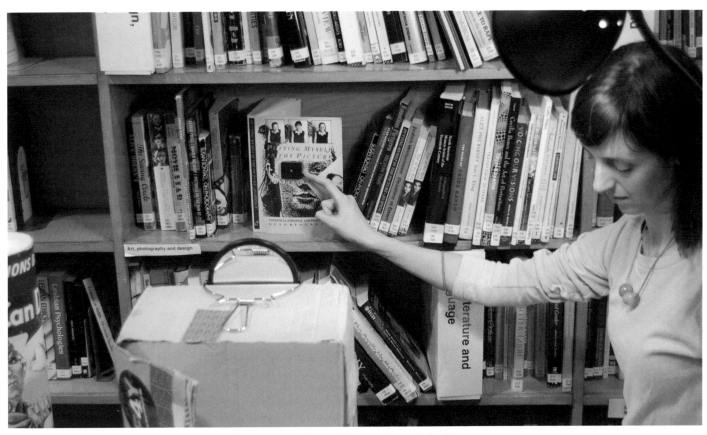

Artist Kate Davis developing her work *Not Just the Perfect Moments* at Glasgow Women's Library, Spring 2012.

Webster and her favourite flower, the one-flowered wintergreen); a print which conjures abstraction from representation, the collective from the individual (Corin Sworn's *Arms!*, inspired by Carol Steedman's *Landscape for a Good Woman*); a re-imagined portrait in the form of a page or two from an imaginary scrapbook (Fiona Dean's *To the Dear Love of Comrades: in Memory of Flora Murray*); and Kate Davis's *Not Just the Perfect Moments*, a work that takes up Jo Spence's iconic work of autobiography, *Putting Myself in the Picture*.

And then there's Lucy Skaer's *Cheiron in Type*, an ambiguous image of an ambiguous object – a book cast into a block of melted typesetting tin. The book is R. C. Trevelyan's *Cheiron*, a play about the centaur who tutored Achilles, Odysseus, Perseus, Theseus and Hercules. To those mythic names, Lucy adds those of Virginia and Leonard Woolf – the book was published by their Hogarth Press. Lucy's work typically ties and unties connections, either finding a way to link disparate objects into one image in such a way that the link remains arbitrary, insisting on the individual specificity of the objects; or by handling related groups of things within an image in such a way that the connections between them are dismantled. This print seems to be doing both at once – there kind of is a reason to entomb this book in the hot metal with which it was produced, but then again not much of one. What is left is an almost visceral delight in the stuff from which books used to be made, here running rampant, threatening to destroy an object that (however much in jeopardy in the digital age in which the print is made) has actually outlived it.

Art helps us make sense of the world; makes space for ideas and creates a context in which to think things through. For so many good artists to have made work in dialogue with the collection of the Glasgow Women's Library is a testament both to them and to the Library. *21 Revolutions* was commissioned as a birthday present for the Library: it is a present that celebrates not only Glasgow Women's Library, but its place in the modern history of art and ideas in Scotland.

Artist Ruth Barker undertaking research for her piece *A Scarf for Glasgow Women's Library* using GWL's poster collection, Spring 2012.

Another Ring in the Tree of History

Dr Lesley McDowell

Writer, Margaret Elphinstone researching in Glasgow Women's Library archive, January 2012.

'A revolution is not the overturning of a cart, a reshuffling in the cards of state. It is a process, a swelling, a new growth in the race. If it is real, not simply a trauma, it is another ring in the tree of history, layer upon layer of invisible tissue composing the evidence of a circle.'

Kate Millett (b. 1934), U.S. feminist theorist, literary critic, essayist, autobiographer, sculptor. *Flying*, pt. 3, Alfred A. Knopf (1974).

I once had a boyfriend who talked me into reading Norman Mailer. I was a nineteenth century classics girl who worshipped the Brontës, Jane Austen and George Eliot but I briefly obliged him by reading his literary hero, Mailer. Not altogether unsurprisingly, Mailer remained a closed book to me. Some time later in an effort to understand another male writer, D. H. Lawrence (the male-dominated literary canon was in full force throughout university departments in the mid-Eighties), yet another closed book in many respects, I happened along Kate Millett's *Sexual Politics*. Suddenly, a light flashed on, and stayed on, shining powerfully. So that's why I didn't 'get' them, the light said! And my incipient

gender awareness, always felt but never articulated, found in Millett the attitude and the words it needed. A different kind of talk; a different kind of persuasion.

Women's individual journeys towards that kind of light are necessarily personal ones, often sparked by a sense of unfairness or 'not-understanding' the world at large and the face it presents to us. Yet what we find when we arrive at that stage of realisation is a place we once knew but have forgotten or had torn from us; its familiarity surprises and delights us, granting us a reunion that we feel deeply to be right. I didn't discover Millett to be right; I'd always known it. That knowledge had always been there but it was deep down and silent, never sure how it could be voiced. But once it was, how different the world looked. I read the literary canon differently, and I read a different 'literary canon', too.

Each woman's journey is inevitably different, and in this collection of writing, 21 women celebrate those journeys in different ways. They show the variety of women's experience on the way; they show the impact, for instance, that feminism

Writer Muriel Gray (left) at the networking gathering for *21 Revolutions* contributors, exploring the GWL Archive collections, January 2012.

Writer Anne Donovan reading her *21 Revolutions* piece 'Lassie wi a Yella Coatie' at Bridgeton Community Learning Campus, November 2012 as part of GWL's programme for Book Week Scotland.

Writer Laura Marney reading her work 'Mango' at the first *21 Revolutions* public preview event, *Two Decades of Changing Minds*, Glasgow Women's Library, June 2012. Photo: Jean Donaldson, Glasgow Women's Library collection

has had on their daily lives, their thinking, and feeling. Some show liberation from the home, others a coming to terms with a more restrictive past; more still show how to find one's place in the world as a woman, and how not to be exploited for doing so. In reflecting on 21 objects from the Glasgow Women's Library that may have started just such a journey, these women writers have alighted on the words of others such as botanist Mary McCallum Webster, anti-suffragette clocks, the images of album covers or girls' annuals. Women writing here are inspired by a wide spectrum of narratives: Janice Galloway's mother's loathing of women's popular magazines that only showed her 'recipes she'd not the time to make, face powder she couldn't afford and frocks she couldn't wear.' This ambivalence is contrasted with the even more troubling messages contained in the ones published today of "sexism gone devious". Alison Miller's 'An Innocuous Tale of Love and Romance' opens with an iconic feminist book cover and sees her heroine begin to articulate her anger, whilst Muriel Gray's 'Guidance' reflects on magazine advice given to women in marriage ("Have dinner ready. Plan ahead, even the night before. Most men are hungry when they come home").

The message in a text can inspire of course, but that inspiration can be doggedly personal, exposing perhaps things we do not wish to see or acknowledge about our lives. That long-held feminist mantra, 'the personal is political' was popularised by American feminist Carol Hanisch in the late 1960s and it resonates throughout this collection, as seen in the historical contexts of Karen Campbell's 'The Colour of Queens', Anne Donovan's 'Lassie wi a Yella Coatie' and Donna Moore's 'The Mouse's Umbrella'. For Campbell, a young woman responds to the call of the suffragettes through a chance encounter with a fellow art school student; for Moore, her impoverished heroine meets an older suffragette whilst in prison for stealing a fish supper. Donovan's story reminds us forcefully of the devastating exploitation of working women in factories, fatal conditions that the suffragettes were flagging up in their publications. But the present and the future, particularly in reference to the use and mis-use of women's bodies, is

also of concern: Helen FitzGerald's 'Parts Beyond the Skies' gives us shades of Margaret Atwood's *The Handmaid's Tale* as her narrator is transported to a faraway colony to be paired with men working there, "[l]ike the boatloads of women they sent to Australia"; Laura Marney's victim of gang rape in the Congo in her short story, 'Mango' is avoided by other women patients in the hospital where she is recovering, her body a site of shame that is altered forever.

The focus of Marney's story takes us far beyond Scotland's shores and this is particularly important. Few volumes of short stories are made up solely of women writers, and in gathering this group of women together the Glasgow Women's Library far from being myopic in it's focus has actually extended, not narrowed the subject matter. It has gone beyond a sense of what it means to be a Scottish woman writer or a woman writer living in Scotland and instead has highlighted what is essential and crucial about women's experiences: that they go beyond our own recognised terrain, that they extend across borders. The sheer global range of the subject matter defies any sense of limitation that nationality may seem to impose on it – from South-African born Zoë Wicomb's 'Writing Lesson', which is about more than refugees simply learning English, it is about the post-colonial experience and how negotiations between women are made; to Leela Soma's homage to Annie Besant, rescuing children in India; to Denise Mina's author at an international book fair pointing out the true status of a pioneering woman like Martha Gellhorn who traversed the world and reported on it.

A broad outlook from singular objects prompts not just short stories, but poems by Jackie Kay, Vicki Feaver, and Jen Hadfield. It prompts flash fiction from Kirsty Logan, graphic fiction by Heather Middleton and non-fiction in essay form by Margaret Elphinstone. No place is forbidden to women writers and no form is denied them here, where the exploitation of women or the celebration of what they can achieve together is revealed. By no means is all the work in this volume angry or confrontational, but each piece has a point to make and that point often highlights the private and public split of women's

Writer Denise Mina (left) on a research visit to Glasgow Women's Library, Spring 2012.

Poet Vicki Feaver holding the source for her poem *Time-Piece* at the second *21 Revolutions* public preview event *Two Decades of Changing Minds*, at Glasgow Women's Library, June 2012. Photo: Jean Donaldson, Glasgow Women's Library collection

lives, with a focus indoors on marriages in jeopardy (Muriel Gray), on women outdoors and the sheer joy of walking as an autonomous individual through the countryside (Elizabeth Reeder), and on what freedom for a woman at particular times in history can mean. Demonstrations that were carried out by the suffragettes didn't just shock people because they often turned violent, they shocked because of their public and visible nature. The nineteenth century had placed the private and public self-sacrifice that women were required to make, silent and uncomplaining, above everything else as satirised in Virginia Woolf's *A Room of One's Own*. By the time we reached the early twentieth century such self-sacrifice was exposed for what it was: a way of ensuring women didn't protest against their lot, either at home or elsewhere.

But going public isn't always easy. In 'Anyone Who Had a Heart', Zoë Strachan and Louise Welsh show a young girl torn between what she feels and what she says. Margaret Elphinstone ruminates on the badges in the Glasgow Women's Library archive that women once wore proudly and publicly to declare their status and their views, which remind her of a time when women were confident enough to think "we were going to change the world." How have we changed things, we must wonder now, when schoolgirls still feel unable to be honest about their sexuality? When we still fear state control over our own bodies? When women all over the world are still being exploited, raped, or sold into marriage? Are we still willing to declare ourselves so publicly? To stand up and be counted?

Elphinstone ends her essay with a mention of the woman who helped me articulate my feminist views for the first time, Kate Millett. She refers to the 2010 BBC series on feminism, which I saw too, and which showed us an elderly Millett who "lives alone and earns her living by selling Christmas trees, and her great-niece had just bought her some sandals." A withdrawal from a public life of protest it seems, yet this gentle fate of a former feminist warrior does not deter Elphinstone. Instead, it reminds her of Robin Morgan's search for "her foremother, the real woman Emily Dickinson behind the great poet. She finds an empty chair in an empty house near Concorde. But the poems are still with us, and still relevant to our condition in their revolutionary form and subversive content". Kate Millett's words, the publication of her thoughts and feelings, can still be read by us today and even if she is no longer able to take part in the ongoing protest, the ongoing voicing of our fears and our demands, she can still influence future generations of women with her words. If I had to choose an object from the Glasgow Women's Library, there's no doubt that it would be a copy of *Sexual Politics*.

21 Revolutions
Art and Writing

JUS SUFFRAGII JULY

VOL. IX. JUS SUFFRAGII VOL. IX. Nov. 1914 - Sep. 1915

JUS SUFFRAGII OCT. 1915 - SEP. 1916

VOL. XI JUS SUFFRAGII Oct. 1916 - Sep. 1917

VOL. 13 JUS SUFFRAGII Oct. 1918 - Sep. 1919

We Want

Ashley Cook

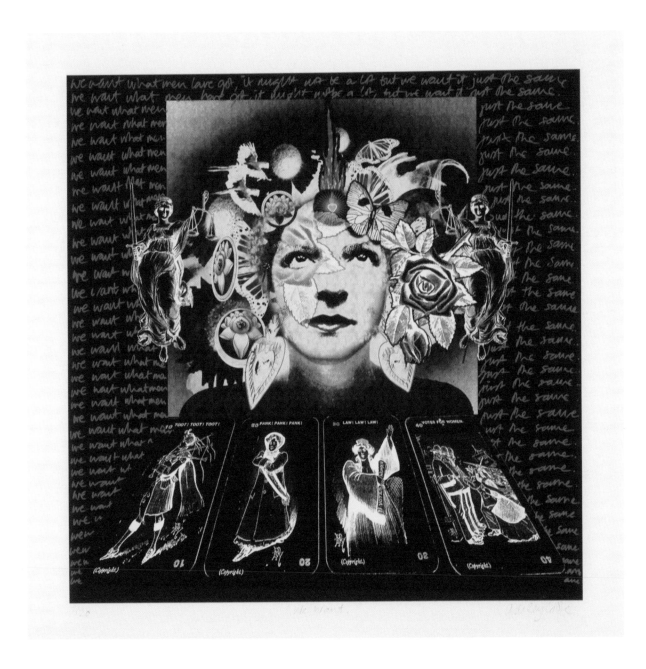

We Want, 2012
Digital print and screenprint
39.6cm (w) x 39.6cm (h). Edition of 20
Photo: Alan Dimmick

The Colour
of Queens

Karen Campbell

Her mother minded. Her father was affronted.

'What do you mean "just out?" You're just in, for God's sake. Is it not enough you're swanning up to thon Art School, without gallivanting off at night as well? You're a... you're my daughter. It's just not right. Theresa, tell her.' Folded arms and that bland-blank face.

'You have to say where you're going, lass. We canna just let you...'

'I told you. It's a sale of work. *For* the Art School.'

For months, Clara had begged her father to let her attend the Glasgow School of Art. It stood virtually at the top of their street, clean and wonderful and almost-new; flooded and chattering with men in waistcoats, who carried canvas and folios. And girls too. A clutch of magnificent girls who wore bold silk scarves, who shimmered with industry as they slid beneath the metal arch, floated up the narrowing stairs. Clara's schooling was long over. Her suitors had not yet emerged. Her fingers itched for purpose.

Her father was a quiet man, working hard and well as an administrative manager at Templeton's Carpet Factory, which was a paean to art in its own way, of course it was, but it was still a noisy hot shed inside, and he liked to come home to the peace of their comfortable tenement flat and feel he'd done his duty. Or so her mother said. What would she know about the world? Stuck in her kitchen all day, although they could afford a maid, but her mother would not hear of it. Would not *hear* of it. Still, it was her mother that turned him, eventually.

'But she draws such pretty pictures. And think, James, on how useful it might be. Drawing, design; think o' the skills o' the lassies in your pattern room.'

Father did not want her working in the pattern room. Clara heard them talking in the parlour; her mother's voice low, her father growing shriller. Heard words like *expense* and *marriage* and then a sad, single *when?*

''Tis nothing sorer in the world/Than to hear inner hurts aloud.'

As well as drawing, Clara wrote (mostly inferior) poetry, kept a tiny notebook on a bracelet for that very purpose. She'd stopped her sketching the moment he'd said no, but her notebook was almost full. Then, one day, after several parlour-and-kitchen conversations to which she was not privy, her father arrived home with a prospectus and a leather art case, and thrust them across the table. The decision had been made. But he didn't come with her to enrol. No, it was Clara's mother, strangely, that did that, ceremonially removing her pinafore and headscarf, replacing it with a knitted tammy. Clara thought mother might blink as she emerged into the daylight, but she carried herself surprisingly well.

'Clara! You're faither's talking to you!'

'I said, where exactly is the sale? And what is it that you're selling?'

'Artworks.' She shrugged. 'Some pictures and some poems. Other girls are showing pottery.'

And a case of careful jewellery, which is hidden in my room.

'Well, that sounds fine, eh James? Maun we'll come too, for a lookie.'

'No! No. You can't come: it's in a ladies club.'

'A ladies' club? I thought it was for the Art School.'

'It was — it is. Lucy's going too. But it's in private rooms. In Bath Street.'

Which was true, so it was only a half-lie. And Bath Street was further over the hill.

Those first weeks at the Art School were... they were like the time when Clara had woken from a recurring dream of it being her birthday and then, that one day it *was*, she had dreamed the truth and it really had been her birthday. All day, it had been hers. The studio was bright and cold. High windows, clear against the black-wood walls, and the young men forever leaving the door wide, as they passed through for spare brushes, white spirit and furtive — and not so furtive — glances. You tried to keep your eyes on the paper, but it would flutter in the draught and you'd look up. Skim glances with a pair of eyes or a flash of white shirt or worse — a bare arm with the sleeve rolled back.

'You'd think they'd never seen a woman before,' the girl next to her had whispered. Tall she was, with a fitted pink shirt and brown hair that billowed, and was caught, above her ears in a way that seemed too simple to stay up. 'Don't they have turpentine in their studio? Oh...' Clara felt the press of air on her cheek. 'Is that the butterfly you're doing? How lovely. The wing: it's flawless.'

Flawless. A perfect description of Lucy. 'The Honourable Lucinda Lawson,' she'd laughed, of Lawson and Spur Shipbuilders. What's your name?'

And Clara had instantly said, 'Claire.'

They began to lunch together. They would walk the length of Sauchiehall Street, Lucinda linking arms, Clara watching their reflections in the window-glitter of the shops, and being asked — being *asked* mind — what she thought of that hat, and did she like the writings of Myrtle Reed, and wasn't Mr Asquith funny? Lucy was long and polished, her skirts swung like they were dancing one inch above the ground. Clara bobbed clumsily alongside in her grey, mother-made coat. Lucy had even prised that from her.

'Truly? How clever your mother is! To make something useful

with her hands. I mean, it's all art, you know. Even the men at Daddy's yards — that's art. Oh, you should see them, Claire. All the flares and fires, how the metal blazes white. And the noise! Oh! Why don't we do craft too? Yes! I know! Silversmithing. What fun.'

Clara wasn't sure if she could afford silversmithing. In drawing and painting, the Art School provided paint; you brought your paper. Was the silver to be paid for too? Lucinda, being flawless, took her hand. 'But you must let me pay, please. For dragging you away from your lovely paintings.'

Clara was glad to leave the painting alone. She'd drawn and coloured every permutation of butterfly wing she could, eventually fashioning it into a repeating motif her tutor said would work beautifully in a rug. But, no matter how close she scrutinised, how fine her extraction, her execution of the greens and livid turquoise, Clara would always see the dry-brown corpse attached to the wing. And the silver of the pin holding it.

'Perhaps you could make a butterfly brooch?' Lucy went on. 'But stylised. All stretchy like the Spook School.'

'Perhaps.'

Clara loved the silversmithing. Her parents needn't know, just as they didn't know that lunchtime strolls (with a friend they much approved of and did she have a brother?) had now become lunchtime meetings. From silver, Lucinda had quickly progressed to beaten brass. Miss Grey, the metal mistress, thought Lucinda very promising. 'Beautiful, regular indentations. Look how neatly you hit. It's your strength, dear. Quite formidable.'

Miss Grey was a suffragist. It sounded a sad, painful word, but Lucy said no, that they were warrior queens, all of them. 'Imagine, Claire! Imagine being a warrior.'

'But why would I need a vote?'

'Think how it feels to be here, with the men. Then multiply that feeling... ooh, I don't know, a million times. Wouldn't you feel proud? Don't you feel angry when your brothers get taken to Daddy's boardroom, and you have to look through the fence to see all the light and the heat?'

'I don't have a broth—'

'Isn't our world so... small? Ugh.' Lucy tugged at her sash. 'Small and mean until you simply can't breathe?'

'I suppose.'

'Come with me then. Come to the next meeting. See what you think.'

'Clara! Here! Is this the sort of paintings you'll be showing?' Her father was flapping a piece of paper at her. It was a long-discarded sketch... she'd thrown it in the parlour fire, she had, she *had*. It was a design for a silken banner. With the letters WSPU.

The Women's Social and Political Union. Clara had thought the meetings very fine, in the way that the sea is fine: all those layers of tumbling colours which can be still, majestic, then turn marvellously wild. The sense of it had seeped round her too, how at first the cold wash just stuns you numb (her father was a great exponent of sea-bathing), but then you tingle back alive, can feel each piece of you sparkle. Well, her brain was sparkling. At the meetings, a number of clever women would stand, arms wide and extol the virtue of struggle — of militancy, even. They were mostly artistic, or rich. She couldn't follow everything: the... what was it? The socialist argument for the franchise of poor men, before that of all women: that one, for example, confused her. One of the best speakers, a fellow artist named Helen, was organising the event tonight. It was the opening of their headquarters! The proper commencement of battle. Dr Gilchrist would come and address them. There was even talk that they would learn Morse code!

Clara had made several pieces of jewellery. Most of it enamelwork, but there were a couple of silver chains, and this brooch — her favourite, in silver-gilt — which she had pinned on, rather than sell. Absently, even as her father was railing at her, she fingered the delicate filigree, how the swirl of leaves became a claw that was a flower that held a jewel. Three different gems: peridot, amethyst, pearl. It was a perfect secret, Lucy had said. 'Subtle.' Clara liked the hiss of this word; its rolling, whispering kiss.

'Clara. Are you listening to me?' Her father made a gap in her reverie, forced himself in. 'You are having nothing to do with all of this nonsense. Votes for Women, indeed. Good God. These are the very women caused a riot — a *riot*, mind — up in Aberdeen.'

'Aiberdeen,' agreed her mother.

'We've not worked hard all our lives so that you can make an embarrassment of yourself. Don't you want the advantages we've toiled for? When I met your mother, she was in service *and* working as a seamstress.'

'Scrubbing in the day, sewing all night. Tessie Two-jobs: that was me!' The pert way she held her chin. You'd think she was proud.

'Aye. What your mother would have given for the chance to learn to paint. Drawing, pattern-making. You don't know you're born, girl. But I will not have you flaunting yourself with these... wimmen. Shrews and slatterns, the lot of them.'

'James! Thon Lucy sounds a lovely girl. A real lady.'

'Aye well. To be fair. Her father's a gentleman, so I suppose she might be. A misguided one at that. Gentry aye have time on their hands for games. But it'll no be them getting huckled into police carts at the end of the night.' He was shouting now. 'It'll be daft girls like you, Clara. And then where will you be?'

'My name is Claire!' she shouted louder.

Her father's hand was up, up high and quivering, his eyes were quivering, and his lips were quivering purple. They held it, both, held the breath between them for an instant until she heard her mother make a sound that wasn't no, wasn't anything, just a sound, and go hurrying into the scullery. Sloshing water, battering on the copper. He was still grasping at the air, like he was trying to catch it or squeeze it small. She wanted to look away from the terrible thing she'd made of him. Could not. And then he lowered his arm. 'Aye and my name is skelp your arse, lady. Now away and help your mother with the washing.'

She wouldn't weep.

In the scullery, her mother flitted through clouds of steam, loading the copper, smoothing the pile of half-dried sheets. She tapped her mangle. 'It's a fine thing, this, that your faither bought me. Gets through it a' in half the time.'

'It's still washing.'

'Aye, but it's *my* washing. My mangle. There's a freedom in that too, lass.' Her mother laid the tongs on the cooking range. Slowly towards her, then her head pecking awkwardly as she kissed her,

once. Warm raw fingers smoothing her eyes. 'Your daddy loves you, ken. He only wants to keep you safe.'

Clara thought her heart would knot. The pin of the brooch was stabbing her. It was growing hair-thin and it was sliding through her breast, her spine. Skewering the pretty colours flat. Safe. With a rough pat, her mother released her. 'I'm near done here. Just the final rinse.'

'Father says I've to help.'

'Did he now? Well... I'm... aye... I'm almost out of crystals for the blue bag. I'm needing someone to run over to that wee shop near Watt's. Mind, the Russian man's one?'

'The one in Bath Street?'

'Is it now? Well, there'll be none other open at this time of day. They keep funny hours, thon Ruskies.'

She straightened the collar on Clara's grey coat. Touched the centre of the brooch. 'That's my favourite colour, so it is. Did you know that? Purple. The colour of queens.'

'We've to call it violet. I mean, we do call it that. It's just its proper name. At the Art School.'

Her mother smiled. 'Purple for dignity.' Moved her finger to the peridot. 'Green for spring. Well, that's hope, isn't it?'

She was going to unpin it. Clara was terrified. Her father would throw it in the fire; throw all the jewellery in the fire. Their stall would be empty. Her mother traced the pearl. 'And purity for the white. You're my pearl, lass. You know that, don't you?'

How did her *mother* know this? How did she *know* this?

'I was never really a seamstress, Clara. We were a' just skivvies. Rows of us in candlelight, jagging our fingers since we couldna see for tiredness. One day, someone telt us about this fine American lady, who was coming to speak at St Andrew's Halls. Lady Candy or some such — I canna mind. Och, she was a fine speaker, a' talk of freedoms and rights. They were letting women ratepayers vote for the cooncil see, and we were getting a' excited that soon it would be us. All o' us. And then an Irish woman spoke, then a Scot, and they were getting right riled aboot the English, and someone shouted out aboot the King...'

'Was there a riot?'

'Och no lass, no. But I worked for an English family, and ane o' the lady's friends was there too — even smiled at me, she did — but she must have telt them. Any road. So, I lost my job, but...' She blushed suddenly, a pretty, shy-girl blush, not the scarlet of washday at all, 'but then, I married your faither. He didna need to look at me, ken. He started as a delivery boy, but you could tell. You could tell just the man he'd be. Working nights to pay for his office exams. And he has the kindest heart I know.' Clara stared down at her brooch. Again, her mother kissed her. 'Now, away you up the road and get me thon crystals, eh? Take your time, though. There's nae rush.'

'I...'

'Just be careful for me, eh?'

Clara walked to the hall. Lifted the case of jewellery from the doorway of her room. From behind the parlour door, she heard a cough. Her mother nodded. 'On you go.'

She was nearly at the close-mouth when her mother called after her. 'I mind when you were born, Clara. It was May, and he made me a chain of daisies for ma hair. I mind that, Clara.'

And in all the marches to come, in the pamphlets and the protests, in the speeches, in the smashing, the jails and the blood, in all the other brooches crafted of silver chain mail and prison gates, in her father's disdain and his angry almost-pride, in the washings and scrubbings and small quiet life, her mother minded it all.

Timepiece

Elspeth Lamb

Timepiece, 2012
Digital pigment fine art print on paper
24cm (w) x 46cm (h). Edition of 20
Photo: Alan Dimmick

Time-Piece

Vicki Feaver

At the centre of the face
a man in a red nightcap
holds a baby on each arm;
round the edge, replacing
numerals, twelve letters
spell 'VOTE FOR WOMEN'.

How progressive and sweet,
I think, an Edwardian family
where the husband gets up
in the middle of the night
to see to his children,
leaving his wife to sleep.

Then I notice his grumpy
expression. And the babies
are screaming. Like postcards
of a man in a floral piny
or tearful infant complaining
'My Mummy's a suffragette!'

it's half a joke, half warning
of the pitiful prospects for men
(and their offspring) if women
escape their proper place
and role as housekeepers
and child-carers at home.

But be careful what you put
on the face of a clock.
'VOTE FOR WOMEN
VOTE FOR WOMEN'
the hands spelled out
all through the Great War –

tick tock tick tock tick tock –
until gradually, grudgingly,
some women got the vote.
And round and round
went the hands – all through
another war and beyond –

tick tock tick tock tick tock –
until women, nominally,
were granted equal rights.
And, if the clock stopped
in horror at what its cogs
and wheels had brought about,

other clocks took up the ticking,
until a man getting up in the night
for his children, became a thing
that a few men, arriving bleary-
eyed at work in the morning,
might even boast of doing.

Untitled

Claire Barclay

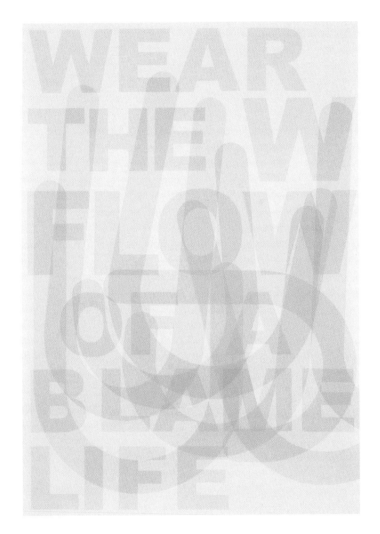

Untitled, 2012
Screenprint (diptych)
41.9cm (w) x 59.6cm (h). Edition of 10 diptychs
Photo: Alan Dimmick

Untitled, 2012
Screenprint (diptych)
41.9cm (w) x 59.6cm (h). Edition of 10 diptychs
Photo: Alan Dimmick

The Mouse's Umbrella

Donna Moore

November 4th 1913

Alice shivered and pulled the thin blanket up over her chin. The wooden slats creaked underneath her slight frame. She sighed and watched the little puff of warm breath turn to fog in the cold room. Winter sun shone weakly through the dirty window high in the wall and the thick stone walls stripped any heat from the thin shaft of light. The cold bored its way into Alice's flesh, icy fingers reaching out to glaum at her bones. She breathed out again, trying to form rings like her Uncle Albert did with his smelly pipe smoke. Thirty days. Could she stand thirty days in here?

Keys rattled outside. She sat up on the bed, pulling the blanket around her. The heavy door opened and a well-cushioned woman strolled into the room, a sturdy black umbrella over one arm, soft leather gloves on her hands. A do-gooder? Some sort of prison visitor? The newcomer adjusted her *pince-nez* and stuck her chin into the air. Her sharp eyes seemed to take in the high window, the two beds, the rickety chair in the corner, the metal wash bowl and Alice in one sweeping glance. She turned back to the wardress who stood behind her, face impassive. 'I see my usual quarters are unavailable, turnkey. I suppose this will do.' The wardress flushed. 'And don't bother bringing me any luncheon. As usual, I won't be partaking.' She waved the now flustered wardress away. No lunch? Alice wanted to shout at this woman not to be so stupid.

As the door slammed shut and the keys rattled in the lock once again, the new arrival turned to Alice, giving a smile that made Alice feel as if she'd been gifted an extra blanket. The smile faded. 'Oh dear, oh dear,' said the woman, taking Alice's chin in her hand and turning her head firmly but gently from side to side. 'We can't have this.' She strode to the door, petticoats rustling, and banged on it with the side of her hand. The metal shutter opened and the wardress peered in. 'I've changed my mind, I *do* want luncheon delivered, after all.'

She turned back to Alice and pulled off her gloves, holding out a hand covered in what looked like dried blood. 'Florence Crossman,' she said. Alice hesitated. 'Don't worry about that, my dear. It's only red paint.' She grabbed Alice's hand and shook it with great enthusiasm, almost wrenching Alice's arm from its socket.

Alice had never had her hand shaken before. 'Alice, ma'am,' she said. She gave a half curtsey, then cursed herself, silently. She was angry with this woman for refusing food. With her fancy clothes and her fancy voice; what could *she* know of hunger?

The woman felt around the navy blue hat she was wearing. A bunch of bright red cherries on the top bounced cheerily. 'Well,

Alice, for heaven's sake, don't treat me as if I'm the Queen of Sheba. I'm just a prisoner here, like you.' She removed her hat and held up a pearl-ended hatpin. 'They should have taken *this* off me.' She turned the full force of her smile on Alice once again. It softened her oblong face, making her look like a queen Alice had seen once in a painting.

Florence scanned the room, twirling the hatpin around in her spade-like fingers. The red paint that covered her hands was all over the cuffs of the blouse she wore under the thick coat. Florence tucked the hatpin into the seam of the thin mattress on Alice's bed. 'They won't find it there.' She pulled off her coat and sat on the bed, smoothing out her skirt. 'Now, my dear. You look like a child. Why are you here?'

A child? 'I've just turned eighteen, ma'am. An' I stole a fish supper, that's why I'm here. They gave me thirty days.'

'For stealing a fish *supper*?'

'Well, naw,' Alice felt her stomach churning with shame, 'the thirty days wis for gi'in' the polis a doin' when he caught me.'

Florence laughed loud and long, slapping her knee with glee as she hee'd and hawed.

Alice enjoyed hearing that laugh. 'What about you, ma'am... Florence?'

'Oh, let me see... I think I got nine months for breaking the windows of the City Chambers. But it was so long ago and I've been in and out so much since my sentencing that I forget...'

'What do you mean... in and out?'

'The Cat and Mouse Act, my dear.' Alice shook her head. She didn't know what the woman meant. 'Mr Asquith's delightful new law. We go on hunger strike and become weak, they let us out to regain our strength, then they arrest us again after a week or so. If they can catch us. I've worked out that I shall be in and out sixty-six times before I actually finish my sentence.' She beamed. 'Of course, by that time, I'll probably have sixty-six further offences under my belt, since I am rather good at escaping from whatever little mouse hole I'm hiding in.' She held up her paint-covered hands. 'This time they caught me red-handed.' She hee'd and hawed once again. 'I was caught painting the outside of the Botanics.'

How could this woman think going hungry was a joke. 'Hunger strike?'

'At least they don't force feed us here, like they do in Perth Prison.'

Nobody would *ever* have to force Alice to eat.

November 7th 1913

Alice awoke to find Florence unpicking the hem of her coat. Florence hadn't eaten for over two days now and her face was looking drawn and her movements were slow. She turned to Alice, holding up the paper and pencils she had pulled from inside the hem of her coat. 'I thought I'd write to my friends, let them know how I'm getting on. Would you keep an ear out for the turnkey, my dear?'

Alice nodded. 'How are you gonnae get a letter out?'

'My friend Helen Crawfurd will be coming to visit. She'll sneak it out for me.' Florence held out a pencil and a sheet of paper. 'She'll take one out for you, too, if you want to write to your people.'

Alice took the pencil and paper and looked down at them, not quite knowing what to say. 'Naw, it's fine, Florence.'

Florence studied her. 'But you told me how much your mother worries.. Don't you want to let her know how you are?'

Alice shrugged. 'I cannae write. And, even if I could, ma maw cannae read.'

Florence pursed her lips. Then she nodded. 'Right, my girl. We'll see what we can do about that once I've finished my letter.' She lifted the coat that was still on her lap, its hem now frayed and torn, and unpinned an enamel badge from the lapel. Alice had noticed it before. A flag with stripes of green, white and purple. Each stripe had something written on it. Florence held out the badge. 'In the meantime, you can copy these words.'

Alice turned the badge over and over in her hand. 'What does it say?'

Florence pointed to each of the words in turn. 'Votes. For. Women.'

November 9th 1913

'Are you sure you're up to this, Florence?'

'Of course, my dear. Besides, they'll be letting this mouse out of her cage in a day or so. Who knows when I'll be back? Carry on reading.' Florence sat on the edge of the bed, ramrod straight, but drawn and pale. The lines on her face looked as though they had been engraved and her eyes had lost their twinkle.

Alice traced a finger across the words as she read aloud. Her voice was slow, heavy, hesitant.

Footsteps sounded outside and a key turned in the lock. The Governess entered the cell, accompanied by two wardresses struggling with an iron object and a sack. They dumped both unceremoniously on the floor. An umbrella stand: cold grey, robust and no-nonsense, with a tray at the bottom. Scrolls and flowers cut into the metal gave it a gallus air.

Alice stood up, her hands fluttering nervously around the edge of her apron, head lowered, trying to fade into the thick stone walls. The Governess ignored her. 'Florence, are you sure you won't eat?'

'Quite sure.'

The Governess sighed. 'Aye, I thought as much. You asked for some entertainment for Alice when you're...out... and when she's not stitching in the workroom. This umbrella stand belongs in my office. It needs cheering up a wee bit. I thought Alice might like to paint it.' She turned and strode out of the cell. At the door, she hesitated and turned back. 'Florence, is there...'

'Thank you, I neither need nor want anything.' The Governess

nodded. She had been dismissed.

Alice opened the sack. She prised each tin of paint open with the end of one of the brushes. 'Look, Florence. Look at this yellow – it's like sunshine. And this braw red? What colour shall I use to paint the umbrella stand?'

Florence gave her a tired smile. 'Alice, you may paint it whatever colour your heart desires. Now, if you don't mind, my dear, I want to sleep for a while.' She closed her eyes. Alice watched her for a moment, troubled, then lined up the paint pots in front of her. White, pillar-box red, black, sunshine yellow, and duck-egg blue.

November 10th 1913

'Florence, you can open your eyes and look at it noo.'

Florence gave a pained laugh. 'Bring it over here, child. I'm too weak to come and see.'

The umbrella stand clanked on the stone floor as Alice heaved it over. 'I didnae have the right colours but I did ma best. See, Florence?' Alice ran a hand along the front edge of the stand. 'The white was easy, there wis a tin of white. That's purity, you tell't me. The green wis tough, but I added a wee bit of yellow to the pale blue. Hope. That's what you said the green means. I couldnae get the violet, though, an' I tried all sorts of mixtures.' She gestured to the plain stone walls, now decorated with stripes and dots of varying hues. 'So I had to settle for mixin' red and white.' She sighed. 'It's jist pink, that's aw. But it's meant to be violet and that means...'

Florence was silent. Alice struggled to bring the violet word to the forefront of her mind.

'Dig-ni-ty. Aye, dignity. And you told me what that means an' ...well...that's you, Florence. You're dignity.'

But Florence's eyes were closed. 'Get the Governess, Alice.'

Alice ran to the cell door and banged, banged, banged.

December 3rd 1913

'Are you ready to go, my dear?'

Alice nodded, buttoning up her thin coat. The rain was rattling the small windows in their frames.

'Unlike me, *you* won't be back.' Florence raised one stern eyebrow as she picked up Alice's hat and handed it to her. 'Will you?'

'Aye, well, I'll be comin' to visit you, just like you visited me. But I'll no' be back to stay.'

'Now, remember that Helen Crawfurd is expecting you tomorrow. Bath Street.'

'Thanks for getting me that job, Flossie.'

Florence snorted. 'I'll Flossie you, my girl. And they'll help you with your reading and writing.'

Alice put her hat on and pinned it into place. 'Thanks, Flossie. I don't know what I would have done without you in here. I missed you when you wis out. I almost wanted the cats to get haud of their mouse again.'

'Away with you, my girl.' The rain continued to hammer the windows. Florence pulled her umbrella out from under the bed. 'Take this. I shan't need it for a while.'

January 8ᵗʰ 1914

Alice placed the brown paper squares into a neat pile on the table in front of Helen and Ethel. Helen leafed through the sheets. '*Votes For Women*' was neatly and carefully painted in black paint on each one.

'Thank you, Alice,' Helen patted her hand. 'You've done a grand job.'

'Can I go out wi' you?'

Helen and Ethel exchanged glances. 'Florence would have our guts for garters.'

'Aw, please, Helen. I'll no' tell her.'

Helen stood up and picked up her coat. 'Well, you can go along ahead and stick them to the windows. Ethel and I will follow and do the smashing. But you must keep your eyes peeled for the police, and promise me that you'll run home once the sticking is done.'

'Why are we botherin' wi' stickin' these to the windaes, if all yous two are gonnae do is break them anyway?'

Helen's lips twitched. 'Brown paper deadens the sound. Hopefully, Ethel and I will get half way along Argyle Street before the police are made aware.' She handed Alice a tin of golden syrup and a brush. 'Here, we use this instead of glue. It's cheaper and more effective.'

Alice's mouth watered as she looked at the tin – shiny gold and green and white, with bees buzzing around the head of the resting lion. She walked out of the room, brown paper in one hand, syrup tin in the other, wide eyes still fixed on the tin, imagining the sweet goodness inside. Sometimes, she still didn't understand these women.

'Oh, and Alice?' Alice turned. Helen was looking at her, head tilted to one side, bird-like. 'Whatever's left of the syrup, take it home.' Alice ran out of the building before Helen could change her mind.

It was dark and quiet in Argyle Street. Alice looked around for signs of the polis, but she was alone. She tip-toed to the first shop window and placed the pile of brown paper on the cold ground in front of her. It was a milliner's – women's hats decorated with flowers and feathers, frills and furbelows. Alice prised open the syrup tin and stuck her nose inside, inhaling the sweetness. She crouched down and picked up one of the sheets of brown paper, brush poised over the tin. She put the brush into her pocket and stuck the tip of her index finger into the syrup, before pulling it carefully out and placing a miserly dot of syrup in each corner of the brown paper.

After syruping four sheets of brown paper this way, she sucked her finger, not wanting to waste a drop of the golden goodness. She carefully pasted each sheet to the window and stood back to admire her handiwork. 'Votes For Women', 'Votes For Women', 'Votes For Women', 'Votes For Women'. A good job done, using the minimum amount of syrup. It wasn't as though the paper would be up long, anyway. She could see Helen and Ethel waiting on the other side of the road, stones in hand. Alice skipped on to the next window.

February 10ᵗʰ 1913

Alice sat down next to her mother on the shabby sofa with its faded red and green roses. The letter was written on the backs of old envelopes.

'Dear Alice,' she read aloud, her finger moving over the words. 'As you will see, I am writing to you from Perth Prison. Unfortunately, when the cats caught me this time, they brought me straight here, rather than to Duke Street. It's far more unpleasant here, there's no sympathetic Governor, and I knew what I was in for the moment I refused to eat. Luckily, they'd forgotten to take my hatpin off me when they came to force feed me and I managed to stab two of them in the back of the hand before they could hold me down and force the feeding tube into my nose. It was rather satisfying to hear their yelps. As you can imagine, I did not give in gracefully, and I rather think I gave one of them a bloody nose. I do hope so, anyway. I shall gloss over what happened next, Alice, but it was not pleasant. I know that I must put up with it again, and the very idea fills me with both apprehension and defiance. But do not fear, my dear. Never fear. With any luck, they will give up on this force feeding nonsense, and this mouse will be out of this rat hole soon enough. Don't come and visit me here, Alice. It is not a pleasant place. I will see you very soon and we will go to that little ice cream parlour again. With much love, your friend, Flossie. P.S. please tell Helen and Agnes that I will write to them soon and that there is a woman here who broke the windows of the Prime Minister's car with a large turnip. What a firebrand she is!'

February 16ᵗʰ 1914

As Alice opened the door of the WSPU Headquarters in Bath Street, the warmth came out to welcome her in, away from the cold dreich day. There would be a fire in the fireplace and the tea urn would be on. And there was always fresh baking on a Monday. Alice's mouth watered as she took off her coat and hung it on the coat rack, along with Florence's umbrella. She always carried it, rain or no rain. Alice was ready with her usual round of greetings. But only Helen and Agnes were there. Helen's eyes were red-rimmed and Agnes's usually neat hair was escaping from its pins.

Alice knew something was not right. Had she spelled a word wrong in a letter? Or forgotten to lock the office door when she left on Friday? Helen patted her hand, then gripped it tightly, squeezing and releasing. 'I'm so sorry, Alice. Florence died in the prison yesterday. It was pneumonia. They got food in her lungs when they force fed her.'

Alice said nothing. She took her coat from the rack, leaving Florence's umbrella hooked over one of the wooden arms. As she left the building, she tried to remember Florence's face the first time she had seen her. But all she could remember was Florence's face the *last* time she had seen her.

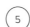 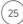

the complete
shorter fiction of
Virginia Woolf

New Edition
edited by Susan Dick

165 Stars,
Found in GWL
Lending Library

Shauna McMullan

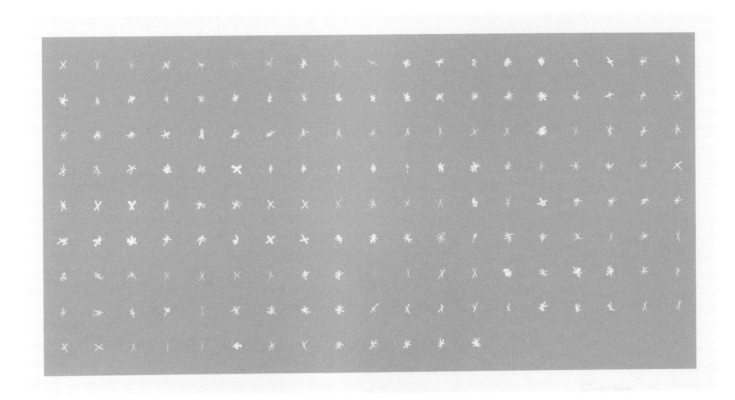

165 Stars, Found in GWL Lending Library, 2012
Digital pigment fine art print on paper
56cm (w) x 28cm (h). Edition of 20
Photo: Tian Khee Siong

Not Just the
Perfect Moments

Kate Davis

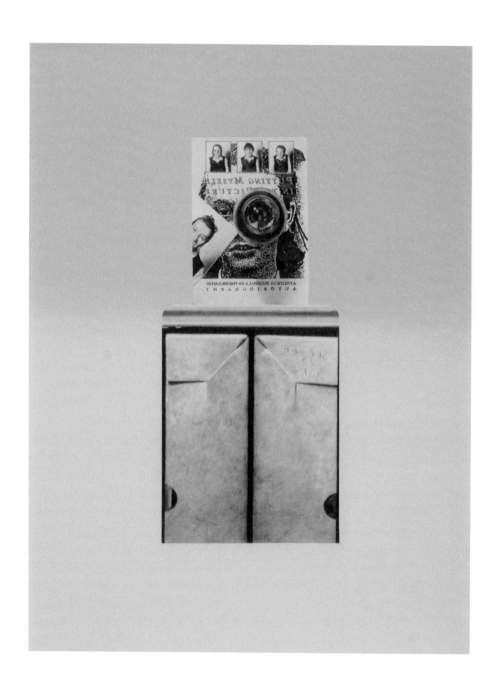

Not Just the Perfect Moments, 2012
Digital pigment fine art print on paper
32cm (w) x 40.5cm (h). Edition of 20
Photo: Alan Dimmick

(12) (45)

Mango

Laura Marney

Dr Mukendi wants everything to be fair and everybody to be nice. He's posh; from Kinshasa. He doesn't know how things work out here.

It's the same performance every morning: I go and stand in the queue for the pump and they all stand five feet away from me. Nobody brings a tape measure, but it's always about five feet. I take a step forward, they take a step forward. Sometimes I do it just to wind them up: they're all watching me, pretending they're not, and I take a step. Then another cheeky one. Then I give a big loud sigh, and then another one. By this time they're all squashed together round the pump.

Dr Mukendi doesn't think it's funny.

'Lulu, leave them alone,' he says, 'they'll turn on you and you'll only have yourself to blame.'

'I'm nowhere near them!' I say.

I know what it is – they're jealous of me. They're out pummelling fufu all day with three or four kiddies to feed and oftentimes no man at their back. They see me sitting about in the compound getting my dinner put down to me and they're scunnered. They think because I sleep on a nice clean bed, instead of on the floor of a manky hut like they do, that I've got the life of Riley.

'You know Lulu, every living thing smells,' Dr Mukendi says.

'Dead things stink and all.'

'Yes, you're quite right. Inside your head, here, just behind your nose...'

He puts his pointing finger on the bridge of my nose. I close my eyes to enjoy it but he takes it away again,

'...there are neurons: nerve cells, which have tiny hairs to 'catch' smells. When we breathe in, odor molecules stick to the cilia.'

'That's disgusting,' I say and Dr Mukendi laughs, 'molecules from inside my body go up inside their bodies? I'm penetrating them from five feet away? No wonder they hate me!'

'They don't hate you Lulu they just don't...'

'The faces they pull; I make them want to puke.'

'They can't help that. It's an automatic response. Smell is the only sense our brains can't block, that's why it's so evocative. It really is an excellent survival tool.'

'What's excellent about having to smell something rank?'

'Well, a smell might identify food, or danger. Having to smell everything is actually in our best interests.'

'Okay, they have to smell me, but they can just breathe it back out again.'

'Hmmm.' he says.

'What?' I say.

'Actually they can't. A molecule that has triggered a response has already entered us; absorbed in the nose or swallowed. We ingest it and it becomes part of us.'

'My molecules become part of them?'

'Exactly! But not just yours; mine, everyone's. We're all absorbing each other's molecules, breathing each other's exhaled breath. The human body is being recycled all the time. Cells dying, being replaced, whole organs completely regenerated. When you think of it in those terms a baby is just a bundle of recycled, reordered molecules.'

'Is that supposed to make me feel better? I don't want the villagers' manky molecules, thanks very much.'

Dr Mukendi tuts.

He does his best to keep the peace with the villagers but it's not easy. When he fills in the Médicins Sans Frontières forms he always pushes out a sour laugh when he writes The Democratic Republic of Congo. 'There's nothing democratic about this republic,' he says. He always says it. He's never done bumping his gums about how the DRC is the richest country in the world, all the minerals we've got: cobalt, coltan, diamonds and what have you, and he gets right steamed up about the looting, especially whenever militia come through.

He's not allowed to get involved, MSF rules, but last week a mob of raggedy arsed Interahamwe militia came through and took a couple of men. I say men but really they were wee boys, two brothers, maybe twelve and fourteen. The boys knew not to make a fuss but their mum was bawling and screaming until her neighbours pulled her back and shoved her into her hut. Dr Mukendi pushed his glasses up his face and shook his head.

'Dr Mukendi,' I said; I like saying his name out loud, 'if a lion comes and takes a zebra, what can the other zebras do about it?'

He didn't answer.

'Her neighbours did her a favour. She's got two other kiddies to think of.'

I see the girls in the village struggling to look after their weans, I could give them a hand, I was a good wee auntie in my own village before I got married, but they don't want to know.

'You don't know me,' I say. I don't say it out loud, just to myself: 'You swallow my molecules but you don't know me.'

It was militia that took me. I don't know who they were, they weren't wearing uniforms: RDC, FDLR, they're all the same. I didn't struggle, never made a sound, I just did what mum told us to do when the soldiers came: shut your eyes, keep breathing and think hard about somewhere safe.

While they were doing their grunting and groaning, inside my head I was sitting round the fire with mum and granny and the other weans and we were all singing.

Ally Bally
Ally Bally Bee
Sittin' on yer mammy's knee

They tore a branch off a big mango tree and used that. That's the Mai Mai trademark way of doing it, so they say.

Waitin' for a wee bawbee

They probably didn't want to use their bayonet, get it all bloody, then they'd have to clean it.

To buy some Coulter's Candy.

When they let me go I walked back to my village but my husband threw me out. I took the peanuts he was going sell at the market and started walking. Six days of eating peanuts scunners you. I used to pure love peanuts.

When I got here they gave me a bed in the ward and pills three times a day. I thought that would make it heal up, but when it didn't I asked Dr Gustin and he said I need an operation.

I try to make myself useful about the compound, I do all the cleaning – they don't let me cook - and I do everything I can to help Dr Mukendi. He says I'm the best assistant he's ever had.

Most of the time I'm good. I tell myself to wait; to hold on and haud ma weesht but sometimes when I think about the molecules inside me, I lose it. I start screaming and going mental. I can't stop myself. He comes and sits on the end of my bed and shooshes me, tells me I'm frightening the other patients, makes jokes, tells me the villagers'll think they're killing me in this hospital and then they'll not bring their children in for treatment.

'Good,' I say.

Dr Mukendi knows I would never hurt a wean but once when I was shouting the odds he lost it and all. His eyes were blazing and he started ranting about the richest country in the world. His face was all twisted and the spit was flying out his mouth. I didn't want to hear it again but he was squeezing my arms and shouting right into my face.

'Yes, you want corrective surgery, of course you do, doesn't everybody? But where is the money to come from? There are just too many! You're not the only one; don't you understand there are two million of you? Join the queue, Lulu!'

I know he didn't mean it, he said as much afterwards, he was stressed out, and my shenanigans didn't help matters. He said he was very very sorry. Not as sorry as I was. I can be awful selfish sometimes.

A couple of days later he took me into the office and showed me a letter. I've no idea what it said so he explained that he was referring me for surgery to another hospital.

'I don't want to go to another hospital,' I said.

'Don't worry Lulu, you won't have to go into the bush. We'll put you on a supply flight.'

'But can you not do it, Doctor Mukendi?'

'I'm sorry Lulu, obstetric fistula surgery is quite a specialised procedure. The doctors in Shamwana perform this operation regularly; you'll be in very safe hands.'

'Well what about Dr Gustin? I want to stay here.'

'I know you do,' he sighed, 'but this is just a field hospital, we

haven't the facilities here. You do understand though, don't you? The internal damage... Nothing is guaranteed.'

'Will I be able to have children? 23 isn't too old, is it Doctor?'

He squashed his lips together.

'I don't think we can expect that much Lulu, I'm sorry.'

I had a think about that.

'Will I die?'

'Obviously there are risks with surgery but you shouldn't worry.'

'I wasn't asking because I'm scared.'

He smiled at that.

'You know, there's a famous argument in philosophy about a ship.'

'A ship?' I said.

Sometimes Dr Mukendi talks in riddles. I don't mind.

'If a ship goes on a long voyage and has to replace worn out planks, until eventually every plank is replaced...'

'Are you talking about molecules again?'

'Exactly! You're the only person in this village who takes the trouble to understand me, Lulu.'

I didn't know what to say to that.

'It's still the same ship. The ship's identity doesn't reside in the individual planks.'

'Yeah,' I said, 'I was wondering about that. I was thinking that if every molecule in my body gets replaced then how come I still look the same?'

'You're right. Our bodies can't grow new neurones; the central nervous system can't regrow or we could fix spinal cord injuries. The one thing that remains inalienable on a cellular level is our brains and therefore our minds.'

'So even if all my molecules change, I'm still me?'

'Yes. You'll always be you, Lulu.'

We both smiled. I stayed awake all that night thinking about it. It was the best thing he'd ever said to me.

I didn't ask him about dying because I was scared. I was just thinking about my last wishes. When I first came to the compound I told Dr Mukendi how I wanted to be buried and he promised me. He said he'd make sure they followed my instructions.

I've asked to be buried headfirst. If they plant me upside down my body can give the seed nourishment, it can grow out my body and up towards the sun.

When I first told him Dr Mukendi went: 'The seed?'

'From the mango tree.'

He just nodded, never said any more about it.

'A young woman with your spirit, there's no reason why you won't make a full recovery. We're going to miss you here Lulu.'

'Miss me? You'll not miss my pissy smell.'

'It's only a smell,' he said, 'and anyway we're used to it, of course we'll miss you.'

Sometimes when I can't sleep in the ward I can make myself dream. In the dream there's something growing inside me. It grows and grows till it bursts right out of me. It's a mango; a mango that big I need to hold it in the crook of my arm. I peel the skin back a bit and there she is, peeking out: a wee baby. When I have that dream I always wake up smiling. I try to stretch it out, to sniff up every molecule of happiness from it because, in that wee tiny moment, the only thing in my head is the clean fresh smell of mango.

Necessity

Karla Black

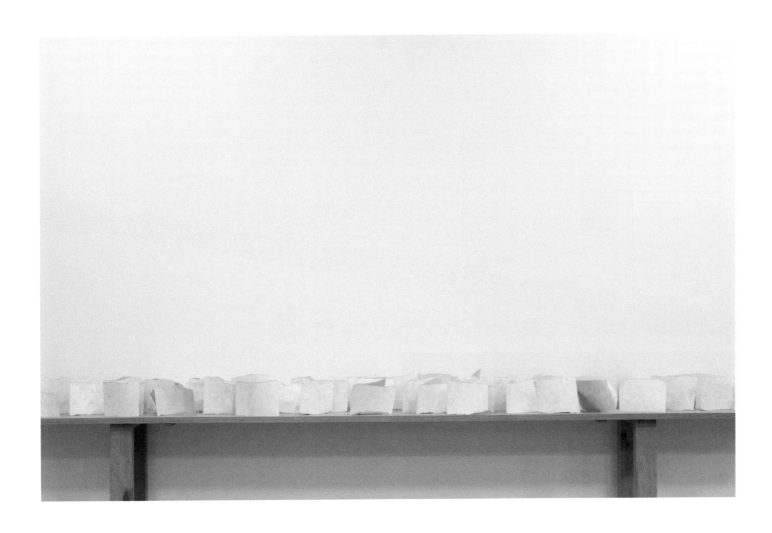

Necessity, 2012
Sugar paper and body paint
Approximately 11cm (w) x 12cm (h), each work varies
Variable edition of 50; each work is unique
Photo: Alan Dimmick

Necessity, 2012 (details)
Sugar paper and body paint
Approximately 11cm (w) x 12cm (h), each work varies
Variable edition of 50; each work is unique
Photos: Alan Dimmick

10

Cheiron in Type

Lucy Skaer

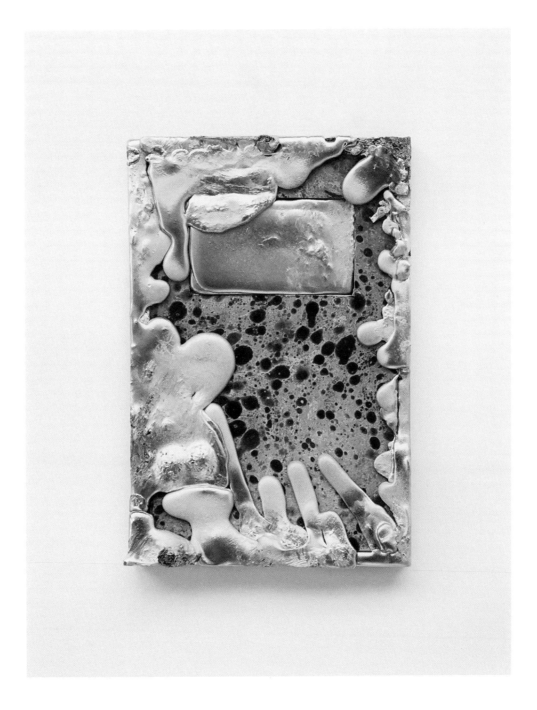

Cheiron in Type, 2012
Digital pigment fine art print on paper
25.4cm (w) x 32.7cm (h). Edition of 20
Photo: Tian Khee Siong

21

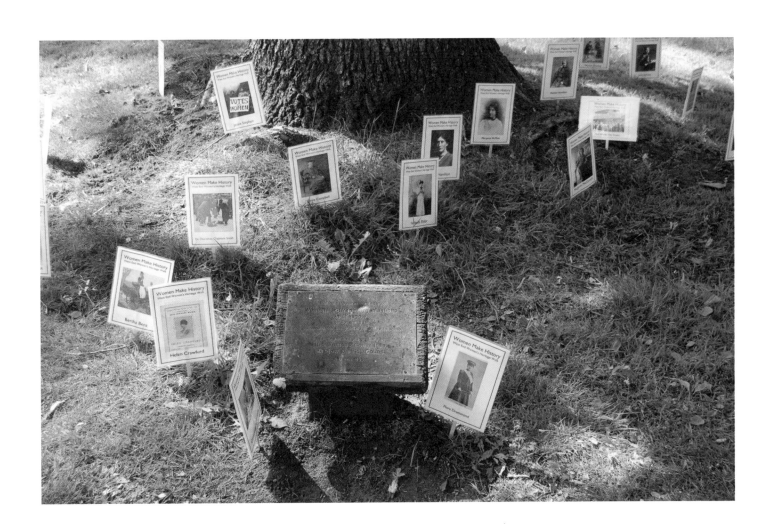

This Land
is Your Land...

Sam Ainsley

This Land is Your Land..., 2012
Digital pigment fine art print on paper
50cm (w) x 50cm (h). Edition of 7 blue on red
Photo: Tian Khee Siong

This Land is Your Land..., 2012
Digital pigment fine art print on paper
50cm (w) x 50cm (h)
Edition of 7 black on white
and edition of 7 red on blue
Photo: Tian Khee Siong

Infestation: A Memoir of Pests

(plus two Dubious but Complementary
Theories of the Universe, gratis)

Jen Hadfield

Breathing very carefully through my mouth, i baited and set the little line of traps [...] we laid a votive dish of something sweet in every room [...] crunchy or smooth it doesn't matter [...] in the basement we found a rotting salmon [...] they love compost, burst drains, wet clothes, the colour blue [...] my god they were just everywhere a cloud so thick you could cut a door in it [...] in your ears and up around your ankles [...] something biblical [...] a nest at the bottom of the sleeping bag; another in the underwear drawer [...] i pulled the afghan blanket over my head and sweated out the night [...] i heard them tap-dancing under the floor

[...] it was right there on the mantelpiece, next to the Japanese Buddha [...] big enough to sting through corduroy [...] i don't know who was more surprised [.] that squatting brute puffed up with blood [...] (of course they carry fever under their hood) [...] this old dear in her nightie [...] waving a frying pan over her head

[...] stalemate. Then i ate up the nuts myself, starting at the door [...] when i got to the fireplace i chose the poker [...] it hung on by the skin of its teeth [...] fell back in my lap, sort of chill [...] well i damn near died; i screamed blue murder [...] it had given something up...a bogle or its spores [...] Everything was sticky, the handles, the floors; cats all shaking their tacky paws. You get down here this minute John Robertson i said

i've got a bone to pick with you.

My latest half-baked theory is that each squashed fly
must open a fly-shaped instability
in the universe

a vacuum
that necessarily pulls another into existence
a buzzing knot yanked through the lining
of your concentration.

From the window above the desk I pass a fly into the custody
of the warm bright wind and fog
and its instantaneous replacement – fat as a hedgehog –

struggles from the vortex mired in pollen
to drop onto the centre-spread
of this hippie book, brailling the page
with jazz hands.

It rubs its wrists together (a yolken rain falling);
it chafes a fore
and a middle leg.

Juvenile gulls like broken crocks
throwing back their crashed spouts
and arched handles

to sick up
laughter

broken pumps wheezing above dry wells

gulls like pitchers of stale water
on every lumb

a prophetic alert
a moral judgment

canticling the passing of the essy-kert

preserving
the continuum.

31

To the Dear Love of Comrades: in Memory of Flora Murray

Fiona Dean

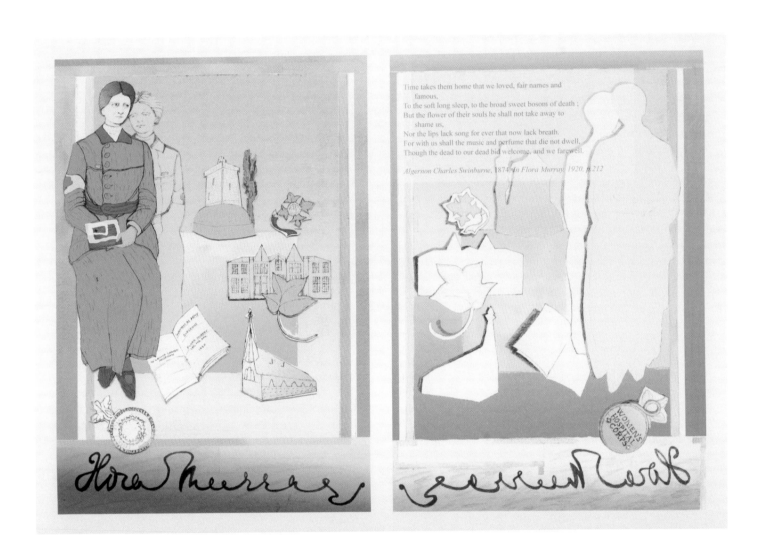

To the Dear Love of Comrades: in Memory of Flora Murray, 2012
Digital pigment fine art print on paper
46.5 cm (w) x 32.5 cm (h). Edition of 20
Photo: Alan Dimmick

(26) (32) (43)

Lassie wi a Yella Coatie

Anne Donovan

I lift three rolls frae the shelf, lay them on the wooden counter.

'These are our finest cottons, Miss. Any of these would make a lovely frock for the summer.'

She feels the fabric between her fingers, tests the softness.

Her mother stands beside her, stares critically at the cloth. 'Blue is not your colour, Elinor, it makes you look washed out.'

'And Alice is wearing pink so I must have something different.'

I stand, attentive, but allowing them time tae examine the material. I've been in the shop three year noo, and have learned how tae deal wi customers; when tae gie them time, when tae make a wee suggestion. My faither cries me a big jessie for working in a drapers but my mither was glad when I gied up the factory. I wanted a job in the park among the flooers, but they werenae taking on any men. Nae Catholics anyhow. And as long as I'm away frae the stour and the racket, I can thole ma da's jokes about me knitting him a jumper for his Christmas. Mr James, who owns the shop, is a fair man, and I've come tae enjoy the beauty of the fabrics, the touch of silk and linen and wool unner my haund. It soothes me.

'I just can't decide.' The young lady's eyes scan the shelves. 'What about those?'

'These are a slightly heavier weight, Miss. Not as delicate, but they'll make up well too.'

I set them on the counter, bold and brash beside the cotton lawns.

'I love this one - it's so cheery, isn't it Mother?'

The mother looks unimpressed. 'I've never liked yellow - it's such a vulgar colour.'

'Mother, you're so old-fashioned. Everyone's wearing yellow now.'

'If that's your choice, we shall take it.' She turns to me. 'Five yards, please. Have it put on my account and sent to the house this afternoon.'

'Certainly, Madam. Will you be wanting any lining?'

In the back, folding the fabric intae its parcel, my haund tremmles. The yella background glares at me, its brichtness hurts my een.

Sarah.

Eighteen year auld and as bonny a lass as you'd ever set eyes on. I met her at the dancing; in the midst of the smoke and noise of folk talking over the music, she seemed tae glow like an angel in the gaslight. Gowden hair and skin that sparkled.

'It's as if someone had sprinkled ye wi stardust,' I said. No that

first night of course, I was far too shy tae talk tae a lassie like that; if it hadnae been for my pal Wullie, who fancied her pal, I might never have asked her up. But once we were dancing - her saft curls touching my chin as we birled unner the lights - I was in love. Folk talk aboot love at first sight; they say it's all blethers, but it isnae. There was Sarah and me, and that was it.

I walked her hame that night. The four of us went thegether: me with Sarah and Wullie with Maggie, her pal who stayed up the same close.

We all sang as we went, the words of the last waltz stuck in our heids,

'Lassie wi a yella coatie

Will ye wed a moorland jockie?'

'That's you, George,' said Wullie. 'Still has the hay stuck behind his ears, this yin.'

Sarah lived in wanny they streets in the Calton that my mither thought wasnae good enough for us. When we got tae the building, Wullie led Maggie through the close tae the back court, so they could winch in the darkness, but I stood like a chookie at the front entrance.

A light burned in a second-flair windae.

'Who's waiting up for ye?' I asked.

'Ma mammy. Ma daddy's deid and my wee brithers'll be in bed. I need tae be awfy quiet in case I wake them up - it's a single end we're in.'

Even in the dim light she was that douce and sweet. I shifted frae one fit tae the ither.

'What about you, George. Where d'you stay?'

'Ower at the Cross. The close next tae the butchers.'

'They're big hooses. Yous must be posh.'

'No really. Me and ma da and ma brither are all working but.'

I felt embarrassed that we had a room which was never used except for visitors. My mither and faither slept in the recess of the room while me and Francis shared the bed in the kitchen.

I heard Maggie giggling, then Wullie emerged frae the close, straightening his tie.

'You're in a dwam, George.' I turn and Mr James is standing next tae me. 'Is that ready?'

'I'll just be a minute.'

'Well, when you're finished, there's new stock waiting to be marked into the book. Then you can go for your dinner.'

The day I take my pieces and heid doon Argyle Street intae Glasgow Green. It's a fine April day - blue sky and white clouds birlin. Me and Sarah had walked there often on a Sunday efternoon; the lang straight road tae the fountain was aye mobbed wi courting couples and faimlies enjoying a day out. We'd watch the weans playing and I'd imagine us wi bairns of wur ain.

I worked in the factory then; lang, hard shifts. I hated the clatter and the coorseness of it but I was strong, I tholed it. The money was better than maist places, and every week I went tae the Savings Bank on the corner and added tae my account. My brither Francis spent every penny, took lassies out tae fancy teashops and bought them wee presents. I thought he was daft. I'm a country boy at heart. We'd come tae the city when I was thirteen and I longed tae go back, dreamed of setting up hame wi Sarah somewhere clean and fresh. There was one thing on my mind and that was our future.

I had my eye on a ring in Archer's windae, a ring I was gonnae gie Sarah when I proposed. I wanted tae wait till I could dae it right, had enough tae set us up in a place of wur ain. I'd seen too many of my pals start merriet life squashed up wi their parents, or in one room in a crumbling building. I didnae want that.

Noo I imagine a scabby wee room somewhere, just me and Sarah, and I think it could be Heaven.

I never go anywhere these days. My brither tries tae get me tae go tae the dancing with him but I cannae. Saturdays, efter the shop closes, I walk. I feel close tae Sarah, as if she's by my side. Dauner up toon, through Blythswood Square where the posh hooses are, alang Charing Cross and heid west. It's cleaner there, less works and smoke. And it has nae memories.

*

Sarah never mentioned her work. Naebody did. Why would ye? You spent all they hours stuck somewhere you didnae want tae be, daeing something you didnae want tae dae. Once you were out, you just wanted tae forget it.

I only mind her talking about it the one time. In the wee cafe at the cross on a Sunday efternoon. We'd been for a walk in the Green - oh such a bonny day it was and her cheeks were pink and flushed wi the wind. She'd her blue costume on. A pot of tea and two scones on a plate in fronty us.

'I'm ready for this efter that walk,' she said.

'Aye.' I looked at her, bricht and shining like a new penny. I near did it, near blurted it out, never waited till I'd saved up, just asked her right then.

She'd taken aff her gloves to eat her scone and I could see her looking at her haunds.

'What is it?' I asked.

She showed me her thumbnail. Round the edge glinted a rim of gold.

'You're like a princess in a fairytale,' I said.

'Ach, George, you're such a blether,' she laughed. Then she frowned, rubbing the mark wi her hanky.

'I thought I'd washed it all out, but it gets everywhere, this yella. We're all the same, the lassies - everything gets clarted wi it, your hair and claes and skin. You should see the state of us gaun hame at night fae thon place.'

Last Saturday I was coming back frae my walk. I'd been to the Art Galleries, numbed my mind looking at the fine pictures and strange objects in glass cases, worn out my body by walking and walking the park. It was dark, some time efter nine when I passed ower Blythswood Square. A big house was bleezing wi light, every windae a picture, folk in fancy goons dancing and talking. A carriage drew up and a gentleman came to help the lady out. It was the fabric I recognised: gyre and gaudy.

'That's a stunning frock, Miss Montague,' said the man. 'You'll be the belle of the ball.'

She stood on the pavement, looking fresh and young. Dark hair carefully arranged, her skirts swaying round her, the colour of daffodils.

As the carriage drew away, I heard the music float frae the doorway. Just the tune, but I know the words fine.

'Haste ye lassie, tae my bosom
While the roses are in blossom
Time is precious, dinna loss them
Flooers will fade and so will ye. '

She started getting headaches. At first naebody paid much notice. We all spent too much time in stuffy places wi noisy machinery all around us - maist folk had a headache during the week. They went away at the week's end. A good blaw on the Green on a Sunday efternoon, that sorted you.

Sarah's headaches didnae go away at the week's end.

She went tae the chemist and he gied her some pills tae take away the pain.

But it kept coming back.

I noticed she was getting tired on our walks, couldnae manage to go as far.

One day we were in the cafe, having a cuppie tea. She barely touched the scone, held hersel tensed up.

'Sore heid again?' I asked.

'It'll pass.'

Her face was blanchit and she looked thinner than usual. A dark pain touched my heart.

'You should go tae the doctor.'

'It's too dear, George.'

'I've got the money.'

'Don't be daft, you cannae dae that.'

'Of course I can. I've been saving it for you, for us.'

I reached across the table and took her haund. It was like ice.

'Don't, George,' she said. 'Everybody's looking.'

But she never took her haund away.

I met her at the doctor's on the Saturday efter work. She'd went hame first tae change and was smart in her blue costume, though so pale you could near see through her skin. When she came out the doctor's office, she said, 'Take me hame, George.'

Walking alang, she held my airm; no lightly, the way she used tae, but as if she was feart tae let go.

She was silent. I was waiting for her tae speak first, but, haufway doon the street, I couldnae stand it any longer.

'What did he say, Sarah?'

'What I expected.'

'How d'you mean?'

She stopped, looked in my face. 'He cried it plumbism. It's the dye.'

'The dye's making you sick?'

'I knew anyway.'

I grasped her haunds.

'You knew it was making you sick?'

'Aye. Lots of the lassies get the leads after a few year. Everybody knows.'

'I didnae.' Her wrists were that wee my fingers could reach right round them.

'You kept on working there?'

'I hoped I'd be lucky. What was I supposed tae dae?'

'There are other jobs.'

'Nae matter what job you work at there's something can make you sick. Maggie got blood poisoning fae a dirty needle at the weaving shed. My uncle lost his airm in the factory. I have tae work, George. My mither needs the money.'

'She'll get nae money if you're sick and cannae work.'

Tears started in her eyes. I pulled my airms round her and held her tight. 'I'm sorry, I didnae mean . . . I'm just that worried about you.'

She leaned against me.

'What did the doctor say? Can he gie you something?'

'Just pills. For the pain.'

'You're no gaun back. I'll take you somewhere, somewhere nice, somewhere at the seaside. And you'll get better.'

'Oh George,' she said.

*

I keep walking, frae west tae east, frae the big lit-up hooses tae the dark tenements. Doon Buchanan Street wi its fancy shops, alang Argyle Street and the Trongate, past the big steeple. The place is mobbed wi folk out for their Saturday night, their night of freedom frae work and care. Sounds of singing and laughter frae the pubs. A crowd of lassies barring my way.

'Who's the handsome fella all by hissel? D'ye no want tae join us?'

I smile and pass them, heid on till I reach the Cross. I'm tired and want tae go hame but I stop at the cafe first, cannae face my mither and faither; her worried face and him trying tae joke me out of it. It's three year noo and they think that's lang enough, time for me tae stop brooding and find anither lassie.

'Sarah was a lovely lass,' said my mither. 'It's terrible what happened tae her, but there are other fish in the sea. Time you got merriet and gied me some grandweans. There's precious little chance of any frae that brither of yours.'

That was efter she found the wee book that I'd copied things intae. I'd went tae the Mitchell Library and looked it up. They have all kinds of books there, you can find out anything. They know all about it: the doctors, the folk who inspect the factories.

'The symptoms of plumbism are manifold. One of the earliest signs is pallor of the countenance. There is a developed degree of anaemia. In several large dyeworks I have examined the girls who handle and pull the yarn covered with yellow dust. I found them anaemic, complaining of headache, and showing a well marked blue line on their gums, while several complained that they suffered from colic. In some cases more serious symptoms developed. A fatal termination is not unknown.'

She went downhill very quick. She wasnae fit tae go tae the seaside, was barely fit tae go to the fancy tearoom in Buchanan Street. The waitresses dressed in black frocks and starched pinnies, there were vases of flooers on the tables and a big cakestand wi sandwiches and scones and cake. Sarah, white as the lilies on the table, sat across frae me. She looked around and smiled, ate as much as she could of the cake and humoured me while I talked of our future, about getting merriet and all they bairns we were gonnae have.

I finish my tea and leave the cafe, walk the few yards hame. My faither's in bed but my mither is still up, hugging the remnants of a fire.

'You're late, son.'

'Went a good lang walk.'

'You're aye walking, son.'

'Aye.' She stood up and I pit my airm round her shoulder. She's affy wee, my mither.

'I'm away tae my bed noo. Dinna be lang.' She touched my cheek. 'You look tired son.'

'Aye.'

I sit and stare at the dregs of the fire. There's precious few flames, just a glow and a flichter that keeps me there. The auld wifies say that late at night you can look intae the fire and see the future. But it's too late noo. These days I see nothing but the past.

Mary Barbour Monument

Sharon Thomas

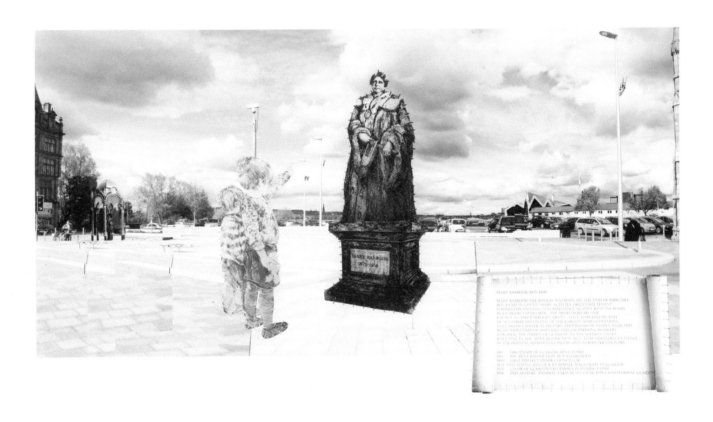

Mary Barbour Monument, 2012
Collage (etching/digital print)
87cm (w) x 48cm (h). Edition of 10
Photo: Tian Khee Siong

22

Boxed In

Leela Soma

Yatra Naaryasthu poojyanthe
Ramanethe thatra devathaha

Where women are treated with dignity and Womanhood is worshipped, there roam the GODS (Sanskrit Hymn)

I stood at the doorway as I heard my mother pleading with the man. 'I have two more mouths to feed, you know that I'm working in two houses as a maid, and I can't do any more. Please give me more time,' her voice shook as she implored.

'Then that rogue of a husband of yours shouldn't have taken a loan. I'm no charity. The full amount tomorrow or else you'll be out of this miserable hut,' he roared, his moustache quivering. He strode away; his menacing look burned my face. I ran and stood beside my *amma* (mother) tugging at her sari, she was shaking her head, her voice reached a keening that I had heard four years ago when my father had drowned in the river.

'Suicide, shame, leaving the family destitute,' words from my neighbours that I had understood with creeping fear, came back to me. My little brother beside me, pulled at my sari. I put an arm around him.

My mother beat her chest and cried, 'What will I do? God help me. Someone help me.' My mother sat on her haunches, looking spent.

I touched her arm and said gently, 'Remember *amma*, when I joined the match factory, Mani, the gaffer said he'd give you an advance if you let Ram work there. You didn't want to take him away from the school, but we have so much work now and they are looking for extra hands. I know he'll take him. Let's go right now, we can't wait any longer.'

Her sobs were quieter now and her face crumpled with deep lines. With little energy she wiped her tears and her nose on her sari. She nodded and got up slowly. We walked the two miles to the gaffer's house in the blazing sun. Mani was annoyed that we had disturbed him on the one afternoon in the week that he could take rest.

'See me tomorrow at the factory,' he said, but I spoke up and explained. 'You also need that order for *Diwali* completed by next week. Ram is a quick learner. I'll make sure he works hard, please sir, help us.'

He took his time, and then said in his gruff voice, 'I'm only doing this because you are a good worker Devi and it is temporary, till the *Diwali* order is completed. If he is no good I'll turf him out the next day, do you understand?' My mother fell at his feet and cried her thanks.

We offered a coconut to Ganesha temple on the way back to the house. *Amma* kept the money safe in the tin trunk and locked it. Ram was excited, 'I can go with Devi in the van. No more school!' he exclaimed.

At four am next morning the van arrived and a sleepy Ram and I got in, greeted by the fifteen others from the neighbouring villages who were in the van. The van trundled on its way to Sivakasi. The long shift at the factory started as soon as we reached the shed. Ram task was to pack the match sticks into bundles and then into the boxes. It was simple and he did it with enthusiasm, so I carried on to my end of the shed, where we older ones dipped the match stick tips into hot sulphur. The smell still irritated my eyes and nose. Sometimes the strong chemical seemed to stick to my skin and I scrubbed hard when I bathed. The radio blared out a Tamil film song and we worked till lunch time. The shade of the mango tree was better than sitting inside in the stifling airless room. Chatting about film stars, dreaming about good food and mimicking the gaffer, saying 'Right, Right,' the man, who made our life all wrong, gave us something to laugh about and took the boredom out of the day. I hoped that *amma* had paid the loan shark and we could have peace for a few weeks at least.

At the end of the day, Mani shouted over to me. I walked over nervously.

'Right Devi, your brother is coping okay. I'm doing you a favour, right?' He was sweating profusely, the rivulets running down his cheeks making the dark pock marks glint. 'Right, if there is any one poking their nose in this place, he needs to say he is fourteen, not ten. Got it.' 'But even I'm not fourteen...' I interrupted. He rolled his eyes. 'Right?' he shouted. A bit of his spit fell on my cheek, I cowered, lowered my head and said, 'Yes, sir'. 'Right, he needs to work a bit faster tomorrow,' he said and turned his back to me.

I went home with a light heart.

Two months later, our routine was set. Ram and I settled down at work, I was proud of him; he was fast making the bundles, packing them in the safety match boxes and made the gaffer happy.

'*Amma*, we even got some crackers and a tiny bonus for Diwali,' he cried as he jumped off the van that evening before Diwali. *Amma* had been given some second hand clothes and a packet of sweets from the houses where she worked as a maid. It was the first Diwali that we had celebrated after father passed away. We went back to work feeling good, and then it happened.

A tiny spark and the whole factory went up in flames. I screamed for Ram. I ran to the end of the shed where he had been working. The fire singed my arms, but I got him out safely. Mani roared that we should all get the buckets of water and throw water at the shed. It was not enough. The flames were huge and we stood in shocked silence as our livelihood went up in smoke. The next few days were a blur to me. Our vans came, collected us and we were crowded into the other shed to do some work, as well as help clean the surrounding area of the fire.

That's when I saw them. The owner of the factory whom I had never seen before arrived first. He spoke to all of us for a few minutes and warned us that we should be discrete and not talk to anyone. The local politician arrived next in a plush car and promised compensation to the grieving parents of the boy who had died. The newspapers clicked away, the politician and the owner and even Mani stood for photographs. They gave them lengthy interviews and smiled at us workers. When the journalists tried to talk to some of us, Mani shooed us away. I was curious, I wanted to know more but I could not get near them. They left soon after. The show was over.

I spread some turmeric and oat paste that my mum had ground on the burns. They started to heal. In just over a week, the shed was replaced by a new one and we were back at work. There was a fire hose ready for use but water supply was from the same tap. We were glad to get paid again.

Then one morning there was a commotion. A big van with a logo painted on it, squealed to a stop at the door of the shed. Three well dressed men rushed in and asked us all to get in the van. We were petrified. Mani was enraged but a woman stopped him in his tracks. 'Right, who are you?' he screamed at them.

The woman spoke firmly but clearly. 'We are from the Bonded Liberation Fund. We believe that most of these children are underage and unless you can prove otherwise we are here to take them away and give them a childhood.'

Mani's face went from dark to purple, apoplectic with rage.

'Who gave you permission? Right? Tell me who allowed you in here? I'll call the owner, you talk to him,' he screamed.

'I don't need any one's permission, I am Sweta Nair from the Foundation and I have got enough evidence that these children have been removed from school and are working here. Here's my card. Tell your boss to contact us,' she said and turned to all of us.

'Don't be afraid. Come with us and we will help you. We have met your parents and they have given us permission to rescue you. Devi, help me please,' she said looking at me.

'How do you know my name?' I was surprised.

'I told you we have met all your parents. This is the only way to get you all out of here. Get in the van, quickly,' she grabbed my hand.

'Ah...' I said withdrawing it. She looked at the scars.

'You've been hurt and not even a bandage on it?'

I looked at her face and the other men. They looked kind, I knew they were right.

'Let's go,' I said bundling Ram first into the van and the others followed. Mani's face was a picture; He picked up his mobile phone and talked furiously into it. We were soon on our way, and the countryside rushed past the speeding window.

They had brought some *Limca* and toffees for all of us in the van. We savoured the treats and looked out of the van window. Sweta explained to all of us. She said many things that I could not really understand about the Child Labour Act 1986, that it was a scandal that eleven million children were working in India. That all of us were under fourteen, the legal age when we were allowed to work in India and not in hazardous industries like safety matches and fireworks. She held up my hand and said that my scars, the blistered hands of some others and the breathing trouble some had were because we were working in a factory that was not for children. That made sense to me.

'Will we see our parents? Where are we going?' I asked her in a whisper.

'Of course you'll see your parents! We are taking you all to a safe place in Chennai. We will settle you in first then we need consent from your parents, court orders and people to help school you.'

'Chennai?' I was excited. The city where the films were made, my dream come true, I thought to myself. I had never traveled this far before. Huge posters of the Chief Minister of Chennai and colourful film hoardings decorated the city's outskirts. Then the traffic snarled almost to a halt and inched its way to our new home.

This was a whole new experience. We had running water, bathrooms for boys and girls, a huge dormitory where forty girls slept, and the boys had the same. We were given food that was delicious, not cooked in mud pots like my *amma* did, at home. There was a garden with flowers and trees. I thought of my *amma*, alone, struggling in that little hut and the tears ran down my cheeks.

The next morning at eleven all the parents of our little group were in the hall. Ram and I ran and hugged *amma*. She looked happy for us and held us both tight.

'Lord Ganesha has been kind. He has helped you both, I have no more worries,' she cried.

'*Amma*, I can't leave you on your own there,' I said, hugging her more tightly.

'*Achadu*, (silly girl) you must get back to school and get a better life than me. This is a god sent opportunity, grab it with both hands and work hard. I can manage on my own. My heart is glad now that I can see a future for you both. In three years when you finish school, and get a job I'll be so happy. They say that we can visit each other too, so the time will fly,' she said, smiling at Devi.

Ram prattled on about the toys, the play area in the house and his bed which had a mattress. 'It is so soft, you must lie on it,' he said to *amma*. She patted him on his head and hugged him.

I missed my mum, but my new life was so much better. Sweta often spoke to us about what had happened to us and helped us speak about our time at the factory. She took us to the Adyar Theosophical Society and showed us the huge Banyan tree, the biggest in the world that had survived for 450 years. The aerial roots had spread over a massive area. We looked at the tree and marveled at the sight. Sitting on one of the branches she told us a lovely story about the lady Annie Besant who had started the Society in Madras. She was a brave woman from a faraway country called Britain. Two hundred years ago in 1888 she had rescued and fought for young girls who worked in a Safety match company just like us. She had led a strike, *a hartal* that forced the owners to make the factories safer and stop using young girls in such dangerous job.

I looked at Sweta and admired her. I wanted to be like her and that lady Annie Besant.

Maybe one day I'll be able to help other young girls to lead a better life.

*

A few years later, a local newspaper in Sivakasi reported:

Social Worker Sweta Nair received a National Award for rescuing children from a match factory.

Ram, a former factory boy has passed his Central Board exams and has been admitted to a course in Physiotherapy. His sister Devi works as a care assistant in a senior citizen home. These children's lives have been transformed by the determined efforts of the social worker and her team.

In her acceptance speech Sweta Nair said: 'Though India's Acts of Parliament provides for protection of our vulnerable children, the reality is that it is hard to enforce in our area where the cottage industry is reliant on child labour. Eradicating poverty is the only measure that will prevent this happening again.'

Women In The City

Jacki Parry

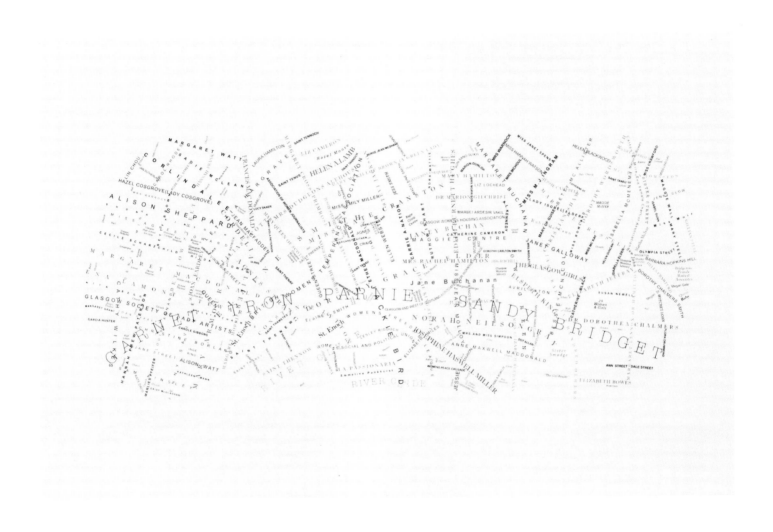

Women In The City, 2012
Photo-etching on mouldmade paper
71.5 cm (w) 54cm (h). Edition of 20
Photo: Tian Khee Siong

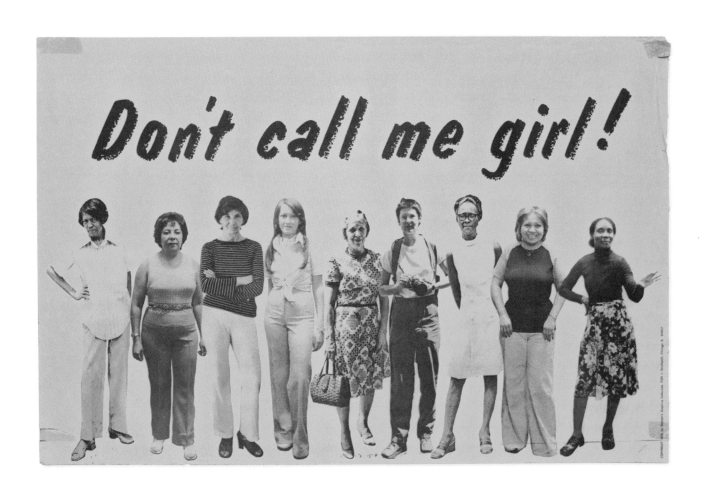

21 Spare Ribs

Helen de Main

21 Spare Ribs, 2012
Screenprint, 21cm (w) x 29.7cm (h)
Variable edition of 21; 2 of each print
Photo: Alan Dimmick

21 Spare Ribs (January 1986), 2012
Screenprint, 21cm (w) x 29.7cm (h)
Variable edition of 21; 2 of each print
Photo: Alan Dimmick

An Innocuous Tale of Love and Romance

Alison Miller

It looks sore. It looks all wrong. The skin's wrinkled at the shoulders on the pole, stretched out of shape, so it falls in folds. If you could look over the top edge of the picture, you would see down into the empty sack of the woman's body. Except it's not a sack either. More like a swimsuit made of skin, but with ribs. You can see ribs through the skin. And the boobs sit on top of the ribcage just like normal. What gets to you most, apart from the handles on the hips, like pot handles, and the yellowish, sort of dead-looking skin, is that there's no – there's no – well, no vagina. Just two holes for the legs.

Her friend Rosa's birthday was on one of those bright Saturdays when the sun hits the back of the house from early morning and comes streaming through the bedroom curtains. Inga managed to sneak out of the room without waking her sisters. Her mother was back in bed with a cup of tea after the van had collected her father for work. Nobody else was up. She had peace and quiet to think, wash her overall and dry it, first by rolling it in a towel and trampling it with bare feet, then ironing it on a low setting. Steam rose from it, but she knew how long she could press on the nylon without it melting. It was warm, dry and crisp when she put it on.

And now here she was walking to the paper shop down the empty, shining street that was still wet from rain in the night. No shops were open. At J&W Tait's across from the cathedral, somebody was washing the windows. The glass shimmered and moved in the sun like water.

A group of boys dressed in a kind of naval uniform went past and wolf whistled. She kept her face stony and looked straight ahead. They must be cadets off some boat berthed at the pier. She had reached the corner when one of the boys came running after her.

So what's wrong with me? he said, earnest, looking her in the eye.

She was flustered.

Nothing's wrong with you, she said. I already have a boyfriend.

Which was not true, but the cadet peeled away from her and ran back to his friends.

*

The order had arrived in the shop with her name on it. Thank goodness! Mr Wilson handed it to Inga still wrapped in the original brown paper when she got in. And then he started cutting the string on the bundles of newspapers, setting small piles on the counter and squaring them off. She stuck the parcel in the drawer underneath to open later. Mr Wilson was in one of his silent moods so it was not easy to ask him, but she did anyway.

Have you thought any more about... well... what I asked you three weeks ago?

What was that?

You know, us Saturday girls, Rosa and me, getting the same rate as the paperboys.

Ah, yes.

And then he went quiet again. So Inga squeezed by him and stomped up the stairs to get the lemonade bottle with the hole in the screw top and fill it with water in the toilet. Nineteen Seventy One and he can't even put down a bloody roll of lino! Or at least slap on a coat of varnish. You were meant to sprinkle the water all over the wooden floor, right from the front shop to the china department at the back, before you swept it. Like putting vinegar on chips, but it was supposed to keep the dust down. And it must have worked to some extent, because one Saturday Inga swept the floor without it and the clouds of dust would have choked a horse. It floated down onto the china and the books like volcanic ash.

The dust was from the newsprint, Mr Wilson said. Even with the water sprinkled on, you would be amazed at how many shovelfuls she emptied between the back shop and the front every Saturday morning. And still it never looked clean. Inga enjoyed it all the same. It was the one quiet time before the customers started pouring in for their Saturday orders and she had to run back and fore to the store to see if Sam and co had got them made up yet. They were supposed to take turns at the sweeping, her and Rosa, but Rosa was never in early enough. Which made it kind of difficult to ask for a rise in their wages. And why should she do the asking anyway? Rosa was the one who came in shouting about equality for the workers. Well, OK, not shouting exactly, but most of the folk round about didn't have a political bone in their bodies and didn't like to offer an opinion. Unless it was about the price of beef cattle or the farmers not getting enough for their milk. Still, there wasn't much else you could do with a name like Rosa after Rosa Luxemburg. You're kind of destined. A firebrand, that's what Inga's mother said she was.

Now don't you get too caught up with Rosa's wild schemes, Inga. She's a bit of a firebrand, a chip off the old block, her mother said.

Rosa's dad was different from other fathers Inga knew. He stood for the council and tried to organise the farm workers, that sort of thing. Which went down like a lead balloon in the isles. The Red Clydesider some folk called him. Up from south twenty years before and married Rosa's mother.

Politics is all very well for Glasgow, but not for Orkney, folk would say.

If he's that keen on communism, why doesn't he go and live in Russia?

Stick him in a council house in Siberia, see how he likes it.

That was the kind of thing people said. Inga had even heard them in the shop. A couple of the farmers, in for their *Exchange & Mart*, standing at the side complaining about him. She had to stop Rosa getting out from behind the counter to let fly at them.

They're not worth it, she'd said, just ignore them.

All right for you, Rosa said. He's my dad.

That's when Inga noticed the tears in Rosa's eyes. And that's when she decided she would have to give her something special for her birthday.

*

She doesn't get a chance to look at it properly till her teabreak. Then she smuggles it upstairs inside a copy of *Petticoat*. Rosa's busy serving customers and doesn't suspect a thing. Even so, Inga keeps it in the paper and pulls back the edges. The picture makes her scalp prickle. She forces herself to look at it again, half an eye on the door in case Rosa's sent up early for her break. Or anybody else, come to that. She doesn't fancy being caught with it.

The ribs, she's glad of them. And the boobs. Otherwise the whole thing would hang down limp exactly like a swimsuit. Or at least a swimsuit with no support cups inside. The ribs make it look more normal. And more weird. Yeah, but what is 'normal', anyway? That quiz in last month's *Honey*, 'Do you have a ribcage like a laundry basket?' She had never wasted a single thought on her ribcage before she read that. But when she checked in the mirror it was sad but true that she took after her dad. Her mum had a narrow torso and her dad was sort of barrel-chested. A barrel-chested man and a laundry-basket-chested woman. Not quite the same, was it?

Imagine if the boys at school got hold of it. *Hahaha, she's got no fanny. You'll have to stick your thing up the leg hole, Stevie boy.*

Hahabloodyha.

They'd been like that ever since that grumpy wee man came to the school to give the class some sex education. He was from south, a doctor supposedly. Well, could you imagine any of the teachers talking about sex! After the anatomy lesson, the sexual organs and what goes where, the pictures of gonorrhoea and syphilis, it was a relief to write down their anonymous questions, fold up the bits of paper and give them to the doctor to read out.

Can you have sex standing up?

Rosa and her tried to guess who'd asked that. Whoever it was, the wee man was not amused.

You can have sex swinging from the light if you want! he said.

Inga went red when he came to her question.

What is the function of the clitoris?

Hrmmh, hrmmh... it's a sensitive part of the female anatomy, he said.

Is that all? she thought. But nobody dared to ask any other questions. He looked like he might burst a blood vessel.

*

When Inga gets in from work that night, she manages to sneak the parcel in the front door, upstairs and under her bed, before anybody knows she's home. The usual crowd's there, her dad and her uncles drinking beer, her aunts talking on the sofa and all the kids sitting about watching *Doctor Who*. Except Charlie. He's playing on the floor with his toy cars and ooo-ooo-OOO-ing the theme tune in a high voice.

Her mother's in the kitchen with the door closed, red in the face from the heat and trying to cook for the whole crew. The place is full of smoke and the smell of frying: bacon, sausages, black pudding, eggs, bread, tatties, tomatoes. She bends down to put the next lot in the oven to keep hot and Inga can see there's already a mountain there.

Can I do anything to help?

Yes, you can get out from under my feet like the rest of them.

I'll put some of the stuff that's ready on plates and take them through.

Yes, sorry, Inga. That would be great.

Why does she do it? Same thing every Saturday. John sticks his head round the door.

When will tea be ready, Mum? I'm starving.

It'll be ready when it's ready! she says. And she looks right wild.

Only asking!

Then David comes through.

Don't even say it. Their mum points at him with the fish slice.

Say what? When will tea be ready?

Inga lifts the two plates she's filled and pushes them at David.

Give that to Dad and Uncle John.

What did your last slave die of!

Oh, for the love of goodness, their mother says, and she snatches the plates out of Inga's hands and marches through with them.

I was only trying to help, she says, when her mother comes back through.

Yes, well it's easier to do it myself.

But she's a bit calmer since she's got the first two served.

Inga fills some more plates and carries them through without saying another word. Her uncles first, then her aunts, then the bairns. They all sit eating with their tea on their laps, except her aunt Ellie. She has Charlie on her knee and is feeding him from her plate on the sofa. It's peaceful now except for the croaky shouts of the daleks from the TV.

Her mother tries to catch her eye when she goes back in for another couple of plates, but Inga keeps quiet and doesn't look at her. She was only trying to help. She can't see why the boys should get off with doing sweet bugger all when she's been out working.

Your nose is black, her mother says. Did you walk up the street like that?

Oh no!

Inga looks in the shaving mirror above the sink and sure enough there's a black ring round both her nostrils and smudges under her eyes. Bloody panda face! The hankie she fishes from her overall pocket is filthy already but she blows the black snot into it anyway. Then splashes some water on her face and rubs off the printer's ink with a clean corner.

That hankie wouldn't disgrace a coalman, her mother says. She's smiling now and trying to make a joke of things but Inga is not in the

mood. If she wasn't mad at her, she might show her Rosa's present. Her mother's quite broad minded. Still, even she might not be too impressed with that picture.

I'm going upstairs to change my clothes, Inga says.

Please yourself.

Midge is in the bedroom getting ready to go out. She's standing on her bed looking at the mirror propped up on Inga's bed to get a full-length view.

Is that my green blouse? Inga says. It is! It's my blouse.

She tugs it out of the waistband of Midge's skirt.

Oh go on, Inga. Midge tucks it back in. You're not wearing it tonight. I'll wash it, I promise. It'll be back in your drawer tomorrow.

She can't be bothered to argy-bargy, so says nothing and sits on her bed in front of the mirror. It suits her sister more than her, anyway, though she would never let on. Midge moves her head from side to side trying to see her reflection past Inga.

You make a better door than a window, she says. How do I look?

Fine.

Is that all?

Inga says nothing and digs the parcel out from under the bed.

What's that?

Rosa's birthday present.

Ooh, what did you get her?

This.

She holds it up in the brown paper and pulls the edges back from either side like a stage curtain. Midge's mouth falls open.

You're not going to give her that are you? That dirty book?

It is not a dirty book, Inga says. It's about women's place in society. And you better close your mouth or you'll catch a fly.

Well it looks like a dirty book to me. Her dad will go bananas.

No he won't. It's political.

Midge flaps her hand in front of her mouth and yawns.

Bo-oring! she says. Right, I'm off.

Where you going?

Out.

Why bother asking? The only place to go on Saturday night is the Cosmo. The lasses will sit along one side of the hall and wait for the boys to get pissed enough to walk across the floor and ask them to dance.

Once Midge has slammed out the front door, Inga takes the book right out of the paper for the first time. The cover's grown on her. She doesn't see why it's any worse than the photos in *Parade* or *Penthouse*. That Mr Bain coming in for his order, staring at her across the counter, while she has to stand there tying up his nudie magazines inside his *Daily Express*.

All this and heaven too, he says, and winks.

Every bloody week!

He was none too pleased the time she rolled up his papers with the *Playboy* on top and tied them tight with a granny knot, the boobs staring straight out at the world. Serves him right. Take that home to your wife.

Rosa's expecting her at seven, which leaves not a lot of time to get ready. The bathroom door's locked of course. Inga shouts through it, How long will you be in there?

About five foot ten.

Very funny, Alec. I need in to wash. I'm going out.

So am I. Get in the queue.

Bella sticks her head out of the sitting room door. I'm next, she says.

Oh, forget it, Inga says. She shoves past her into the room, steps over the outstretched legs and picks up her mother's pinking shears from on top of the sewing machine.

Where you going with them? Her mother's voice is raised above the racket of the bairns shuffling round the room with one arm out, shouting, *Ex-ter-min-ate*!

I'll put them back when I'm done, Inga says, and runs upstairs before anybody else speaks to her. The inside layer of paper the order came in is still pretty smooth, so she spreads it on the floor and sets the spine on the middle of the sheet. Then she makes two cuts at the bottom and two at the top the width of the book, creases the narrow strips up inside and holds them in place while she folds the paper over the back and front cover. When she's finished, except for the jagged edges made by the pinking shears, it looks just like her French Grammar book. Should be easy enough to slip it past Rosa's mum.

*

You're late, Rosa says.

I know, sorry. Couldn't get into the bathroom. You know what it's like. Happy birthday!

Inga hands her the present and sits down beside her on the bed with the red candlewick bedspread Rosa dyed herself.

What's this? Rosa says. *An Innocuous Tale of Love and Romance*? Inga had written the words in italics with a red felt tip to make it look like the real title of a book.

Rosa's dad comes in with two glasses of his homemade ginger beer. His face is flushed and he's grinning. He looks like he's been into the homebrew himself.

From the only bottle that didn't explode in the cupboard, he says, so you better sip it. If it was wine it would be worth a fortune. What's that?

My birthday present from Inga, Rosa says.

Before Inga can warn her not to, Rosa is ripping the paper cover right off.

The Female Eunuch, Germaine Greer, she says. Fab! Thank you!

Inga's face is hot now and she takes a gulp of the ginger beer. The bubbles go straight up her nose.

Let's see? Rosa's dad says. He stares at the cover for a minute, then starts to flick through it. At one page he stops and reads for what feels like ages. Then he looks at Inga as if he's never seen her before and sets the book down on the bed.

Silly lassie, he says.

A Scarf for Glasgow Women's Library

Ruth Barker

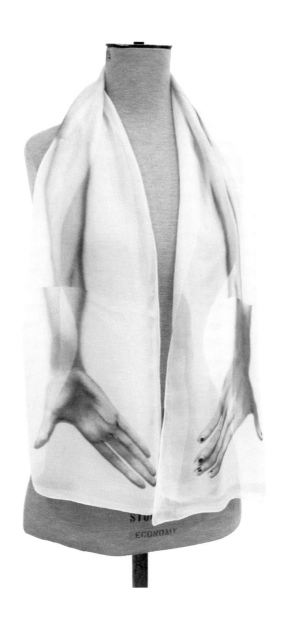

A Scarf for Glasgow Women's Library, 2012
Digital print on silk chiffon
30cm (w) x 135cm (h). Variable edition of 20; each print is unique
Photo: Alan Dimmick

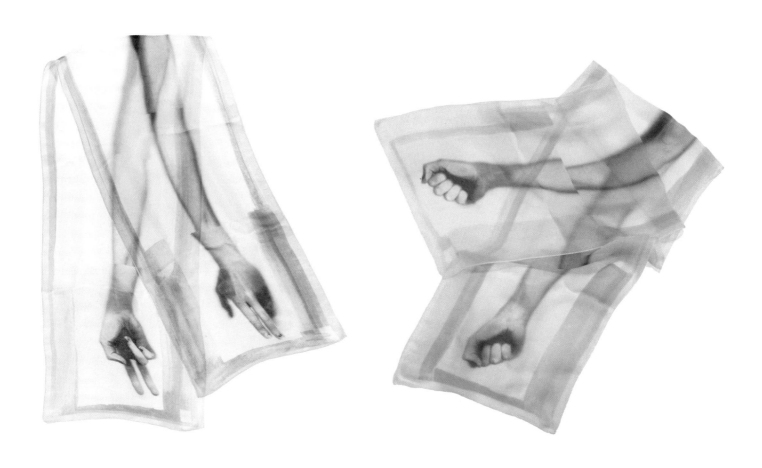

A Scarf for Glasgow Women's Library
(memory purple, two fingers) 2012
Digital print on silk chiffon
30cm (w) x 135cm (h)
Variable edition of 20; each print is unique
Photo: Tian Khee Siong

A Scarf for Glasgow Women's Library
(welcome salmon, strong fists), 2012
Digital print on silk chiffon
30cm (w) x 135cm (h)
Variable edition of 20; each print is unique

We Thought We Were Going to Change the World

Margaret Elphinstone

In the archives of Glasgow Women's Library there is a box of badges from the late 1960s to the mid-1980s. They say things like 'I'm a sister', 'You can't beat a woman', 'CND', 'It's time to upset the order of things', 'Women for Peace Faslane 1983', 'Fight the Criminal Justice Bill', 'Stop the War', 'So Many Women So Little Time', 'Give Peace a Chance', 'Peace Truth Justice Freedom', 'Extremist...' There are home-made badges for local events, and badges with internationally known symbols. There are badges proclaiming sexuality and personal power, support for local groups, and allegiance to international feminist, civil rights and peace movements.

I used to have a drawer full of such badges myself, which I wore as fancy or circumstance suggested. Why didn't I keep any? Where have they gone?

Those badges belong to a particular aesthetic that is now history. Feminists now seldom use their bodies as message boards proclaiming personal taste, ideology or allegiance. Feminism is no longer highly salient in public spaces, in the form of notices, cafés, bookshops, libraries, printing presses, theatre, art and literature. Recently, the bookshop/café Reading Lasses in Wigtown had, in its bathroom, a collage of postcards of the 1970s and 1980s, featuring women's banners which were used on rallies and protests. Seeing those postcards in the 2000s was like looking backwards through the wrong end of a telescope. When I marched behind banners like those, I didn't perceive them as a particular aesthetic response to a definite historical moment. The generic antecedents of the women's banners of second wave feminism were traditional women's crafts, such as quilting and embroidery, ethnic designs inspired by the colour and vivacity of Mexican and South-American textile arts, and naive painting in twentieth-century art. The banners seem exuberantly cheerful in their protest against oppression and annihilation. They suggest a possible alternative, offering hope for the future through exaltation of a female and ethnic aesthetic, in apparent opposition to grey-faced patriarchy.

Women's art wasn't simply folk art, although the feminist home-grown aesthetic was everywhere. It was fuelled by high art, theatre and literature. In 1980, I went to London to see the exhibition of *The Dinner Party* by Judy Chicago, in which thirty-nine well-known women, some historical, some mythical, are represented by place settings around a triangular dinner table. I walked round and round the dinner table, looking at the settings over and over again. It was one of those experiences which tweaked my perspective on the world, altering it just a little, but forever. It represented something

about being a woman which I had not internalised before, because nothing in my background or education had taught me to understand my gender in quite that way. It continued a process that began consciously when I read Simone de Beauvoir's *The Second Sex*, when I was fourteen. Beauvoir's book astonished me. It said things about being female that I'd thought were unmentionable, but, now that I read them in plain print, I knew from my own experience to be true. But until I read the book, I had no idea what my own experience was. Encountering second wave feminism, in popular culture and high art, in early adulthood, it seemed as if these new images, this new aesthetic, reflected something hitherto unknown inside myself. They confirmed what I already almost knew, by apparently expressing for the first time who and what I was.

In order to understand fully the impact of feminism in the late 1960s, one has to remember what our world was like before. I was typical of those early feminists in being white, middle-class, well-educated, and English. As a matter of historical fact there were many oppressions that I did not experience. I came to the Civil Rights movement through the music of Joan Baez and Bob Dylan, but it was only when I encountered early feminism that I truly felt that the struggle spoke to my own condition. When I look now at the seven demands of the Women's Liberation Charter of the early 1970s it amazes me that I grew up in a society where a demand for equal pay for equal work, equal education and equal opportunities, free contraception and abortion on demand, legal and financial independence for women, and an end to discrimination against lesbians, was regarded as radical (and often ridiculous) left-wing nonsense. The first six demands are now mostly accepted by mainstream society. The expectation is that they will be met, and most people are justly indignant when they are not.

Economically and politically we have come a long way in the UK. The seventh demand makes more uncomfortable reading: "Freedom for all women from intimidation by the threat or use of violence or sexual coercion, regardless of marital status; and an end to all laws, assumptions and institutions that perpetuate male dominance and men's aggression towards women." It strikes me now that the more unequal the society we live in, the more women will continue to suffer intimidation and aggression. While many of the demands of the Women's Liberation Movement (WLM) have been met, such victory is undermined by economic disparities within a society that grows increasingly inequitable as the years pass.

I feel nostalgic when I look now at the artistic representations of second wave feminism. I'm wary of nostalgia. It's necessarily retrospective, and ahistorical insofar as it's sentimental about the past. But what if the past I'm remembering was more positive than the present? Can that be true? It certainly seems to me now that it was a freer and happier time to be young. Growing up in Somerset, I watched the first hippies arriving at Glastonbury long before I'd heard of feminism. My friend Peter and I sat on our bicycles and watched the long-haired (men), long-skirted (women), sandalled, exotic-smelling strangers arriving in our small town. I thought, *I want to be free like that when I grow up.* Before he was 16, Peter had crossed the street and joined them. I didn't drop out, but when I encountered the Civil Rights Movement, and then Feminism, I thought I was becoming radicalised. Our post-war generation had missed the terror of real conflict, and were now living through an economic upturn. It is easy to rebel when you can always find a job if you have to. Decades later, I'm still asking the same question: was our revolution real? Many of the things I hoped for, and, indeed, expected, have not happened. So what difference did it make?

In the 1990s and early 2000s, I taught feminist theory at a university. Seen through the lens of postmodern theory, the feminist aesthetic of the 1960s to 1980s may seem shockingly essentialist, if not pathetically hopeful of some kind of unified, alternative, celebratory solution to the conundrums of patriarchy. In the BBC series on feminism in 2010 Marilyn French looked back at those times and said, 'We really thought we were going to change the world'.[1] Then she added, 'It was wonderful'. I cried (most unlike me), because what she said was true. We really thought we were going to change the world.

I should have known better, because I studied history and literature at university. The world does change, but nobody changes it. Ideologies come and go. Empires and economies rise and fall. The Golden Age is an aesthetic conceit which, in historical terms, neither was nor will be. What was real was the present which we inhabited. It felt like a revolution. It was heady and exciting. Sisterhood existed, and seemed like a new discovery. Sometimes I couldn't help saying to my 1990s students, as they ploughed through the denser texts in the student anthology of feminist theory, 'But it was exciting. It wasn't a theory. It was about our lives. It changed everything'.

Leafing through old copies of *Spare Rib* in Glasgow Women's Library – (Why didn't I keep mine? Where did they go?) – I'm struck by the continuing juxtaposition of the personal and the political. In 1973, Betty Friedan wrote:

"[Feminism] meant that I and every other woman I knew had been living a lie, and all the doctors who treated us and the experts who studied us were perpetuating that lie, and our homes and schools and churches were built around that lie. If women were really *people*, no more, no less – then all the things that kept them from being full people in our society would have to be changed."[2]

'The personal is political' became our watchwords, because for the first time, we were seeing our personal experience of gender as a political issue. Now, looking backwards through my telescope, I would say the personal is historical. As a historical novelist I try to interpret historical situations and events through the lens of individual experience, to address the question of what it was like to be a particular person, in a particular moment in space and time. Individuals are constructed by history: not only do they speak and act according to their context, but they can only *think* and *feel* within that context. For women to change what it means to be a woman it has to be an internal as well as an external struggle. That is what the Consciousness Raising (CR) groups were all about, and that is why I maintain to this day that they were essentially political. I was in CR groups from the early 1970s to the late 1980s (when I abandoned CR for a women's writing group). From the basis of CR, we argued and wrote, we took practical action, we went on demonstrations. But it was the attempt to reconfigure the internalised ideology of gender that drove us. It probably changed us less than we realised, because the insidious thing about ideology is that it's invisible from within. What we have learned from our earliest days to perceive as the natural order of things cannot be entirely wiped out by any effort of will. To begin with, what can we replace it with, if we have no other experience? Hence, I believe, the bitter arguments about what feminism was, or ought to be.

For there was a shadow side to second wave feminism. I was horrified by SCUM (the Society for Cutting Up Men).[3] The rejection of men, even small boys, by extreme separatists, made me think of Orwell's *Animal Farm*: male chauvinist pigs there certainly were, but I didn't want to look through the farmhouse window and see a world dominated by their female counterparts. To regard any human being as subhuman on account of any genetic characteristic is, as we used to say back then, 'Not all right'. I was also upset by the savage conflicts within the WLM movement itself. I sometimes felt defensive of my motherhood, my sexuality, class and race. Apparently, sometimes I ought *not* to be who I was. A neo-puritan element decreed implicitly that true feminists always dressed as if they were camping (justifiable, of course, at Greenham, because we were). I remember when Hélène Cixous came to Edinburgh in about 1985: she looked like a true Parisienne, elegant to the bone, as she expounded her radical feminist position. She had a silk scarf which she kept rearranging as she spoke, each time in more decorative folds. At least one member of her dungareed and jerseyed audience was enraptured. Was it then possible to be aesthetically pleasing without enslaving oneself to the tyranny of the male gaze? Later on, I was swept into the conflict between hard-line feminism and the Women's Peace Movement. There are possible parallels with Christabel Pankhurst's defection from the suffragettes to supporting the war effort in 1914. And in her case the vote, albeit limited, came in 1919, as a recognition of women's war work, not because of the suffragettes.

Cruise missiles left Greenham Common not because of the women's peace camp, but because of remission in the Cold War: as in the early twentieth century, direct action by woman was not the overt cause of change. But the difference was that we were

1. 'Libbers', episode 1 in series *Women*, by Vanessa Engle. First broadcast 8th March, 2010, BBC, http://www.bbc.co.uk/programmes/b00rgphp/episodes/guide

2. *Spare Rib*, no. 13, 1973. Betty Friedan, article ten years after *The Feminine Mystique*, 'How to succeed by really trying'.

3. *SCUM Manifesto*, Valerie Solanas, 1967

against war, undermining, not supporting, a belligerent foreign policy. I certainly experienced Greenham Common as an extension of my feminist involvement. I've mentioned how the WLM posited an idealised, peaceful, colourful world through its consciously naive art forms. Surely peace was the obvious outcome to terminating patriarchal wars? But the Women's Peace Movement was far from peaceful in the conflicts it engendered within the movement itself. Should we not have been surprised? Was there ever a revolution that didn't splinter into dissonant shards as soon as it began to take effect? Thirteen years in single-sex education had not shown me a world of constant peace and harmony among sisters. What evidence was there that a matriarchy would manage any better?

And yet, when I consider Greenham now, it confirms that there was such a thing as sisterhood. With other women, whom I had not chosen as friends and whom often I hardly knew, I made and implemented plans that seemed to me both frightening and dangerous. The historical context of my existence had blessed me with an extraordinarily sheltered life by the standards of world history. It still does. How many people have inhabited this planet for over 60 years and had no first-hand experience of war, famine, plague or natural disaster? Perhaps this is why I belong to a first-world generation which seems unable to accept historical cause and effect, over issues such as climate change or economic profligacy. We have not fully experienced how the world changes.

We were, of course, reading a genre of feminist utopias, by authors ranging from Charlotte Perkins Gilman's *Herland*, in 1915, to Suzy McKee Charnas's peculiar book, *Motherlines*, in 1978. I was cynical about this rather pallid genre, feeling that a world without men would lack a certain *je ne sais quoi*. (*Vide Motherlines*, I was never *that* keen on horses). I greatly preferred satire such as Gerd Brantenberg's crazy role reversals in *Egalia's Daughters* (1977), grim dystopias such as Zoe Fairbairns' *Benefits* (1979), or best of all, the overwhelming psychological insights and social realism of *The Golden Notebook* (Lessing, 1973) or *The Color Purple* (Walker, 1983). I wanted literature to represent the human condition as it was, not to entice me into escapist fantasy, which all too soon became slightly dreary. The problem about Paradise, as Milton had demonstrated categorically 300 years earlier, is that the characters have nowhere to develop, and without evil there is necessarily no plot.

Maybe I shouldn't quote Freud in the context of feminist history, but in retrospect perhaps the issue really was, 'What do women want?' It would be hard to argue against total gender equality, an end to every related oppression, plus world peace. But perhaps too many of us hoped for historically impossible outcomes. I'm not suggesting that the WLM was not politicised; the *Spare Rib* archive gives ample testimony to highly aware involvement with the wider political and economic context, and related liberation movements, on a global scale. Articles of self-development (everything from spiritual growth to how to be your own plumber) rub shoulders with first-hand analyses of the situation of women in Iran, South Africa, Eastern Europe etc., in the context of rapidly changing political agendas and social conditions. As I've mentioned, the WLM could and did have its impact on strengthening resistance to oppressive regimes, and supporting women in lobbying for change, or simply surviving.

Over time one's perspectives change. In 1973, Shumacher published *Small is Beautiful*. I read it avidly then, but the succeeding decades have, I think, taught me to read it better. It is the small-scale changes that alter people's lives. Individuals can help themselves and other individuals, and many small changes amount to what we used to call 'revolution by change of consciousness'. For example, in *War and Peace*, Tolstoy shows us that a Napoleon is an even greater prisoner of his ideology than the most obscure of his subjects. Some people in power were, and are, appalling in their record of human rights abuse. Others do their poor best. But they are all in thrall to the times they live in. Paradoxically, the more private the individual, the more freedom they often have to make changes. I remember being involved in a bitter argument with fellow university students following a demonstration in Durham marketplace. My opponent said it was ridiculous and naive to demand sweeping changes to the established order. He'd spent the summer in an Indian village.

"All those people needed, living with drought, was a well. We could raise enough money in this room, now, to give them their well. You would have done more good to more people then, than by having a demonstration every week for the next three years."

I can't say who was right and who was wrong. Every grassroots movement begins by challenging oppression on the grand scale and demanding change. We did that in the WLM, and at the time, I thought great change would necessarily follow. I'm saddened by the decline in feminist awareness and the apparent backlash of post-feminism. There are countries like Iran and Afghanistan where women have been forced to regress to medieval status. The scandal of sex slavery is rife in our own cities. Consciousness of internalised gender constructions seems to have slumped. And yet many of our initial demands in the UK were met.

All I know for certain is that the WLM of the 1960s to 1980s changed the lives of those who participated in it. This is not always demonstrated by great worldly acclaim. In the same BBC programme from which I quoted Marilyn French, we saw Kate Millett.[4] She lives alone and earns her living by selling Christmas trees, and her great-niece had just brought her some new sandals. A retired domestic life in the New England countryside, I couldn't help being reminded of Emily Dickinson, and of Robin Morgan's[5] famous essay, in which she searches for her foremother, the real Emily Dickinson behind the great poet. She finds an empty chair in an empty study in an empty house near Concorde. But the poems are still with us, and still relevant to our condition in their revolutionary form and subversive content:

Opinion is a flitting thing,
But Truth, outlasts the Sun —
If then we cannot own them both —
Possess the oldest one —[6]

4. Kate Millett, *Sexual Politics*, 1968

5. Robin Morgan, but I cannot find the reference after all these years.

6. Emily Dickinson, *The Complete Poems*, No. 1455

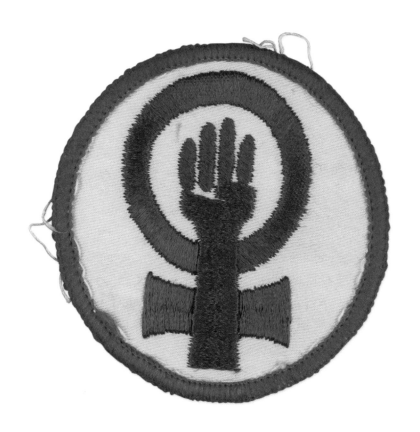

Advice-giver

Ciara Phillips

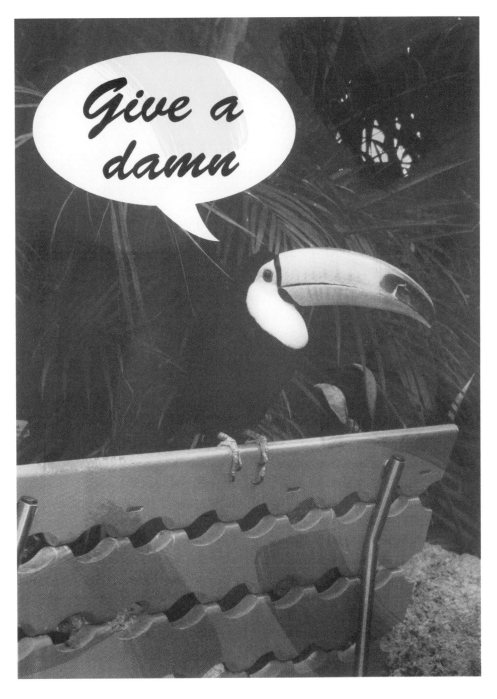

Advice-giver, 2012
Screenprint
56cm (w) x 76cm (h). Edition of 20
Photo: Alan Dimmick

Ingrid McClements' Papers

Jackie Kay

How strange to come across you, old friend,
Amongst your papers and newsletters,
Red Rag and *Links*, *Tell a Woman* journals,
You reappear, framed, folded, faded, open.
Years back, sun out, sons playing in your garden, London.
We didn't think we were pioneers: mums, lesbians.

Years later, we bump into each other, Glasgow,
Outside *Oran Mor* - me with my mum. She loved your hair.
You laughed, gamely. 'It's a wig, you know.'
We caught up on our sons, your daughter.
And here you are, once more - kind Highland face,
Looming through the gone years, that tilt of enquiry-

In this archive you left behind. You might conjure me now,
Or some other woman in Glasgow Women's Library,
Going through your papers on Racial Equality
In her lunch hour as you devoured *Off Our Backs* in yours.
How you would have appreciated the oddity
Of my mum walking through the door of *Oran Mor*

On your funeral day and finding your sister there;
As if some of the networked meetings of the living
Connect to the dead, in the endless future;
As if, old socialist, you're blessed with powers.
How often would we like to bring the dead back?
Tell them something they missed, make them laugh?

You are smiling, surely and the sun is out today,
So present are you here, old friend, my steps have followed
Yours into this sanctuary, this sacred space,
Up the stone stairs and through the open door,
To see you, colourful, old-style feminist, just there,
Passing it down: the grandchildren will meet you here.

Grassroots

Delphine Dallison

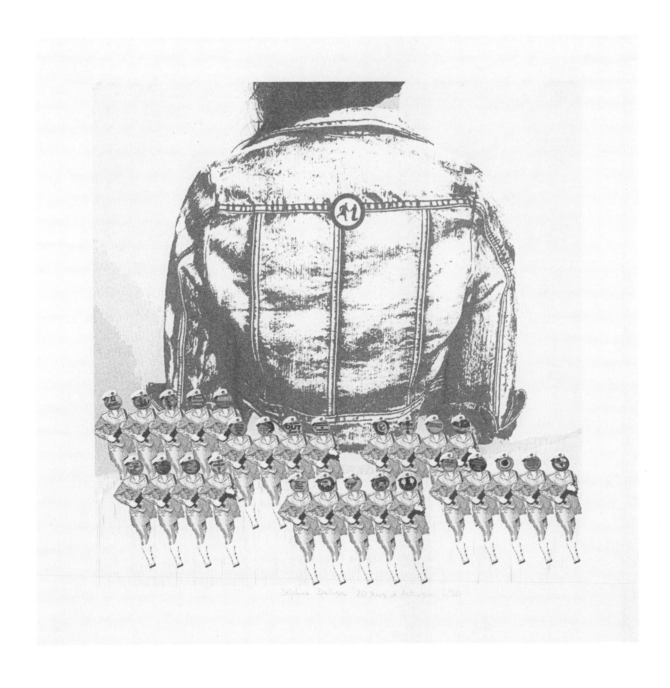

Grassroots, 2012
Digital pigment fine art print on paper
35cm (w) x 35cm (h). Edition of 20 prints and badges
Photo: Alan Dimmick

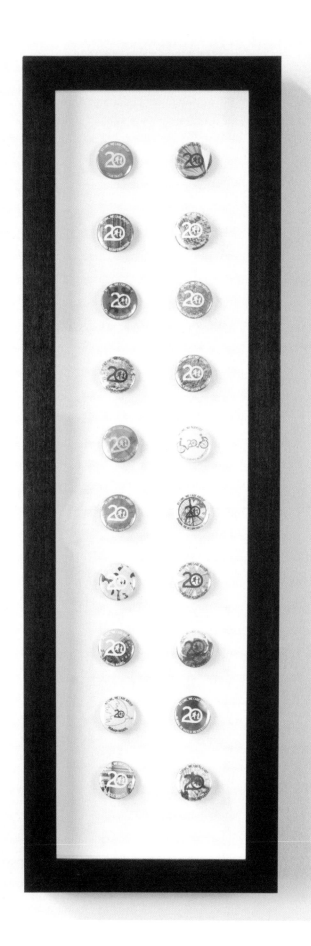

1. At GWL, we care about Fair Trade.

2. At GWL, we care about Providing Education for Everyone.

3. At GWL, we care about Access to Information.

4. At GWL, we are against Rampant Consumerism.

5. At GWL, we care about Freedom of Expression.

6. At GWL, we care about Sustainability.

7. At GWL, we care about Allotmenteering.

8. At GWL, we care about People's Right to Grow and Roam.

9. At GWL, we care about People's Right to Read and Write.

10. At GWL, we support Disabled People Against Cuts.

11. At GWL, we care about Helping People See their Own Worth.

12. At GWL, we care about Ending the Occupation of Palestine.

13. At GWL, we care about Giving People the Confidence to Realise their Potential.

14. At GWL, we care about the Rights of Asylum Seekers.

15. At GWL, we care about Digital Rights.

16. At GWL, we care about Composting.

17. At GWL, we care about Human Rights.

18. At GWL, we care about Listening to the Voices of the Quietest People.

19. At GWL, we are against Toxic Waste.

20. At GWL, we are against People Living in Poverty.

Grassroots, 2012
Badges
35cm (w) x 35cm (h)
Edition of 20 prints and badges
Photo: Alan Dimmick

Arms!

Corin Sworn

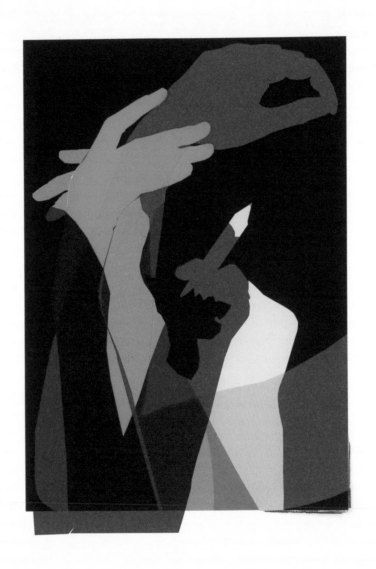

Arms!, 2012
Giclee print, newspaper, watercolour and gouache
43 cm (w) x 58 cm (h). Edition of 20
Photo: Alan Dimmick

Ernest Hemingway's Third Wife

Denise Mina

This is a beauty contest and we are losing. Initially we laugh, how uncomfortable, we say, but we don't really mind because we're not that interested in tricking people who might not get them into buying our books. Slowly though, as the day goes on, as a drip-drip-drip wears curves into stone, we lose sight of ourselves. We start to sag. We feel wrong.

We are sitting at a table, fifty feet long, in the tent, with the sides pulled back so that we can see the sun sparkling on Lake Geneva and the snowcapped French Alps beyond.

French book fairs are different than British ones. There is no hiding in the hospitality area until we materialise at the side of the stage, no room for shyness or ambivalence or reticence. Here, we sit for two hours at a time behind displays of our books, while readers walk slowly by, glancing, reading the backs and the accolades, fingering our creations before smiling small apologies and moving on.

Once in a while a faux steamboat full of tourists passes by outside, pumping black clouds of exhaust fumes that cling to the clean lake water. The decks are crammed like Nigerian commuter ferries. The boat gives a hoot and we laugh but don't mention farting or anything like that. The boat is a reminder that beyond this tent full of literature there is farting and exhaust fumes and shitting. Cysts and hemorrhages happen beyond the blinding white tent full of books and writers.

The writer next to me is young and shy. She is worried about looking younger than she is, she thinks it means she is taken less seriously. What she doesn't know, and I can't tell her because it would be creepy, is that if she isn't taken seriously it is because she is too beautiful. She can't help it. Time will help, but apart from facial tattoos, there's not much she can do about it.

She tells me she is American but lives between London and Paris because she is visa juggling. She comes, she tells me, from a literary family, a clever family in New York, but not a connected family. I nod but I don't really know what a connected family is. My family are from Rutherglen.

We watch yet more people put our books down and move on. We lie to each other. Isn't it nice here? Isn't it nice to have this view? The hotel is nice. The food is nice. I'm nice, you're nice. We don't know how to segue into who we really are because we're sitting in public, selling ourselves and doing it badly. Neither of us are confident.

The man on the other side of me is very confident. He is a philosopher, has written ten novels, *ten*. He gently slaps my arm with the back of his hand. *Ten*. How many have I written? I try to change the subject but he persists - how many? I tell him thirteen. He pauses for a moment before turning back to his next customer. He tells them that his new book is great, very funny. Insightful.

This man is bombast personified. I don't think he has written ten books, it seems to me slightly too round a number to be true. Ten sounds like an approximation up from eight, or even seven. Maybe even six.

His customer leaves with his books and a flyer for his painting exhibition. He is a great painter too, he tells me.

He has another customer. While selling more books he tells me that he's a local. He's lived here for thirty years. Everyone loves him. He's selling books hand over fist, marking them down on a sheet of paper in bushels of five.

Neither myself nor the American have sold any.

He has sold a lot. He needs to, he tells me, because no publisher will touch him. He pays to have them published and sells them himself. They're great.

The American beauty and I sip water, play with our pens, chat. We are not bombastic. We can't bring ourselves to tell customers that we are brilliant or funny or unique. We don't know what the army are really up to in Iraq. We don't know what the future will be like.

We get down to talking about what writers really care about: she has with her a Moleskin Evernote Squared notebook, the 5x8.25 with a pocket, and elastic band to hold the pages and notes in. She opens it and I see checked pages covered in tiny writing. Every so often she makes notes in it with her pen of choice; a Rollerball, 0.2, black, of course. Mine is a black pilot calligraphic tipped 2.0 although at home I prefer a 2B pencil, for the scratch scratchy noise and the smear-free definition. I don't have a notebook but am writing small notes on bits of paper and the inside cover of the book I'm secretly reading under the table. I like chaotic notes, on receipts, in books, tucked into my passport. This method allows small, sometimes banal observations seem arrestingly urgent, like a secret passed through bars.

She makes a note about a woman's hand gesture and I ask if it's for her next book.

'Yeah,' she smiles, looking genuinely happy for the first time since we got here. 'It's about women walking in the city. The first chapter is about Martha Gellhorn. She was Ernest Hemingway's third wife.' As she says this she gives a quick sidelong glance, a mini cringe with her shoulder. It is as if the ghost of Martha Gellhorn had stabbed her in the temple with a hat pin.

'Gellhorn was *not* Hemingway's third wife,' I say. It's the first

honest thing I've said.

'No, I know, but most people don't ...' She looks at me for a minute and a series of thoughts flit across her face.

Statistically, Gellhorn was the third woman who married Hemingway, so she's right. And I've corrected her, quite rudely and fervently and that was wrong, in this context, where fiction is the only thing holding the whole event together. But we meet each other's eye and we both know Martha Gellhorn was on the beaches at D-Day, first into Dachau, that she covered wars when being a woman meant she couldn't even get accreditation. We know she was at the fall of Saigon, with the Republicans in Spain, in Panama. We know she married Hemingway and he forbade her to work so she left him. We know that she never cheapened herself by making grandiose claims or pointing out that *he* followed *her* to Civil War Spain. Gellhorn just did her thing and made mistakes and failed to sell and wasn't sorry. The drip-drip-drip wore nothing from her.

The beautiful American squints at the blinding sun on the water, smiles, looking like the old woman she will one day be, and mutters: 'I'll never call her that again.'

Customers pass by the table, carrying miniature dogs in bags, eating ice creams, drinking take out coffee. We sit at our table, failing to sell ourselves to anyone, just being and doing our thing like Gellhorn.

I feel a gentle slap on my arm and the man next to me says, 'Sold another one.'

Moneses Uniflora

Amanda Thomson

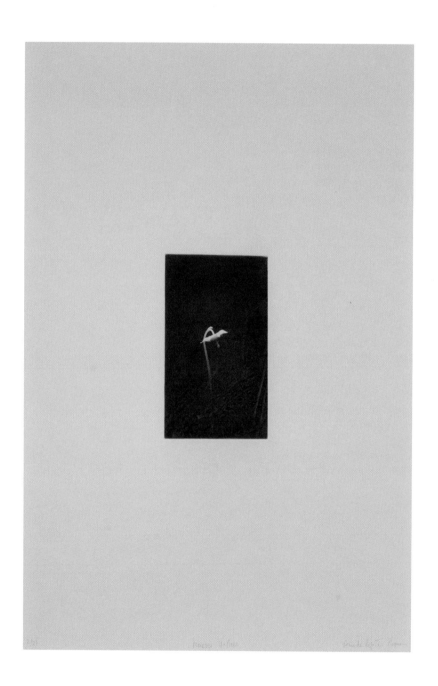

Moneses Uniflora, 2012
Photopolymer etching with chine collé
33cm (w) x 49cm (h)
Edition of 20
Photo: Alan Dimmick

Moneses Uniflora, 2012
Handmade artist's book
A5, 24 pages. Edition of 20

everyday wintergreen

Elizabeth Reeder

Each day, sunrise, breathe, walk, rest.

She wakes early in the summer never-quite-dark. Rises and gets ready for morning, noon, night. Each day she sleeps. All the hours between are full of work.

She walks 100 miles a week during the temperamental Scottish summer and carries a rucksack, probably lined with something waterproof, for the day may hold any sort of weather at all, and often brings more than one season on the wind, beating down as rays of the sun or as vertical rain. Expect any weather here, any day, every day, and nothing halts her walking, her gathering. The essentials are carried: a notebook, a flask, a small camera, bags to hold and protect the plant specimens – these delicate flowers gathered as proof of this life and of these living things.

As she walks she thinks of the photographer, M.E.M, 'herself', who back in the 1900s travelled with her self-fashioned, go-anywhere cart she named 'Green Maria'. It was a wooden box on wheels, with leather handles. She took it throughout the Highlands, and it moved where she moved and held her camera and all her equipment and provisions; hardy, purpose-built (by her own hands) and no-nonsense. She didn't sell the idea or copyright it or brag about it. She built what she needed and used it every day. Another word for this is 'utilitarian'; the practical beauty of usefulness.

Our botanist walks lightly, carrying her rucksack, and tries to be untraceable. Don't announce your footfall, it'll scare the natives, spook up the birds or make the doe bound off. Leave nothing behind for although this is your home, the land does not belong to you, and in this environment plants can take a long time to take root. They too can scare easily.

Each day she wakes, walks, rests. Last night she threw away the cork of the whisky bottle, laughing, saying to her companion, 'We won't be needing that again'. And they hadn't needed the cork or the tent, and they'd slept on thin mats beneath the stars and now she has a full day ahead.

This woman here, waking up, making coffee over an open fire, does not complain or worry or brag. She walks, observes, gathers. In other seasons, or on days of rest back at home in a small Morayshire town, she shapes her hedge into an entrance archway, arranges flowers and plants into wild assortments, pressing bright weeds next to rarities, and often fastens them to driftwood or found slashes of bark. A few lucky souls come across her creations and buy them for a small price to take home and put on their mantel.

Pressing and drying the plants she gathers, she then mounts them simply with tape on large pages, neatly notated. She writes too: meticulously researched notes and articles and books. Her writing is smart and clearly written. The audacious plants create the poetry.

Botany is no different from any other field of knowledge, not really. There's often no distinguishing the common from the rare, at first. Only familiarity brings awareness of subtlety. On one hill in the Cairngorms, the common Welsh Poppy (*Mecanopsis*), which usually flowers yellow, blooms orange. She notes this variation, such a pretty colour here, and she looks for its path to this place. Plants travel by wind or with a delivery of coal or a load of brash, or they may escape from a garden, and once they are displaced, they adapt. These adaptations can only be spotted if you know this flower from other places and remember it, recall it.

Scotland can be a difficult place to survive in. The climate is tough, the kind seasons are brief; the harsher weather fronts tend to linger, and the life of plants is generally short, owing to disturbances caused by the great spates and inclement environs. It's a place full of everyday surprises and this woman records many rarities: shining cranesbill; bloody cranesbill; rough clover liquorice; knotted clover, narrow-leaved water-parsnip; bog pimpernel; skull-cap; pellitory-of-the-wall; herb Paris.

Of all Scotland's plants, one is this woman's favourite: *Moneses uniflora*, the one-flowered wintergreen. It is a flower you always seem to happen upon by chance, even if it's being sought out. Tiny, only the height of a tall blade of grass, its stem bends with the weight of its single, heavy bloom; its white face is open only to the ground, its petals sturdy and protective like the wings of a bird as it hovers. It's almost shocking how it stands out, once you notice it; the white of its bloom against the fallen pine needles is abrupt and striking, like a gannet flying above the sea and caught in a snatch of sun against a darkening sky.

The highest mountains she walks are considered alpine, and in the krummholz zone plants are smaller and bent. On the coasts, trees and plants often lean away from the repeated force of the prevailing wind. In bogs too, a pine's growth is thwarted and these trees grow thinner and shorter, more gnarled, just as they are where a forest has been planted in sand. East of Inverness, in Morayshire, there is a place like this, and it is called Culbin.

Culbin is a favourite haunt and in the dunes sea marram grows, with long underground roots that bind the sand, and leaves that roll up to prevent evaporation... And lyme grass and sand couch grass too, all termed zerophytes (plants tolerant of dry places). In that they can grow where salt concentration is high, they are also

termed halophytes. These grasses are strong, resilient and great for weaving. When we pull them up to make use of them, they can no longer tether the sand, and the dunes flourish and shift further into the firth, further into the land. These shifting, spreading dunes were disquieting and so we planted Corsican pines, to keep the dunes in place.

When she's older, this botanist still walks long distances on many days. She's tired, although she never says it out loud, and she still never complains.

The woods of Culbin are quiet; quiet in that they rustle and stretch. Near the shore, the trees grow in the sand, binding earth to the sand dunes, and they dig down as far as they can, stretch as far as they can, and they are precarious, in their own way krummholzed and dwarfed, kept smaller by the environs they grow in. Their size does not proclaim their age or their endurance. Both the dunes and the trees are in abeyance to the sea. The water is beyond, a sound she fancies she can hear as it travels through the trees and over the thin forest floor that is vulnerable to any small footfall, any exuberant burst through these old pines and over a delicate, perishable carpet of rare lichen.

On a rectangular patch of ground grows a thin grass, and on the slight slope of Scots pines beyond scatters a small population of wintergreens, which remains hidden until you are nearly upon them. Only a few inches high, when photographed each flower looks far more robust than it is when you get down on your knees to get a closer look, or perhaps to touch its delicate form.

You wouldn't know it was rare, to see it with a white unassuming flower, revealing itself downwards like a joyful secret, each waxy petal singular too. This woman might describe this flower as being the most beautiful member of our native flora... with small roundish basal leaves and a single stem, topped by a wide open flower of five waxy white petals, a lime-green ovary, style and stigma and orange anthers. That's the thing: you need knowledge to know enough about what you see. You have to slow down and witness and pay attention to gain that knowledge. Without it you are a tourist, and you're liable to be frivolous, destructive.

This woman has stuck to paths out of deference to what grows here until she arrives in this place, and then she delves into the collocation of trees, Scots pines and Corsicans and so much space between that the light easily breaks through to the ground (when the clouds break enough for there to be sunlight), and she thinks she can't like any other forest but this one. In Sitka plantations the trees grow so thick and close to the ground that they leave no room for light, or for a single figure to move like stealth itself between the trunks. You can't travel through those young fast trees like she travels through these older trees, her head bent low, sending her arms slightly out to the side for balance, as she walks, looking.

Rare, wild, beautiful and sometimes common. Every day you might need to slow down to notice them. Among these trees we find *Moneses uniflora*, delicate lichens, and the more common lesser wintergreen *(Pyrola minor)*, resembling a pink lily of the valley with roundish shining leaves, and serrated wintergreen with a one-sided flowering stem of little green bells.

This woman leans her rucksack against a Corsican and thinks that this would be a good place for a memorial, here among her wintergreen.

After a day of walking and searching and finding she rests on a fallen tree that is cushioned by summer green, and together they are protected, here, by the sea. She settles down, her bones loosening a tether, and her muscles and skin growing light and lifting like loose soil, like dust, and the dappled light through the trees is silent but not still, and a quiet breeze breathes through the trunks like a wild held and released breath, which rustles the trees high up and near the ground, and movement ripples the field of lichen. And these delicate single-flowered beauties, they tremble, alert to the subtlest shift of anything. It is for her they tremble, and for you and me, and yet, even when we look for them we might miss them (perhaps even trample them down into the cushion of needles they push through and flourish in), but our ignorance or oversight or lack of knowledge does not change what is here: these delicate rare everyday flowers are alive, trembling in the breath of the forest for this single witness.

Author's note

Although inspired by the knowledge of the botanist Mary McCallum Webster (1906–1985) and her writings, this is a work of fiction; a crossover piece that contains quoted phrases, as well as my own imaginings of the rare, wild and everyday. Quotes and influences are taken from the following texts: *Flora of Moray, Nairn & East Inverness* (Mary McCallum Webster; Aberdeen University Press, 1978); *Women of Moray* (various, Luath Press, 2012); *Moray Book* (ed. Donald Omand, Paul Harris, 1976). This has been written as part of a collaboration with the artist Amanda Thomson, who has produced an etching and an artist's book.

Undercoat, Model House, Glasgow

Jackie Kay

You carry your home with you –
Always, where your heart beats,
And never a day passes without you
Turning that familiar key.

And one day the old place moves
So it now seems imaginary,
Until you build it again in your mind –
The rugs, the pots made of clay.

Far, far away now:
High Rise Flats, questions,
Forms, dead ends, vouchers,
Double deckers, sirens.

The smile on your face is back,
As you tenderly paint the wall
Lay small covers on tiny beds.
If you were a doll

You would gladly rest a wee while,
Lift your raffia legs,
Smell the curry from the tiny bowl,
Taste the gingery taste of memory.

No place you would rather go now
Than the place here in your head;
No bed you would rather lie on
Than in your imagination:

You see yourself grow small again,
Drinking at the well,
You watch yourself grow tall again,
Remembering it all.

28

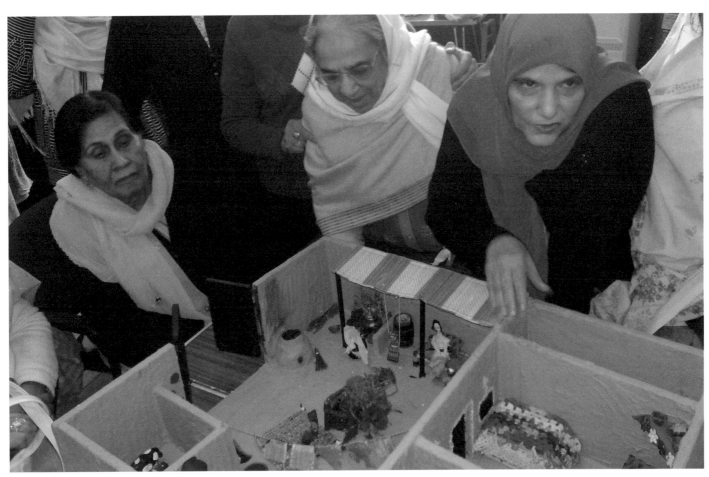

Glasgow Women's Library, *Model House* project workshop participants, 2011.

Model House, Glasgow

Jackie Kay

Carry your home in your head, your heart
And make it again with your mind's eye.
Lay out the *panday*; hang up the *parda*.
Look at your smiling face in the *shishah*.

The *patang*, the *balti*, the *bariyah*,
Covers on the *manji*, brightly there.
Home is what the heart remembers.
Here you are, back safe, September.

And the *booway, koowah, karay*,
Everything is as it should be.
You see the goat in the *mal kamra*,
And now you don't forget to remember.

You build the *peeng*; you climb the *poree*.
You drill the window, you paint the walls;
You hang your washing on the *rasi*.
Nothing's been forgotten at all.

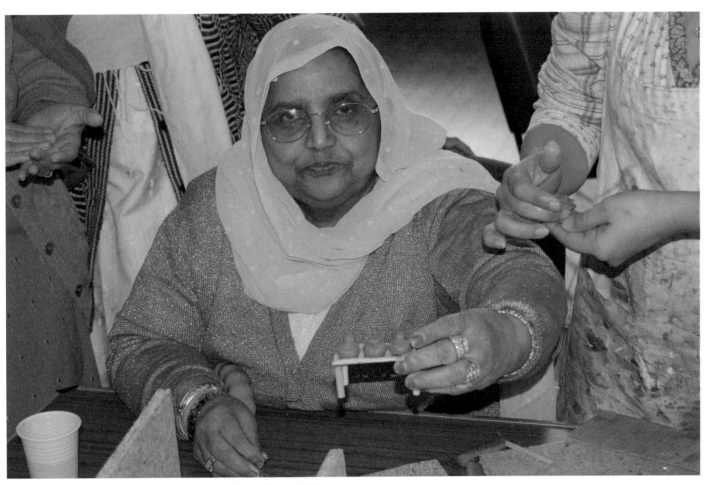

Glasgow Women's Library, *Model House* project workshop participant, 2011.

گھر کا ماڈل

اپنے دل اور دماغ میں گھر کو لاؤ

پھر اس کو اپنی یادوں سے بناؤ۔

برتن سجاؤ، پردے لٹکاؤ

پھر شیشے میں دیکھ کر مسکراؤ۔

پینٹنگ، بالٹی اور چکھ

منجی پر شوخ رنگ چادر کو بچھاؤ۔

گھر وہ جو دل میں آباد ہے

اب یہاں، واپس محفوظ، ستمبر ہے۔

اور دروازے، کنواں اور گھڑے

ساری چیزیں ویسی جیسی ہونی تھیں۔

تم دیکھو بکری کو مال کمرے میں

ابھی تک نہ بھولے جو یاد دیں تھیں۔

تم نے پینٹنگ بنائی، تم سیڑھی چڑھے

تم نے کھڑکی لگائی، تم نے دیواروں کو رنگ کیا؛

کپڑے دھو کر رسی پر ڈالے،

کچھ بھی تو نہ بھولا جو یادوں میں تھا۔

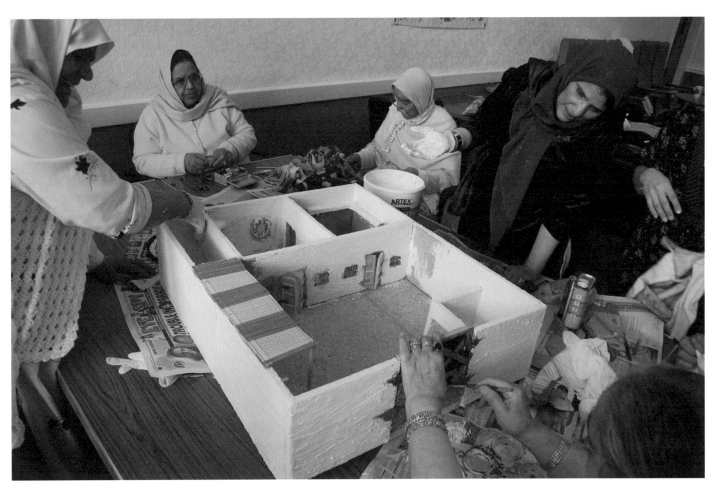

Glasgow Women's Library, *Model House* project workshop participants, 2011.

NEEDLEWOMAN
AND
NEEDLECRAFT

No. 44

ONE SHILLING

Stitches

A. L. Kennedy

How much she loved them – I remember as soon as I lift up the tin. It's old, unmistakably distressed, a big, square container for *Specially Selected Biscuits.*

She liked the special selections, luxury assortments, the fastidious choices that ought to make things nice.

Some of the lettering banded across it has been partially smoothed away and now shows naked metal – it gives the impression it no longer wants to be articulate. When I loosen the lid, remove it, the interior is blurred in a different way: too loud, too deep, too much, too violently demanding.

It's silly.

In a way, it's silly. I needn't be almost afraid of a biscuit tin and its mildly shabby contents when they are just nothing, close to nothing, just a collection of folded papers, knitting patterns.

Here they are waiting for me – my mother's knitting patterns.

Here is the scent of her hands, I've opened that, too.

Here is the echo of her skin and the small gentlenesses with which she surrounded herself: her soap and creams and perfume.

Here is the breathing space she tried to engineer, no matter what.

Here is survival.

And here are recorded decisions, visible indications of *yes* and *no.* Some patterns are dog-eared with use. Others she left nearly pristine, kept only for peeking at and for thinking, for balancing by their edges between fingertips while she studied I'm not quite sure what. She worked up less than half of her collection, the rest she kept purely theoretical.

The practical options were most frequently completed for me. The tin is full of familiar lines and drapes, appropriated by models and trapped in some curious flinch of time. These are pieces that accompanied my childhood, while the minute insect nip and click of needles bled into the soundtracks of countless television programmes – the distractions we shared to keep our evenings light. And Christ, I actually, truly did wear each of these tank tops – tank tops, for crying out loud – with differently but equally garish pseudo Fair Isle designs. They haunted my inexpert dancing at school discos and on less well-supervised nights out. I combined them with flared jeans and splay-collared shirts and a global lack of personal awareness. The illustrations for each show young people who are rather more attractive than I ever was, but nevertheless also helplessly adrift in the carnival of ugliness that was the 1970s. Every seam and colour choice is inexcusable.

The experimental cardigan with ruffles – it still has an alarming undersea look. It appeared in the early 80s and spent its life in a drawer, a pale blue reproach, vaguely reminiscent of Margaret Thatcher's pussycat bow collars and weirdly flouncey blouses. It hadn't occurred to me before now that Maggie was avidly pimping my country while dressed, entirely appropriately, as a cheap, suburban madam.

Heavyweight polo neck in tones of brown – I liked that. It kept me warm right through university, through the chilly lodgings and unwise sex and unfocussed rage and general idiocy. Perhaps because brown is a hippy colour, it always seemed to catch and hold the smell of marijuana like nothing else. I remember joking that I should shred it and roll it into spliffs when I graduated.

And this pullover - my mother knitted it in crimson – was my favourite. The poor thing slowly bagged and bobbled and became too disreputable for even a student wardrobe. In the end I made most of the torso into a lopsided cushion, because I didn't want to miss it completely. That didn't work, though. It tended to give me the impression I was leaning against myself and was unnerving. It's shown in green on the front of the pattern and makes me surprisingly, suddenly unhappy.

Then again, this whole process is unhappy. It couldn't be anything else.

I concentrate on the impractical patterns, the ones that have nothing to do with me and will therefore be untroubling.

But they were personal to my mother.

Of course.

They still are completely hers. They're dated visions, mildly laughable: manufactured images of brisk womanhood, clichéd fathers and carefully delightful children, each dressed in cuddling wool. She decided to find their instructions irrelevant. She didn't cast on, count rows, count stitches, maintain an even tension, cast off. I have to assume that her aim was simply to keep their pictures of frozen eyes and coping smiles and unconvincing backdrops. My mother wasn't a foolish woman, she couldn't have found these fragments of spun sugar lives remotely credible, but she must have wanted them. There must have been a reason to hoard up visions of safely contented people in cardigans, twin sets, daring sweater dresses and crocheted tops that clung to unembarrassed curves.

She said, when pressed, that she didn't knit anything for herself because she'd be tired of whatever it was before it was half way done and wouldn't want to wear it, but the majority of the unapproached designs are for women – fun things and soft things and pretty things and warm things for mothers and wives who'd appreciate hand-made quality. If the clothes weren't for her, they were for no one - she was the only woman, only mother, only wife

in the house. For a while I wondered if those self-assured grins and the promise of contentment when she dressed in the fruits of her labours were a type of encouragement to her and eventually she would have acted out the fantasy, worn her own creations. Now I believe the unused patterns provided a kind of company. She could look at their covers: the stilted hands and faked postures and the faces attempting to conjure up lives far beyond them: and she could feel that she wasn't alone in having to be who she couldn't be.

But she was alone. I didn't understand her and there was no one else beyond the paper people.

She had this and no more: stacked leaflets, small places where she hid herself, or parts of her nature. And before I fully learned that hiding was what we have to do, my mother tried to hide for me. I believe now that my mother knitted because she intended me to wear her protection, her love, and thought this a good thing. She would often complain about our weather - along with the midges, it was *Scotland's Blight* – but she'd smile when she spoke. And she'd known that a bite in the breeze, or a threatened shower might mean I would reach for a present she'd made me, even in summer.

Out of her sight, she meant me to stay properly defended against the world, stitch after stitch – touched by something she had touched, tucked up in the deepest camouflage she could offer. Knitwear doesn't draw too much attention, it's everyday and lets you pass. I left school, left home and dropped down into England for dreams of success, a pointless degree, the discovery that Britain, not just Scotland, was being punished for who knew what: being too industrial, too intellectual, too slow to get greedy, or celebrate depths of pain. My mother kept on with her precautions and sent me tender, foldable parcels, carefully taped and holding gifts I found embarrassing, if not controlling.

I started to dump her offerings straight into charity shops.

I rarely called her. I moved to a country she didn't know and couldn't visit. The city where I made my home was often dry and caught the sun and if I needed a pullover I could buy one. I wasn't going to be her kind of woman. I wasn't going to be breakable. And there was an almost endless list of things – exciting things – that nobody could be expected to attempt while wearing any type of garment hand-knitted by their mum. And I was going to make attempts. I wanted to be shallow and I succeeded.

She sent me her passion, the quiet burning of the care she couldn't show in other ways and I despised it.

I penned myself into a kind of ignorance so that I wouldn't be ashamed I'd run away and left her. I knew – properly and sometimes deafeningly knew - that I should have done more to persuade her to run with me, to do the impossible thing and be free. But I didn't want her with me. I imagined a clean and original life without the fears I had partly come to see as her fault.

Terrible, I do realise, to blame the wife for the violence of the husband, to slowly, slowly turn inside and no longer tolerate the hurt of her being hurt.

She wouldn't leave. She wouldn't argue. She wouldn't hit him back.

And in her face I could see that sometimes she wouldn't think, sometimes she had gone somewhere and was unreachable, frozen in dark hiding.

Which left me alone.

Alone to watch her bake for him and make perfect cushions with piped borders and appliquéd flowers, to cook pickles and chutneys and dinners and set out his dinner parties with pretending, efficient hands. She pressed flowers and then put the best of them in deftly renovated frames, bought an old fire screen to decorate with antique scraps. She eked out her housekeeping money into unrequited wonders and manoeuvred for approval when none would come.

Eventually I got old enough to think she was stupid. It happened after I hit him for her. All of myself and my love in the punch I was still child enough to think would kill him. He took it and stared at me. Then he went and hit her.

I didn't help.

There were days when I made it worse.

And my mother and I jarred further and further apart, because our pressures were not shared, they were incompatible. By the time I was fourteen or fifteen I was so accustomed to being frightened that I had to believe she was a coward, too, or else despise myself.

I staggered through my first rehearsals of being adult and wanted to be gone and out in the nights with music and normal people. I hated that I ought to stay, keep watch for her, at least keep watch against him. Increasingly she shut herself up inside pointless activities, while I wished I could never see her again and wished he would disappear and wished the police could be realistically summoned to intervene and wished I could get home late and find her in the sitting room and smiling and tell her about my evening and being loved and dancing and that we could hug together under our big rug of knitted squares and be nearly one person and ourselves and okay and the way that we'd been when I was too small to understand the fear of real things.

Just before I left, she made a plan to knit twin Arran sweaters: thick, complex testing garments in a wool that softened her hands with lanolin. It was, I suppose, a charm she was trying to work that would make me stop yelling at my father, breaking the phoney peace and introducing risks that might be too great. She finished his and he said it smelled of farmyards. That wasn't a good thing. I never got mine. It was the only piece of work she didn't post.

And he didn't kill her. I was certain in sick hours that he would. I'd like to imagine that my absence, the removal of my petty resistance and provocation meant her life with him was easier. But that isn't why I wasn't around and a neighbour told me later, years later, that there had been a hospital trip. Just the one. My father put my mother in hospital – broken arm after a fall – and the whole street knew about it and did nothing and I didn't know about it and did nothing anyway.

I was busy failing to be a wife, or a mother. I perfected my own way of hiding – never be with a man who could really be with me. Or else I'd pick one who was unsubtle, who would turn into my father so quickly I could still get clear at the first hand twitch, the first shout. And I realised that comfort and tenderness were unbearable, terrifying, and so I would leave them. I would leave and leave and leave.

Eventually, he did die. Cancer. Almost as unpleasant as I would have liked. She sat by his bedside, bought him peppermints and magazines about fishing, told me in letters I barely read how the end crept on.

She moved to a little flat, tiny but hers and set about baking for her neighbours, attending college classes in flower-arranging, genealogy, conversational French.

I visited. I did. The neighbours had sight of me. I was a busy London daughter and preceded by a list of achievements. I could chat at teas and was careful to send appropriate Christmas cards to her friends. But when we sat in her living room, left to ourselves, we didn't speak.

It didn't work between us.

I didn't let it work.

I'm paying a local firm to clear the house and taking nothing.

Except this tin.

She taught me to knit, but I never kept it up.

I think I will work on the pattern she didn't use.

I think I will do that.

I think I will start to do that.

I think I deserve no compassion, or forgiveness, not any in the world.

Homespun

Kate Gibson

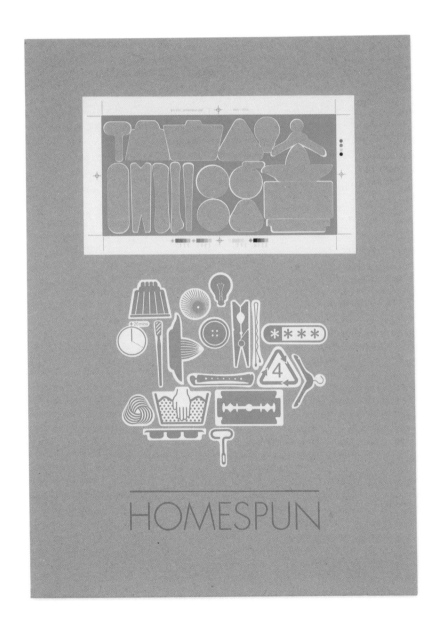

Homespun, 2012
Screen Print, Digital and Laser Cutting
42cm (w) x 59.4cm (h)
Variable edition of 20: each print is unique
Photo: Alan Dimmick

47

Writing Lesson

Zoë Wicomb

And so, and so I... maybe ki...kill... maybe my husband... they... kills...

The woman, whose name she thinks is Sameera, stops, clutches her elbows, then rubs her upper arms, up and down, up and down. Transfixed, helpless, Ellie follows the movement of her hands. The woman's English is shaky, her use of tense unreliable, and her fondness of 'maybe' misleading. Did the father and brothers actually kill her husband or does she believe that he may be killed? Or indeed, the plural pronoun may be faulty, in which case the husband himself has killed someone. Events have from the start been unclear as she stammered her story, agents and affected improbably entangled, with several confusing 'maybes' thrown in.

Earlier, Gulnar shook her glossy curls free of a headscarf that slipped down to her shoulders and helpfully supplied 'Sunni' and 'Shiite' when Ellie's eyes darted with confusion. Perhaps the others have heard the story before. Now that the word 'kill' seems to ricochet about the room, bounce from wall to wall, it seems brutal to ask questions. Besides, Sameera hangs her head as if she herself is guilty of killing, as if there is no more to be said, and the five other women look baleful, or is there reproach in the eyes that flit between Ellie and Sameera? Then Solange clutches her elbows and rocks from side to side. My children, she all but whispers, my children, my children, until the sound breaks down into a stutter. Ellie feels a band tightening around her head. She won't cry. But, like a child, she would like to run away. What has she unleashed here? What has she let herself in for? Mercifully, Solange stops as abruptly as she started.

Ellie has herself approached the Refugee Centre. What was the point in guarding her time when she had been unable to write for so many months? Might as well face up to her failure and do something more profitable than sitting day after day at a desk, at best squeezing out a few words of unleavened prose that cling to the screen, refusing to rise into story.

The director, Ms MacFarlane, a young woman whose teeth bore the stamp of red lipstick, pumped her hand enthusiastically. No, she smiled, unfortunately unqualified persons were not allowed to teach refugees English. That was the specialist domain of those with TESOL qualifications, although there were opportunities, funding even, for volunteers to take a TESOL course. No, Ellie said in turn, she has spent enough years in higher education, also as a teacher – of English, she stressed; she would manage all right helping people to learn the language. Did the woman really say, Oh yes, your English is very, very good? Afterwards, when Ellie recounted the conversation to Scott, he said surely not, and no, she could not be absolutely sure. At the time she was preoccupied,

interrogating herself. It was, of course, snobbery on her part, although once you recognise and admit to snobbery, was it not in a sense cancelled out? Or, at least, transformable? Ellie would never have uttered the words, but it was surely the case that a TESOL qualification was... No, to subject herself to such a course was unthinkable.

Ms MacFarlane's smile was fascinating, nothing short of ingenious, having managed to remain on display whilst marking the various shifts in her thoughts. Now it was congratulatory as the woman inclined her head, raising her left ear to attention. What was that charming accent of Ellie's? So heartening when refugees or immigrants did well for themselves and were prepared to give back to society. We all have to do our bit, she said, but there can be no short-changing those in need. The adamant smile turned swiftly to encouragement as she reached for a form. While you're thinking about it, it will do no harm to get yourself on the waiting list; you may well come round to the idea of helping others.

Had she not come there to help, and of her own volition? Ellie stared at the woman who stared at her, waiting for a response. Perhaps she should say, There's lipstick on your teeth, but McFarlane had had enough, offered a closing smile, and pushed her chair back. Instead, Ellie found herself saying, Look Ms MacFarlane, I'm also a published writer. There must be something I can do without a TESOL certificate.

Genuinely delighted, the woman abandoned the smile. It's Marie, she said, call me Marie. How fantastic, that's absolutely marvellous. Why didn't you say? I'd love to have a published writer on board. Please sit down, she said to the still seated Ellie, and let's have a little chat. You see, our people have been through unimaginable hell, many of them terribly damaged by the suffering, the extraordinarily brutal experiences. They have incredible stories to tell, and this is where your experience comes in handy. They need help. Their stories must be told, must be written.

Ellie noted with dismay the slippage from tell to write. But she asked, And I won't need TESOL to do that?

Oh no, no, absolutely not.

The ghost of a smile flitted momentarily across the woman's mouth. Which flustered Ellie who thought that she had got its measure.

Here, Marie said, piously putting together her hands as if in prayer, here we are talking about the art of writing, and it would be wonderful to have on board some one with your first hand, professional experience of writing your story. An inspiration to our refugees, you'll be. It's so good of you to help.

Ellie hesitated. Did the woman believe that she had written her autobiography or a memoir? Transcribed her own experience, her life, whatever that may mean? Of course. That has always been assumed about the writing of immigrants, minorities, women. Ag, it didn't matter. If memoir was not a genre that interested Ellie, it was hardly of consequence, although a prickle of pride persisted. Was Marie not going to ask her what she wrote? Ellie wouldn't volunteer information; she must rise above such vanity. Why would a has-been, one lately incapable of writing, want to be acknowledged? She had after all not confessed that she's produced nothing for over a year. In fact, should she still call herself a writer? How tiresome it was – the same kind of questions that hounded her so many years ago when she first put pen to paper.

Marie rose to put on the kettle; she stepped on to a chair to reach for a book of recent refugee stories that Ellie absolutely must read. Ellie thought of her own top shelf where, in spite of alphabetising her books, a row of Women's Press and early Virago volumes kept together, defying the classification system. If she hadn't reached for any of them in years, they also somehow escaped the regular donations to Oxfam. Perhaps it was too much trouble to get the ladder; a chair dragged from her desk was as far as she would go in the peremptory clear outs. There was no doubt a thick layer of dust on those books, and nowadays a bunch of well-dried proteas, tossed on to the shelf, balanced there precariously.

The books seem to have drifted together of their own accord, the distinctive spines seeking each other out. She could see them: black and white diagonal stripes interspersed with the green and white, with their respective icons of steam iron and bitten apple. They marked the years of Ellie's struggle with a professorial bellow: objectivity, objectivity, objectivity – that is the touchstone of art. Was it not the case that some of her female models too, Woolf and also Gordimer, argued against women's writing as a valid category? Even as Lily Briscoe murmured brush in hand to the echo of 'Women can't write; women can't paint', Ellie's models snapped, Mere therapy. How then could she dare to differ?

The women of that top shelf – she thought of them as sculpted figures, dykes in dungarees with ankles resting on knees, in pensive pose, munching at forbidden apples – well, they had dared. So, was she, Ellie, not free to try her own hand at writing? Could she not be freed of snobbery and vanity? Yes, like coming up from the bottom of the ocean for air, so that something, words, drifted upward, bubbles bursting the surface, and breathing, she knew that the notion of art, of objectivity, no longer mattered. All she could do was try, no matter how hard, how ungainly the words that came. Work, that was all it required, relentlessly, until something took shape. Her attempts could do no one any harm; she was free to write, and others were free to dismiss her work, or not to read it at all. Shunning autobiography, she, a woman from the bundus, had finally dared to transform what she knew into prose fiction. So why now, a new question tugged, had she stopped being a writer?

Marie could not find the book. Mysterious how things simply walked off. Still, it would reappear, and Ellie would see how precious, these lives committed to print. As if Ellie were a funder, she launched into a well-rehearsed lecture on what it meant to be a refugee, and as for those who helped persons in need, well, they soon discovered how enriching it was. Ellie preferred the euphemism of working with rather than helping others, but Marie assured her that that was no euphemism, that mutuality was the name of the game. You'll be an inspiration to them, she said.

Inspiration – to breathe life into – heavens, what a tall order; she had never been obliged in that way. Ellie wondered if taking the class would make more valuable the hours she spent struggling at her desk, or whether it signalled giving up. Ag, the world she felt compelled to write about, the world of her own country, had changed so drastically, that there seemed nothing left to say. Apartheid, what's that? a young man asked her on the last visit home, and really, there was no telling whether he was being ironic. That's the stuff of old people, he added. Perhaps now that history itself has departed there is no need for – and she lifted an ironic eyebrow – therapy.

The woman in orange, whose name Ellie can't remember, rises. Teacher, she says, we'll have some tea. They all stumble to their feet, grateful, rescued by a British cliché. The cup that cheers but not inebriates, although a stiff gin and tonic is in fact what Ellie needs. She bustles about filling the kettle, finding milk, putting out mugs. She would like nothing more than to reel off the timeworn clichés demanded by her colonial education. Complete the following idiomatic expressions: a stitch in time...; every cloud has a...; procrastination... ah, she can no longer remember. The women chatter in their own languages. Even Sameera for all the talk of killing seems composed as she stirs three spoonfuls of sugar into her tea. Ellie's hand is on the woman's shoulder, but it is she who is helpless. What has she let herself in for? How will she resume the session? The plan for the class, the first of the distancing devices, telling a story about yourself which then is written by another in the first person, must needs be dropped; she has to think on her feet.

When Ellie tries after ten minutes to get the women seated, they are reluctant. Could they play a game? Solange asks. Not today, says Ellie who in any case knows no games. Today we're going to write a short paragraph. About the house I used to live in. That, she figures, may well avoid tales of trauma and atrocity for which she turns out, today at least, to be too lily-livered. She tells them about her childhood home in the Western Cape, about walls washed with ochre dug from the hills; the wooden shutters; the clean smell of floors freshly plastered with cowdung and clay, and the etched oval mirror that she loved, that her father used for shaving. Poor but clean, Ellie smiles to herself. But when the time comes for them to write about their houses, they sit quietly with arms folded. Strange, they had come to the writing class without pen and paper, so she scrambles about in cupboards and finds materials. But they do not make a start; instead, they look anxious; they nudge and whisper to each other.

Really, Ellie suggests, they should write in their mother tongues, but the women are unable to do so. They have been learning to write English words; they attend classes on a Wednesday, but writing a description of a house, well that – they mutter and shift about – that they've not yet learnt to do. Next week, Gulnar consoles, next week they'll try and do it for her. In fact, Gulnar has a better idea. In the library where she does her English conversation class she has seen a picture of a house very like her old house in Afghanistan: she could get the book out and bring it along. Next week.

There is still some time to go before the end of the session. Ellie must keep the panic at bay. They will have to do something, some conversation directed by her. Let's see, she says, what we can remember. She starts speaking of ambivalence, of conflicting feelings, but Solange, moving a hand back and forth across the patterned oilcloth, interrupts to say that she has forgotten, that she can't remember anything.

Ellie holds her hands up in a halt. Right. Okay. She feels like Hamlet's old ghost, the demanding father of remember-mee, remember-mee. So she says that forgetting too could be a good thing. What they should do now is to learn the new things they need to know here in Glasgow, learn the language, practice their speech. Anything, she says desperately. Sameera says the weather, how cold it is, the problem of wearing nice, clean shoes, and then it rains. Everyone has something to say; they call on each other to help out with English words, and it is not long before the conversation turns to food. The women want to know from each other what they have cooked that day. Pakora, biriyani, brinjal, pulao... Ellie plays along, pretending not to know what these are, so that they describe and repeat enthusiastically, explaining what the vegetable looks like, how the dish is made. Just before they leave, she makes another attempt, and yes they would be happy to try writing down the ingredients for a very nice biriyani. A biriyani with meat, Sameera says, since this dinner on paper will be a special one. Not so different from her pulao, says Gulnar; they should write down both the names. Next week.

<p style="text-align:center">*</p>

You don't listen to a word I say, Scott complains.

They are having breakfast. Ellie watches through the window the trees whirling in the wind. Individual branches bend, swoop, momentarily stand to attention, then in deepening greenness, whip up a frenzy, and all at different times, each doing its own thing, although anyone casting a casual look would be deceived, would say that the entire tree is swaying to a prevailing west wind. It's all chaos out there, she says, branches blown in every direction. Were you asked in drama class at school to be a tree swaying in the wind? Expected to stretch and bend your entire body elegantly, first in one direction and then another? All wrong. Against nature. We can't be trees. A tree does its own magical thing.

She butters her toast. God knows how these poor people put up with Scottish weather. If it isn't relentless rain, it's the wind. Imagine, swaying in a dilapidated high rise – not like a tree – on the outskirts of the city. Ellie stops to look at him; she still finds it odd that he is called Scott.

Scott shakes his head. Okay, I'll try another time. By 'these poor people' do you mean the refugees? So how did it go with your class last night? Chapter one of the autobiographies done and dusted?

Nope, the women don't seem to want to write. Or rather, they're not equipped.

Och no, he reprimands, that won't do. What will your Mrs MacFarlane think of that? Give them pen and paper. Don't they know it's obligatory? What every refugee wants to do. Needs to do. How will they earn their right to stay if they don't give us their memoirs? The stories of patricide, infanticide, matricide, genocide,

famines, holocausts... Anyway, how come your group's all women?

Please stop. No need to scoff. I'm not up to it either: the wrong kind of tutor who knows no games. So we're going to write a recipe book instead.

Ah, I hope you'll include as introduction, as tribute to the host culture, our old Scottish favourite – toast water.

Toast water? What do you mean?

Yes, beats your African mealie pap hands down. Take a slice of bread, he intones in a mock-English voice, then corrects himself: Take a *clean* slice of bread, and brown thoroughly without burning. Place in a clean jug and cover with boiling water. Steep until cool, then decant into a clean cup. Your toast water, Missus, is fit to drink.

You're not serious, Ellie laughs.

Oh yes, from *A Plain Cookery Book for the Working Classes* written as a sideline by Her Majesty's chief cook, a Charles Francatelli who had clearly lost his culinary roots in our damp and pleasant land. It was my mum's bible, though, to be fair, she used to read out Toast Water for a laugh. Much shorter than I imagine your Refugee recipe book will be. Ours had a long Preface, a sermon on keeping utensils thoroughly clean, otherwise the actual recipes were short. Everything, including sheep's pluck, was simply to be chopped on a clean board, put into a clean pot, and boiled like hell. Confusing it was too, or possibly encouraging, because according to Signor Francatelli and in spite of the title, we, the readers of the book, were not the poor-but-not-so-clean. No, there were also instructions for preparing a large quantity of good soup for distribution among the actual poor. So the working classes could also aspire to being dispensers of charity. Anyway, how's your story coming on? I forgot to say that toast water's also good for unblocking, and he ducks to avoid the dishtowel that Ellie swipes at his head.

<p style="text-align:center">*</p>

Sameera comes panting; she is ten minutes late; she has brought some pakoras. Still warm they are, spicy potato pakoras, which they eat right away. They murmur their hmm-hmms at the lovely, light gram batter. That trick Sameera will have to disclose for the recipe book, and once they've licked their fingers, they are ready to tackle the writing.

Ingredients, Ellie writes on the white board, starting with the spices that the women call out. The air sizzles with fried onion, garlic and ginger as they carefully shape their letters.

With a sharp hot burst of cumin, coriander, cardamom, something is breathed into being. Ellie's hand moves across a sprig on the oilcloth, moves a tree.

She is free to do it...

...free to let you because look, look. Look where your eyes are. Now.

Parts Beyond the Skies

Helen FitzGerald

Today I will be transported to Parts Beyond The Skies.

They did something similar a couple of hundred years ago, only then it was 'Seas' not 'Skies', and while the ships were quite tall and impressive they never blasted off.

The First Minister is interrupting my thoughts over the tannoy, which is probably for the best as most of them are bad.

'In one hour,' he is saying, 'the gates of Cornton Vale Prison will shut for the last time. We are saying no to poor conditions! No to over-crowding! No to the revolving door!'

No to Ginny, I think, and then I scold myself because I am determined to banish negative thoughts. I will feel nothing but optimism and excitement.

I do feel excitement! I've never done anything daring that's legal till now. Three years in Parts Beyond the Skies instead of two in a cell like this? Only schizophrenic Mary in ILU refused the deal, bald God-loving nutjob. I didn't have to think twice. I am a conquerer and a coloniser and an explorer and I am excited. I'm practically Captain Cook, or at least his wife.

It'll be a proper three-year, no-going-back, rehab. I've packed some Valium to get me through the first days. When I say 'packed some Valium', I mean I wrapped them in cling film and stuffed them you know where.

The only other thing I need to take with me is the recipe my Gran gave me. She said I should learn to make good old fashioned lentil soup for Ginny.

'Fifteen year-olds don't make soup,' I said back then.

'But mothers do,' she said, glancing at my baby.

'The soup will help you think good thoughts.' Gran smiled and put my hand on hers. After that she made a whole lot of noises that freaked me out. Dying's noisy.

I lost Ginny to a social worker a couple of years later, but I kept the recipe book.

In Parts Beyond the Skies, I will make lentil soup and think only good thoughts then I'll return clean as a hospital and get Ginny.

Parts Beyond the Skies is the actual name, although most folk call it PBS and some call it CNN but I like how old fashioned it sounds and I say it to myself a lot. I am being transported to Parts Beyond the Skies, Parts Beyond the Skies.

The Minister's back on the tannoy. Since the last announcement, his voice is deeper and slower and he's found himself an American accent.

'Like the boatloads of women they sent to Australia, or Parts Beyond the *Seas* as it was known, you are being sent for a reason.'

I know the reason and it's not to dig metal out of rocks alongside the men. They have enough miners. And the water and the blankets and the seeds have been sent. We are the next essential cargo. Nothing has changed in two hundred years. New lands need men. Men need women.

'You are convicts who have only ever taken from society,' the Minister says over the loud speaker. 'Like the mothers of Australia, you are about to give back. Your sins will be buried in the foundation of a new world. You will no longer be parasites and villains but heroes. Heroes.'

Hear that Ginny? Your Mum's going to be a whoreoe... hero, hero.

'The pack being dropped through your food slot contains everything you will need,' the Minister says. 'If you attempt to take anything else with you, the punishment imposed by the newly formed *Parts* Government will be severe.'

The pack has a coded lock which I can't crack or break. It feels like it's only got two things in it. A small bottle I think, which rattles, like pills. The other object is square and solid and heavy, a book, full of rules I bet.

'We ask no more of you than your willingness to participate,' he says. 'You will be looked after. But most of all you will be needed.'

Needed. I've not been very good at that, have I my baby girl, otherwise you wouldn't have been 'looked after' all this time.

Another package drops through my food slot, this time wrapped in thin plastic.

'Inside the plastic package you will find your suit. Please put this on and leave all your clothing, including your underwear, on the floor beside the bed.'

Oh dear, the thoughts get worse when I'm naked. The psychiatrist says that's because I was naked when they took Ginny away. Not sex-naked, hear me. I've never done that for money. Never will. How dare you think that! I'm not one of those and I wasn't one of those when they took Ginny away either. No, I was naked because I was in the bath. I was alone. I didn't mean to – my head wasn't working – but I'd somehow forgotten to bring Ginny back with me from the Off Licence.

'You will be collected in ten minutes,' the First Minister says. 'Congratulations to all of you. And good luck.'

The suit is bright yellow and baggy. Very unspacey. I pick it up and hold it against my naked body and look in the prison issue barely-reflective metal mirror. Ugh. No-one decent's going to pick me above the others if they line us up in this Laa-Laa garb. Will they line us up? Will they all look at my teeth? I check my teeth in the scratchy metal. Will some ex-dealer from C Hall compare my teeth to the 109 other sets in line? Will he look at me like Ginny looked at me when I said goodbye yesterday? Like I'm scum?

I am scum.

No! I'm a needed conquering coloniser. I am Captain Cook's wife. Yes, I am calling myself *wife*. And I am excited.

Actually, my teeth are pretty good.

For scum.

No!

I will need that recipe. They won't find it. And I've become fond of punishment.

There, I have pulled the Valium back out and the cling film is not as difficult to unwrap as I expected.

I touch the brown page I tore from Gran's old recipe book. Rough yet warm and powdery: like her hand was when she gave it to me. So old, this recipe. How many plates of soup have come from it? How many excellent thoughts?

"One large leek," the recipe reads. I will find out what a leek is and dice it, so I will.

I wrap the Valium and the recipe in the cling film.

I don't like having to shove things inside me to get by but I'd better get used to it I suppose.

Why am I thinking that way? I'm not one of those. I have been sentenced to transportation, officially, by the First Minister – who is the LAW – and it is not right or legal or possible to sentence a person to three year's prostitution.

Don't tense up Cath, I say to myself. Relax! I muster Gran's voice: Hey my Cathy-Cath-Cath! I imagine the feel of her hand.

And it's back in.

I put my suit on, zip it up just in time because they're unlocking my door and that's me off to be needed by the whole wide world. Off to get me a muscly space miner.

The buses are filled with Laa-Laa's but not one has a smile. Take off is at nine. We arrive a week later. A week later! Just how far beyond the skies are these parts and what skies are they talking about exactly and what are the parts, parts of what? And when I arrive, what then? I don't want to stand in a line. I don't want a man with a Bar-L scar on his face to point and say 'She'll do' then walk away, expecting me to follow.

I can feel the recipe inside me. Ouch, it hurts, but that's good because it reminds me what to think.

My dry mouth clicks as I open it as wide as it will go, clickety click, but that's good because lack of spit helps my lips stay put so my teeth are on show. I make my eyes smile too by thinking back to when I slept in bed beside Gran, rolling over when she told me you needed my breast.

This isn't difficult. I'll smile like this the entire flight and a dapper guard will snap me up before we land. I won't have to stand in line with the others. I'll choose him. I'll convince myself I said 'He'll do' and walked away, expecting him to follow. And the first thing I'll do when I get to my quarters in Parts Beyond the Skies Parts Beyond the Skies Parts Beyond the Skies, the first thing I'll do, my soft sad glorious Ginny Gin Gin – the very first thing – is make soup.

1/-

Girls' questions answered

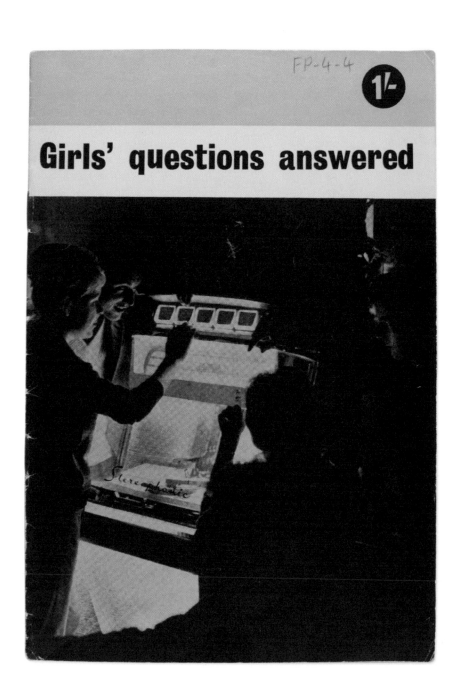

Guidance

Muriel Gray

It's her mother's handwriting. As familiar as the sky. She holds the envelope, turns it over and opens it.

The card is thin, poor quality, one from a boxed set she guesses. Printed on the front, the sketch of a woman in a crinoline, face half revealed, coquettish, beneath a frilled parasol. Things slide out as she opens it.

The paper scraps are yellow with age. She holds them to her face, breathes in the sweet mildew aroma, the smell of childhood story books from damp attics, and hoarded magazines tipping in piles on the staircase.

She smooths them. Lays them before her. Drinks them in.

The first. "Have dinner ready. Plan ahead, even the night before. Most men are hungry when they come home and the prospects of a good meal are part of the warm welcome needed."

"warm welcome" has been circled in spidery blue Biro ink.

Glance to the oven. It's in there. The bake. The bone white fish glistening green with olive oil, nestling in shallots she soaked and she skinned.

She smiles. I'm ahead of you mother. My mother. My mother.

The second. "Don't greet him with complaints or problems. Don't complain if he's late for dinner. Count this as minor compared with what he might have gone through that day."

Touches her watch. The present that took her by surprise. The box that was opened, the breath that was drawn, the heart that beat faster as the gift was fastened around her wrist.

The third. "Make him comfortable. Have him lean back in a comfortable chair or have him lie down in the bedroom. Have a cool or a warm drink ready for him."

Eyes close. Leans back on the hard chair, hand moving over her throat. Thinking of the bedroom. Thinking of the softness to come.

Eyes still closed she sees her mother's body stiffen and defend itself, as the younger she rails and spits teenage fury, cruel taunts into her face.

And calm, mother was. You don't know my love. You don't know.

We were lost, she'd said. Some died. So many. Those who came home, afraid, uncertain. What strangers had they returned to? How to mend this thing, this country, this dream that had been so nearly broken forever?

So you mustn't scorn my darling daughter. My daughter. My daughter.

Listen. Be still. I think, was it… Herbert Gray? Yes. He worried. In '38. The breaking and splintering. The families. The marriages. The lives.

It's guidance. Nothing more. You'll remember. You'll see. Love carries duty, and duty brings love.

What need, the younger she, of guidance to obey, of instruction, constriction, submission? What need she of the shackles of passion? These men who command. These women who lay down.

She'd laughed, a hard bark. We'll shift and we'll move and we'll never settle beneath your command. We'll break it all over and start from the start.

Your guidance is empty, remote. Your shackles are broken. Your duty rings hollow. We'll rage and we'll rant and we'll tear you apart.

And her mother had put out a gentle hand to her daughter's flushed face, a hand that was slapped away, and doors were slammed, and bridges burnt.

Her tight shut eyes screw tighter in memory's pain. Her fingers lie still on the scraps that her mother's bent, swollen fingers have slowly, carefully harvested from her acres of paper memories, still stacked, bound with string and cherished in the room at the back.

Then those years, upon years, and she feels the pearl inside her that grew round the grit. And mother was true. She saw she was true. The country so scared that the cracks war had made would open to chasms, made loving its job. Made guidance its duty. Made kindness a task. A consensus made formal.

Remembering its fight, it fought on to stay free. Stability. Companionship. A promise set in law. The right of all who would have it.

She opens her eyes and touches the last piece from the card. A picture. Another from their wedding day. Her arm on her father's, he still handsome beneath the heavy grill of his illness, thin chest barrelled with pride. Her mother a stove of hot joy in her suit of sky blue. Mother's smile like lightening, her guidance come good. Her daughter, her daughter. A woman devoted. A woman who married. A woman in love.

The key turns softly in the lock.

The room is alight, the air sweetened. Her love bundles in, papers beneath an arm. Car keys between teeth. A smile in the eyes that promises tales of some mischief, an observation or snippet that can't wait to be shared.

The keys are laid down, the papers laid flat, and her face is held softly and kissed like child's.

She says, 'Fish nearly ready', and fetches a drink. She plumps up a cushion and settles to ask, 'How was your day?'

And Betty, her Betty, her Betty her love. She laughs at the question, falls back on the sofa and kicks off her shoes. Her tights have a hole and they point and they joke. Betty pats and beckons her near, and they kiss and they hold and her heart tumbles like an acrobat.

Then silence as she holds her dear Betty, sucks in the scent of her hair. Coconut and wind and the faint tendrils of chlorine.

It was this that they meant, in those words misunderstood. To be loving and kind. Because kindness is catching and hatred is blinding.

So the charlatans lost, those liars who claimed ownership of lips upon lips. Those who said god would beat on his breast, rip holes in the sky if anyone but the chosen would dare to make life-long promises framed in love. Bigots planted their flag and the wind tugged it to rags.

And here's how it stands, Herbert's guidance come good.

This, her dear love. This, her dear wife. This, 'til they die.

Raging Dyke Network

Nicky Bird with Alice Andrews

Raging Dyke Network, 2012
Colour postcard
15cm (w) x 10cm (h)
Variable edition of 20, each work is 1 of 2
Digital image: Nicky Bird

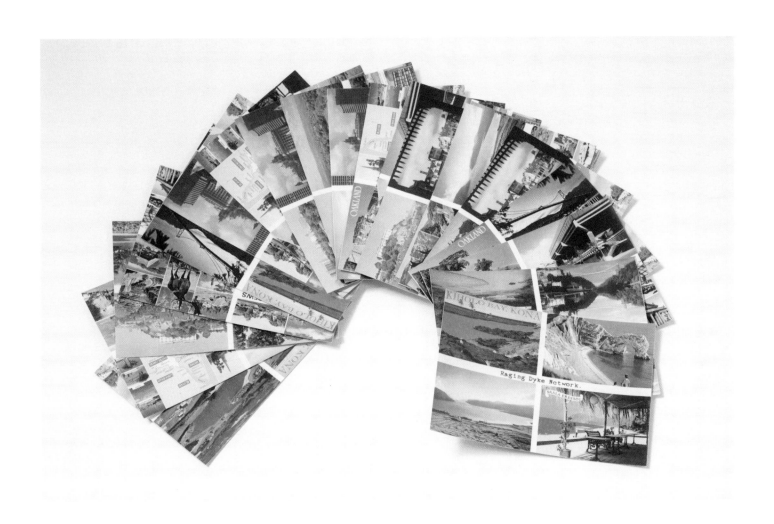

Raging Dyke Network, 2012
Colour postcards
15cm (w) x 10cm (h)
Variable edition of 20, each work is 1 of 2
Photo: Alan Dimmick

(54)

Anyone Who Had a Heart

Zoë Strachan and Louise Welsh

everyone is made differently

Olive is made with hair that grows in curls. She is good at hockey and running. She gets picked early for netball, usually second or third.

you're all so very different

Susan is average. She gets picked fifth or sixth from last. Nobody says 'aw naw' when their team doesn't get her.

Forget about those wretched words

Lemon. Are you a lemon Susan? You should go round with Gary, because Gary's an orange. Gary's a fruit.

think of yourself as a young woman because that's what you are

Susan's mum bought her a training bra and a sanitary belt. Susan found them tucked into her drawer along with a little note that said *Just in case*. It was part of being prepared, Susan knew, because her mum wasn't going to have a lot of time on her hands. There was a pamphlet as well: *Girls' Questions Answered*. Susan didn't have any questions. When she went downstairs she didn't thank her mum and her mum didn't mention it either, just said would Susan put the potatoes on to boil later as she was popping round to Gran's. Susan decided to show Olive *Girls' Questions Answered* when she came round for tea on Wednesday. Olive was good at asking questions.

some *of the questions* **some** *girls ask*

There were things her mum knew, things grown women knew, which it was wrong (dirty) to talk about. That was what the pamphlet was for, to save anyone having to talk about these (dirty) things.

you're certainly not going to ask your parents

Are you hoping for a brother or a sister Susan? You're going to learn to be a good little mother too, aren't you pet?

Everyone grows up in a different way

Susan has been keeping her scrapbook for the past two years, ever since she's been allowed to watch Top of the Pops. Dusty is her favourite. Susan likes her dresses and the sad love songs she sings. Her brother Brian hates Dusty, but Brian doesn't know anything about pop music. All he thinks about is his Panini sticker collection.

Of course, no boy is going to look twice at you if you don't take trouble over your appearance

There's a craze for shiny lip-gloss, black eyeliner and mascara that makes lashes so stiff and spidery they look like they might snap. Mandy even came to school wearing false eyelashes. A little bit like Dusty's but Mandy is a skinnymalink and she's ginger. Mrs Porteous made her leave home economics and wash her face with soap. The school sent a letter home to parents. Susan's mum said she was glad that Susan wasn't silly that way, and that wearing makeup gave you spots. Susan remembered the gloop of Olive's lip-gloss. Sugary sticky. Olive's curls sometimes brushed against it and stuck to her mouth. Olive said it felt dis-gust-ing!

Of course

It was just a laugh. Olive had been laughing too. Both of them, in stitches.

Of course

They had been practicing kissing. You didn't want to make a total fool of yourself with a boy, did you? Olive showed her how. You curled your thumb and finger together, so they made a mouth, and then you kissed it. Olive said that Susan was doing it wrong. Olive poked her tongue between her fingers and wiggled it around. It looked horrible (dirty), moist and alive. Susan laughed so much she thought she was going to wet herself.

Of course

Olive said there were better ways to practice.

Susan pretended to be Donny Osmond and Olive kissed him (her). Oh Donny, Donny.

Then Olive pretended to be David Essex and Susan kissed him (her). Oh David, David.

Everyone did it, Olive said. Otherwise how would you know? It was just a laugh.

it is perfectly all right to wash your hair

Susan isn't sure how Dusty manages to wash her hair. She must get it done by the hairdresser once a week, a shampoo and set. Susan wonders how it would feel to touch the candyflossy stiffness.

Susan bought a kohl pencil with her pocket money and drew greasy lines around her eyes before bed one night, leaning in close to the mirror above the wash hand basin. She looked horrible. Not at all like Dusty. It took ages to get it off. So long that her dad complained and her mum knocked on the door and asked if she was alright. There were smudges on Susan's pillow in the morning.

You can put this rather painful thought right out of your head

People have been extra nice to Susan since her mum started telling them the news. She says 'expecting' rather than 'pregnant'. Susan is glad of this. 'Pregnant' sounds rude (dirty). She didn't want anyone at school to know, but Olive told them. Some of the boys made jokes, but most of the girls have been okay.

you **have** *been a child*

Brian had Action Man and Susan had Cindy. Susan had been jealous of Action Man, she could admit that now, and once had left him close to the fire deliberately so that his fuzzy hair caught fire.

Her mum poured a mug of tea over Action Man, smacked Susan and sent her to her room. Brian had cried, and later pulled off Cindy's head and stretched her shoulders so that the elastic between them snapped. The head popped back on and Susan tried to make up a story about a ballerina who'd lost both her arms in a theatre fire, but really Cindy was useless after that.

the only danger is that

Susan wondered if her mum had ever kissed a girl. She couldn't imagine it, but then she couldn't imagine her mum kissing her dad, not the way Olive said people kissed anyway. Maybe a peck. An auntie kiss.

When she was on her own, Susan tried kissing her hand again (oh David, David) but it felt silly. Then she closed her eyes (oh Olive, Olive) and it felt a bit better.

a habit which may be difficult to break

There's a picture of Dusty doing a show in America. She's wearing a maxi dress, like the one she wore on the sleeve of *Dusty . . . Definitely*. The dress is white. It goes all the way up to the top of Dusty's neck and all the way down to her wrists. It is covered in hundreds of tiny, tear-like beads. Susan imagines the weight of them, the noise they must make when Dusty walks, swinging and shimmering all over her body. Susan looks at the picture for a long time before she turns the page. The next clipping is a picture of the backing singers. There's the tiny wee girl in the middle, the bigger girl on the right, and on the left the pretty coloured girl with the gap between her teeth. They look as if they're friends and have a good time singing with Dusty.

petting does not mean just a kiss

Everyone was talking about Julie and Greg. What they had done. If they had gone all the way. Susan joined in, a bit, but she couldn't come up with many suggestions about what Greg had done to Julie or Julie had done to Greg. Olive said that Julie had let Greg put his hand inside her knickers and that Julie was a slag.

Susan wondered what kind of pants Dusty would wear under the white dress. They would have to be tight and sheer so as not to leave a panty line. She showed Olive her scrapbook and Olive said that her brother had told her Dusty Springfield was a lemon. Susan said that that Dusty wasn't and Olive laughed and asked if she was going to cry. Was she a big crybaby?

sexual thrills

Some people had sexual intercourse, Susan decided, and other people had sexual thrills. Her mum and dad had had sexual intercourse, at least three times.

it's natural

Birds do it, bees do it . . . Susan's dad turned the radio off. Bloody upper-class poof, he said. Brian laughed and Susan's mum said, ssshh.

It's simply a question of the sort of girl you are

Would marriage affect your popularity, the NME asked Dusty. Probably, she said. I'd never thought of it that way.

why does the girl always get the blame?

Brian's younger than you, Susan. He's a boy, he doesn't know any better. And let's not forget what happened to Action Man.

usually men who do this are mentally sick

Maybe Greg is mentally sick and that's why he and Julie went all the way. (Is Julie mentally sick too? Will their baby be mentally sick? Susan's new little brother or sister won't be. It'll be boring, like Brian.)

steer clear of men who have been drinking alcohol

The truth is I'm just very easily flattered by people's attentions, Dusty told the Evening Standard. And after a couple of vodkas I'm even more flattered.

avoid being on your own in lonely or dark places

There's one thing that's always annoyed me, she said. And I'm going to get into something nasty here. But I've got to say it, because so many other people say I'm bent, and I've heard it so many times that I've almost learned to accept it. I don't go leaping around to all the gay clubs but I can be very flattered. Girls run after me a lot and it doesn't upset me. It upsets me when people insinuate things that aren't true. I couldn't stand to be thought of as a big butch lady. But I know that I'm as perfectly capable of being swayed by a girl as by a boy. More and more people feel that way and I don't see why I shouldn't.

such a woman is sometimes called a Lesbian

Susan is a le-mon, Susan is a lem-on, Susan is a le-mon.

Olive told Mandy that Susan fancied Dusty Springfield, and then Mandy told Jennifer, and then Jennifer told Greg, and then the boys were all chanting at her at the school gates.

sexual practices between two men or two women

Susan walked the long way home from school, on her own. Where have you been, her mum said. I need you to help me with things now that you're a big girl.

punishable by law in the case of men

When Susan pressed her lips to Olive's she could feel the softness as well as the slight chapping. Her tongue was tingly but not like sherbet makes your tongue tingly. Susan's mum and dad and Brian were downstairs, watching the television.

Most girls have crushes at one time or another

There was Mrs Bartholemew in primary seven and Dr Liz Shaw from Doctor Who and Donny Osmond and Tawny Owl and cousin Kate (but only when she started wearing the Olivia Newton-John trousers) and Olive and of course Dusty.

we all go through a stage

Susan's school shirt rubbed against her chest now, and her vest felt tight and itchy. She didn't want to ask her mum if it was time for the training bra or if that would make it worse.

a stage when we are specially attracted to one or two people of our own sex

The first time Susan remembers is when they went to the panto and Robin Hood was a girl. It wasn't her fault though, that she expected Robin Hood to be a boy. She thought he was (at first), and that made it all right.

cannot help being as they are

It was frightening (dirty?) kissing Olive. Strange (tingly).

often unhappy people

Susan's mum had read the Evening Standard article as well. Susan had to retrieve it from the bin. She pasted it into her scrapbook and piled her other books on top to flatten the page out. There's a smudge of something that might be jam in the corner.

sissies or pansies or queers

At lunchtime, when they were all standing against the wall at the back of the gym, Susan told the other girls that Olive had asked

her to kiss her. It was disgusting, Susan said. Olive grabbed me and pushed me onto the bed and stuck her tongue in my mouth. I thought I was going to suffocate or throw up.

Imagine if you'd thrown up, Diane said, if you'd thrown up in Olive's mouth.

All the girls laughed. Mandy asked Susan to tell them what had happened again.

I told her she was weird, I said, you're a freak Olive, you're a Lesbian. I'm going to have to wash my face now because it's all your slavers.

When Olive walked towards them the girls all screamed and shouted. Olive's face went red and then she turned and ran away.

Look at her, Diane said, she did it, you can tell from her face, the dirty lezzer.

Are homosexuals dangerous?

Susan's dad turned the television over when Up Pompeii came on. I can't stand that big poof, he said. Oh I like him, Susan's mum said, he's harmless. The kind of harmless that would get him three years in jail if he wasn't on the telly, Susan's dad said.

Remember that your attractive appearance may make him think you're egging him on.

Thunder thighs. That was what Gary shouted at her when the girls ran past to go to the hockey pitch. Susan doesn't think she looks right in shorts. She's too pale, and her legs have grown recently. They wobble where they didn't before.

All they want is a loving husband and family.

Olive must have cried all the rest of lunchtime. When she came into class her nose and her eyes were red. She arrived a couple of minutes late and went straight to her seat. The teacher told Diane to keep quiet and concentrate, unless she had something to share with the rest of them. For a second Susan thought Diane was going to tell, but she just winked at Susan and then went back to her verb conjugations.

furtive, snatched in dark corners

When the bell rang Olive said, I'm never going to speak to you again Susan. I hate you.

love, warmth, kindness, understanding, unselfishness and sheer fun

I want to be honest very much, Dusty said. The image of being a sad neurotic lady worries me. Of course I have sadness in me, everyone does.

sheer fun

In the picture Dusty is so beautiful, with her dark eyes and her long eyelashes.

Probably the best person to ask is your mother.

The baby is due in June. There will have to be a few changes, Susan knows. She's been told lots of times now. So much that she's bored of it.

Perhaps there's a specially understanding friend of the family, or your doctor, or minister.

Susan paused when she saw Olive in the corridor after assembly, but Olive shoved past without speaking, walking so fast that her curls bounced on her shoulders.

you may find it easier to talk to a stranger

Hearing a noise, Susan leans out her window to look into the back garden. Her dad is trying to teach Brian to fight. Dad's a bit heavier on his feet now than he was when he did boxing at school,

Susan guesses. You have to stand up to bullies, he tells Brian, jabbing him in the ribs. Bullies are just cowards, you know. They pick on people they think are weaker but you can be strong. All that over a few Panini stickers, Susan thinks.

some of the questions some girls ask

One day Susan would like to be a backing singer for Dusty. They'll do shows all over the world, and she'll stand in the middle, between the gap-toothed girl and the big girl, wearing a black shift dress and perfect flicks of eyeliner. They'll dance together and laugh, and none of them will ever cry or call each other nasty names. Susan flicks through her records until she finds her favourite. She lifts the lid of the record player and slips the 45 from its sleeve and places it on the turntable. There's a click and it starts rotating. Susan leans in close to get the needle in the right place. She hates the noise when it bumps the edge and it's no good if it starts too late, not with this song.

The music begins. Dusty sings and Susan joins in, hiding her thin voice behind Dusty's deep, melancholy notes.

Anyone who had a heart, sings Dusty.

The needle sticks.

Anyone who had a heart.

Anyone who had a heart.

Anyone who had a heart.

52 53

This is Liberty

Kirsty Logan

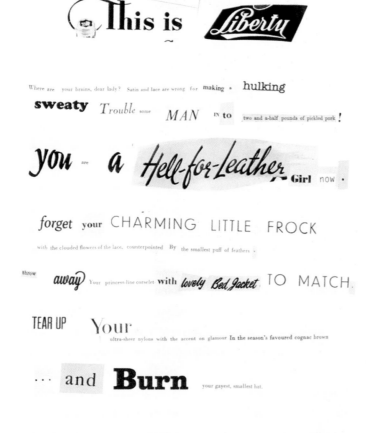

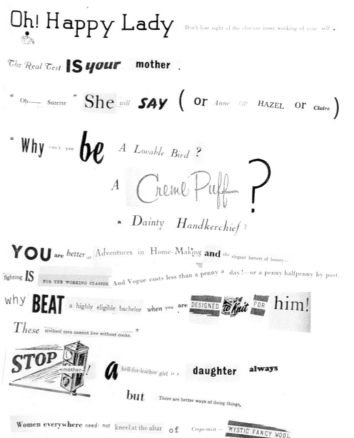

Here's how Boadicea in all her glory IS MADE :

FIRST THINGS FIRST: hurl Off YOUR Matron's Frock.

Square Your Shoulders. Brush your hair upward , pencil the slant of your eyes up towards the temples, tilt your mouth high at the corners. And do not forget that An intelligent woman's face itself— is fatal .

a jewelled, double-barrelled mask .

Shooting The right look will floor ten **men** WITH a low whine AND THEN a thud, as if someone had struck a very thick carpet with an old fashioned cane carpet-beater.

Simple, speedy and above all, successful

When HE'S lying sprawled and defeated at your feet, don't stop.

THROW OFF the Shackles of The regular **all-purpose** *Woman* . so comfort giving, so correct. so subtly designed in such soft, flexible leather, **you** can avoid being made up, tried on, criticized and finally approved by everyone ●

dare to dance a pas deux *Of* thuds—shouts—a wild commotion—

NOT *Baby Knitting* AND **A** MORE DIGESTIBLE PASTRY .

But are **you** **still** thinking in terms of tiaras ?

Ask the women of the world how many

" *Made to Measure* Baby blue **REAL SILK**

Stawberry Shortcake *Flower Corner*

Soft **HEYDAY** Party Face "

dreams come true.

...do not give up *Liberty* for **a**

Stiletto heel & tapered toe .

K. LOGAN
2012

This is Liberty, 2012
Collage on paper
4 x A4
Photo: Tian Khee Siong

58

This is Liberty

Kirsty Logan

Where are your brains dear lady? Satin and lace are wrong for making a hulking, sweaty, troublesome man into two and a half pounds of pickled pork! You are a hell-for-leather girl now.

Forget your charming little frock with the clouded flowers of lace, counterpointed by the smallest puff of feathers. Throw away your princess-line-corselet with lovely bed jacket to match. Tear up your ultra-sheer nylons with the accent on glamour in the season's favoured cognac brown… and burn your gayest smallest hat.

Oh! Happy lady, don't lose sight of the obscure inner working of yourself. The real test is your mother.

'Oh Suzette' She will say (or Anne or Hazel or Claire)
'Why can't you be a lovable bird?
A creme puff?
A dainty handkerchief?

You are better at adventures in home-making and the elegant battery of beauty – fighting is for the working classes, and Vogue costs less than a penny a day! – or a penny halfpenny by post.

Why beat a highly eligible bachelor when you are designed to knit for him! These civilised men cannot live without cooks.'

Stop, mother! A hell-for-leather girl is a daughter always, but there are better ways of doing things.

Women everywhere need not kneel at the altar of crepe-mist 'mystic' fancy wool, prize-winning knitting pins and Kellogg's Rice Krispies.

Here's how Boadicea in all her glory is made.

First things first: hurl off your matron's frock. Square your shoulders. Brush your hair upward, pencil the slant of your eyes up towards the temples, tilt your mouth high at the corners. And do not forget that an intelligent women's face itself is fatal: a jewelled, double-barrelled mask.

Shooting the right look will floor ten men with a low whine and then a thud, as if someone had struck a very thick carpet with an old fashioned cane carpet-beater. Simple, speedy and above all, successful.

When he's lying sprawled and defeated at your feet, don't stop.

Throw off the shackles of the regular all-purpose woman, so comfort giving, so correct, so subtly designed in such soft flexible leather. You can avoid being made up, tried on, criticized and finally approved by everyone.

Dare to dance a *pas de deux* of thuds – shouts – a wild commotion – not baby knitting and a more digestible pastry.

But are you still thinking in terms of tiaras?

Ask the women of the world how many "made to measure baby blue real silk strawberry shortcake flower corner mink soft heyday party face" dreams come true.

Do not give up Liberty for a stiletto heel and tapered toe.

Woman's Realm

Janice Galloway

My mother, a never-miss reader of the *Sunday Post*[1] and three biographies a week (mostly of film stars, royalty or philanthropists) from the library, hated *Woman*. It showed her recipes she'd not the time to make, face powder she couldn't afford, and frocks she couldn't wear to work. The semi-glossy paper it was printed on meant she couldn't even use the bloody thing for kindling. *Woman* was for women with not enough to do; *Woman's Weekly* was drab; *People's Friend*, both drab and old-fashioned; and *Woman and Home*, obsessed with cleaning, was for people who liked *The Archers* and had a meat thermometer. *Tit-Bits*[2] was sleazy, and *Vogue* was class war for debs. *Woman's Realm* was okay on the grounds it did free useable patterns. Useable patterns had a function. What she thought of the problem pages she never divulged. My guess was she read them secretly, wondering at the lives of others. Life, at least, was something we all shared.

This roster of titles recalled in tranquillity come from the mid-sixties, when I was eleven and unaware that puberty was waiting at the next street corner to life as I knew it: a heartland of homework, school dinners, everyday playground brutality and colouring-in. My mother bought no magazines, but found selections in doctors' waiting rooms, having a quick skim to pass the time. Even at eleven, sitting next to her on the waiting room's rock-hard bench, not all magazines looked equal. Glossy pages were surely for would-be glossy people: inky, near-newspapery rags for those whose efforts at silk-pursing would always be a little unconvincing. Your magazine, its advertising, and the face on the front of it told you something about your likely social stratum and expectations.[3] Behind all social divisions lay the apparent fact that readers understood marriage, children and home as the sacred triangle of

perfection. Magazines, like a modern gamer's manual, held tips and secrets to help perfection's acquisition. My mother, as a widow, was out of the loop, my auntie Grace explained. She couldn't stand *Woman's Weekly* because she was bitter. Spring's new colours and delicious home-made cheese straws, after all, could hold no fascination for a woman without a man to care for, while Olay face cream would remind her of loss.

Magazines in doctors' surgeries were unavoidable, however. Any place that hosted FLIES KILL posters with enormous close-ups of *musca domestica's* disease-ridden mouthparts was clearly suitable for Public Health and Happiness guides of any stripe. The huge social and sexual shifts of the sixties demanded it. The war was over: having a perfect life after hell itself was the next big challenge.

If advice for grown women was in demand – and sales said it was – their inexperienced, un-rationed, every-advantaged daughters probably needed it too. Overnight, it seemed, a frenzy of teen mags arrived to render modern girls more confidently fit for purpose. A perfect marriage, children and home were obviously inappropriate lures for purchase, at least for the moment. What better, then, than a trainer slope of new social etiquette, personal hygiene, make-up on the way to boy-catching, with some hints about sex, in case you accidentally caught one and felt underprepared? No one got the perfect three without a husband, of course, and women's magazines were good at telling you how to keep one once you'd bagged him. What teenage girls needed, therefore, was insider information on boys: pictures; generalised social and sexual data; the etiquette of acquisition; management; and how to up rather than ruin your own market-value in the process. Some magazines promised to be a New Best Friend, with chirpy girl-next door names like *Diana* and *Jackie*; others chose the nod-and-wink legal implications of the birthday jackpot, *Sixteen*. In addition, these magazines had teen fashion, pop music and playground slang thrown in; an overt challenge to mums' confidence that mums knew anything worth knowing about young people today, and leaving that stuff to a magazine would be heaps hipper and heaps better. It touches me still that my mother, who would not pay for 'nonsense' for herself, prepaid such magazines for me. Having decided I needed all the advice I could get, she did not stint.

Jackie went on pre-order at the local newsagent, where all I had to do was fetch it home and – and this was important – not share it. Especially not with her. Mum was fifty-three, six years free of a violent marriage and entering menopause; a word she could not say out loud. She was embarrassed by adverts for sausages

1. 'A thoroughly decent read'; a tabloid distributed weekly by the legendary DC Thomson of Dundee. Founded in 1914, this blend of sentimental stories, readers' letters, cartoon strips, cheesy jokes and homely articles was read by over three million people every Sunday in its heyday. A magazine equivalent, *The People's Friend*, featured gentle love stories, patterns, household tips and short features of 'female' interest.

2. *Tit-Bits*, closed down in 1984, was a mishmash of very short, somewhat sensationalised 'human interest' articles and short stories. Pools winners, crime, and women in bikinis for no reason were regular features.

3. Ruth Ellis, the last woman to be hanged in Britain, would never have been covered by *Woman and Home*, for example, but more than once pushed sales from the cover of *Tit-Bits*, which also reported incidents of violence against women as opposed to the more upmarket magazine's reportage of near none. The faces on women's magazines, and their social signifiers of what it mattered to be informed about, are a whole missing PhD thesis.

for goodness sake: she was not someone with whom to share. My sister, at thirty, was psychoneurotic, sexy, scornful and overfond of the punch as a corrective for errant children viz. me, and my father, an alcoholic, had been dead for years. I knew nothing about my own body and even less about boys, save the sneaking suspicion I'd better find out fast.

Even at twelve, obvious, tender, bouncy-when-I ran breasts seemed to enjoy brushing against things by accident while chasing games with boys – me doing the chasing, I should add – brought me out in waves of shivering heat in the lunch break. Anything with revelatory information about a) me, b) boys and c) the roughly contemporary was welcome. If Mum was hoping the magazines would be the companion of my virgin heart and intellect, so was I. Soppy stories about girls with huge hair and too many eyelashes apart, I read everything, sometimes twice and taking notes. What I needed, and knew it, in our manless house devoid of visits from male relatives, was a beginner's handbook to male psychology.

Teen magazines provided pictures of pop stars, which were useful for learning facial similarities and differences (eyebrows; boys had great big eyebrows, and hair growing out of their chins as time went on), without the embarrassment of staring at real boys and being caught out. They presented boys in problem pages ('A boy I know asked me to the pictures, but I don't know if he should pay'), in articles ('A day in the Life of Herman's Hermits'), in quizzes ('You see a boy looking at you across the room at a party. Do you a), b) or c)...?') and featurettes ('How to know if he's keen'). Quality of advice varied from the chirpily hilarious to the dark warning. Over weeks, it proved inconsistent, pointing to lack of solid editorial control. Not knowing what editorial control was, I assumed the inconsistencies were my own inadequate understanding and read harder.

Boys were no cause for worry because, underneath it all, they were just the same as you! At the same time, they experienced definite physical tensions linked with their longings, while girls respond in a more tender way. What's more, male physical tensions might well disturb them violently. Lengthy kissing sessions, lovely for you, are dynamite to him – a warning singing off the piece – was both mystifying and scary. Violence in our house was literal and often hair-trigger and dynamite, well, everyone knew how dangerous that was. Loss of limbs or dignity might be saved, however, by careful management.

I should avoid letting him down; take care I did not lead him on by allowing the two of us to be alone too often. Keep occupied during dating hours! Go out in groups! Join a badminton club! The threat-free alternative was stark: You don't ever need to go out with a boy if you don't want to. The choice is yours! But you see, I did want to. I really did. Just not in the anticipation, to use another frightening magazine phrase, that if things got out of hand, I'd be in deep water without a lifeline, a rubber ring, or even the awareness of my companion to my distress.

Smile and thank him often if he says something nice! was an exception. Light relief, the smiles were a much needed clue that acquiring a friend of the opposite sex, however spine-tingling, was surely not always about a Dan Dare level of risk. Some of it had to be fun, right? 'Maybe' was as far as such articles would commit. That we could be nice to each other, considerate together, if it featured at all, was a fleeting footnote to the long cribsheet of dating know-how.

Problem Page issues in particular – so many of them! – on the issue of how far to go took us back to wholesale caveats, some from such innocent and innocuous-seeming beginnings. Agree to share a tent, I read, and however nice the inviter seemed, he would automatically make the assumption you had agreed to more than a pally bunk-up, playing games with torches and shadow-puppets in the middle of the night. And it would be all my own fault.

Even explicit warnings about pre-marital sex (how odd a phrase does that seem now?) were not so much pregnancy based as the ruin of one's reputation (boys brag about their exploits), or about avoidance of infections. Sex without love can render you a carrier of disease without knowing it. If you suspect your friend has VD, take her to the doctor yourself. Pre-maritally, sex was sex without love. Telling love apart from infatuation, however, was very, very difficult indeed – and not just for you. Sometimes a man does not know the real cast of his own mind until afterwards, when it is too late. A wedding band was the only insurance a girl might rely upon. A wedding (or so ran the implication) guaranteed a disease-free, humiliation-free and fireproofed-against-desertion-in-the-advent-of-pregnancy dream life, with all the requisite knobs on. Sex without was an existential hell. Sex without love can build a wall around you. It can leave you more alone than you have ever been. The life of the unmarried mother is truly tragic. Real love reveals mystery and wonder in physical closeness, while sex without love is meaningless.

Isolation and a life of shame in the shadows was the price of curiosity, of too-keen desire, of a misplaced craving for a decent cuddle. Rubbing salt into the wound was that really scary things, things I knew about because they had actually happened, were something about which eagerly sought advice was not available from Your Best Friend. Not once did I read advice as to how to react to the flasher on the late-night bus; how to react to being touched up by a stranger; how to react to being touched up by a stranger when you didn't know which stranger was doing it, and you were packed in tight on a crowded train; how to stop my sister humiliating me in public about my changing shape; or how to deal with my own racing heart as possibly the most troubling factor in the whole shebang. Was my undoubted interest in getting both talkative and tactile with a boy just looking for trouble? Did it mean I would one day find myself more alone than I could imagine? And what, I wondered – I wondered a lot – were boy teens being told in Eagle, Rover and Custom Cars about us? If it was crazy, I could disregard magazine advice as at least only opinions, not objective truth.

Immediately, taking advantage of the very patient newsagent on the corner of Station Road, I rooted out what chap-mags I could. And found nothing. No advice, no dating tips, no guides to a girl's dangerous muscle tensions. In most, girls and women did not appear at all, certainly not as part of the thrill of adventure (Biggles and Pansy was an unthinkable title), and not even as mothers, friends, girlfriends, teachers or confidantes. All-male environments were de rigueur. In magazines for older boys and men, there were a few, but mostly on the cover with big breasts and big fat lips, their thighs apart on a motorbike and not engaged in conversation with a single bloke. There were no dating tips, no girl psychology

warnings, no pages of dilemmas about how far to go, only a shift from the company of Roy of the Rovers to camshafts and hookers. The anatomy of a WW2 bomber, sure! But women? Girls? Glaringly obvious by their absence in any talking role, the female sex was something a chap had no need to bother his square-jawed head about. Our magazines had mountains of the damn stuff, hard to get on top of and often forbidding. And the view from the top was intermittently clear, if at all.

Our mothers had household and beauty tips (try getting out of bed an hour earlier to put on your make-up before making breakfast; it makes all the difference to keeping the magic going!). In preparation, ours delivered moral and social guilt. For all our Beatles and Stones, even our early Bowie and Bolan; for all the promise of new sixties' freedoms (brought into being, apparently, by fancily dressed Beautiful People focussed on opt-out hedonism, as though a living wage was something they never had to consider), we, the not-rich and unsophisticated mass, were girls then housewives, under proper sets of sex-appropriate controls.

We're less consistently that now, I am told. Look at contemporary magazines aimed at both lower-income and management-income salaries and you'll find that though emphasis has rejigged itself, fearful obsession with sex and its meaning seems merely repackaged. Women are driven not so much by worries about sexual control and hostess manners as by things much more basic and inescapable: our breasts, our wrinkles, our greying hair, our self-esteem (are you trying hard enough to be worth it?), micro-management of bodily hair, and knowing enough sexual positions to keep him enthused longer than ten minutes. Upmarket women's magazines, in a kind of monetarist-cum-dumbed-down feminist way, seem to shift between trailers for absurdly expensive clothes and objects, extremely well-paid city and TV-power prima donnas, and, least helpfully of all, an obsession with vaginas, vejazzles, G-spots and coming like a train; i.e. woman's deepest fulfilment notched up a gear from domestic bliss and hard-won home-making to orgasmic bliss and a fat wallet, which could be used for buying piles of high-status stuff, a super loft space to put it in and some other, less fortunate woman to clean it.

The early training in self-doubt I recall from sixties' teen rags seems not just different but much less damaging to the soul. In-depth articles about Brazilian waxing, the art of pole-dancing and 'How to Release your Inner Slut' are not 'liberating'; they're just sexism gone devious; monetarist drivel working on even deeper insecurities than ignorance of how far to go. *Jackie* and *Sixteen*, for all their daftness, were at least cheap and not crammed with airbrushed impossibilities. They did not promote greed as a worthwhile ambition or insist repeatedly, in varying degrees of pseudo-academic language, that a woman's deepest pleasures came from one organ only – and that organ was not, was never, her brain.

The self-defeating, competitive tosh our teens can encounter in the doctor's waiting room today unsettles me far more than the hokum I encountered in mine. So what's your daughter reading? Your son? These days, is it more a case of watching? What moral imperatives lie behind the words, the pictures, the illusion of neo-consumer 'choice'?

If I were you, I'd ask.

Jigsaw of Doom

Heather Middleton

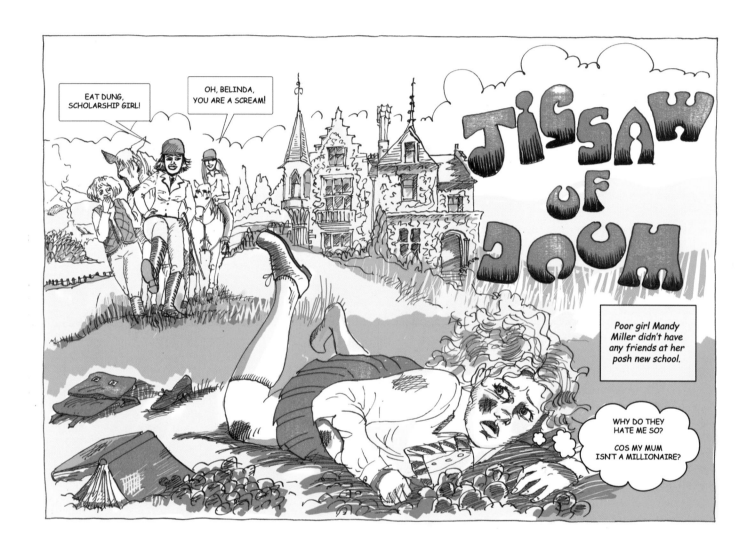

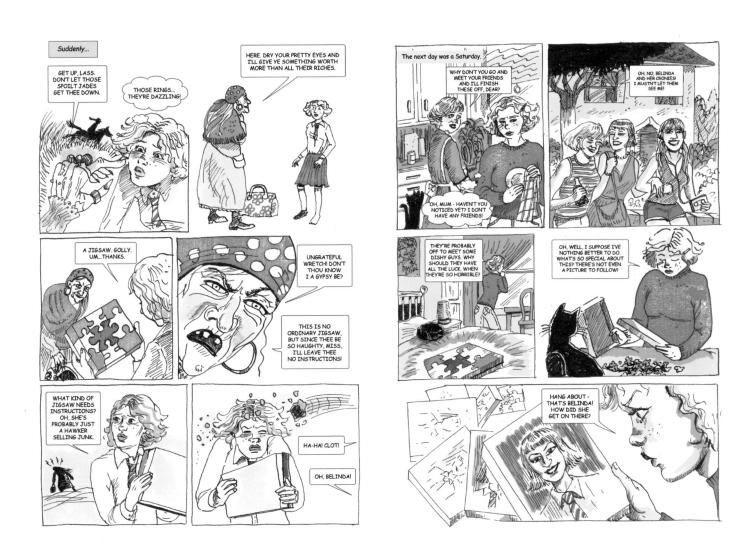

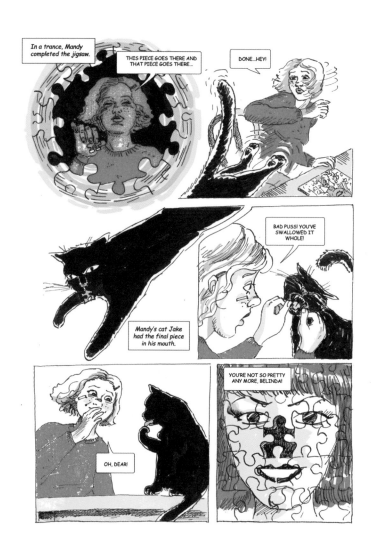

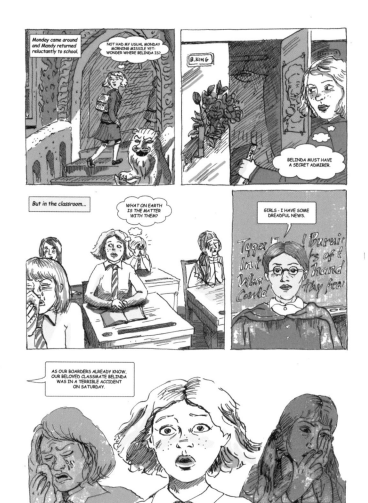

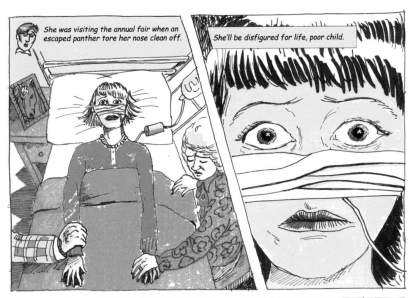

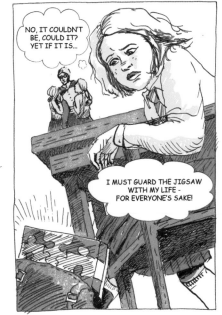

Horses

Sarah Wright

Horses, 2012
Digital print, screenprint and coloured pencil on newsprint
8.5cm (w) x 38cm (h), 20 pages. Edition of 20
Photo: Tian Khee Siong

Horses, 2012
Digital print, screenprint and coloured pencil on newsprint
28.5cm (w) x 38cm (h), 20 pages. Edition of 20
Photo: Tian Khee Siong

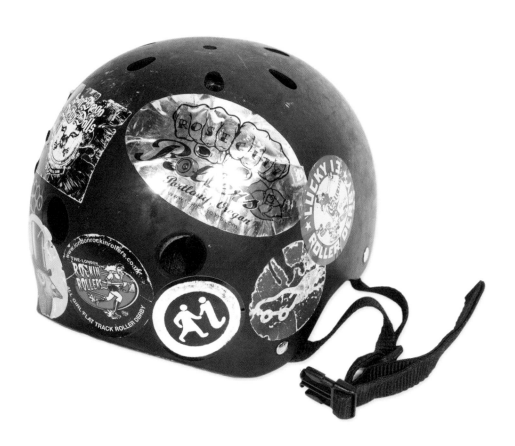

National Museum
of Roller Derby

Ellie Harrison

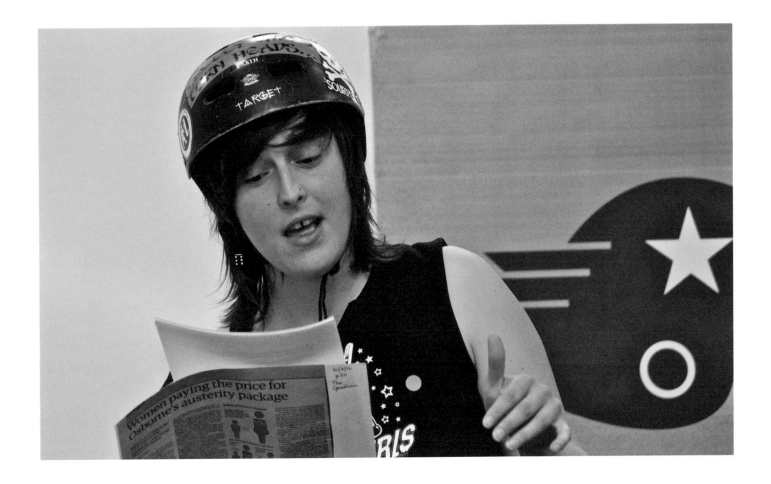

National Museum of Roller Derby, 2012
Ellie Harrison launches National Museum of Roller Derby
Glasgow Women's Library, September 2012
Photo: Jean Donaldson, Glasgow Women's Library collection

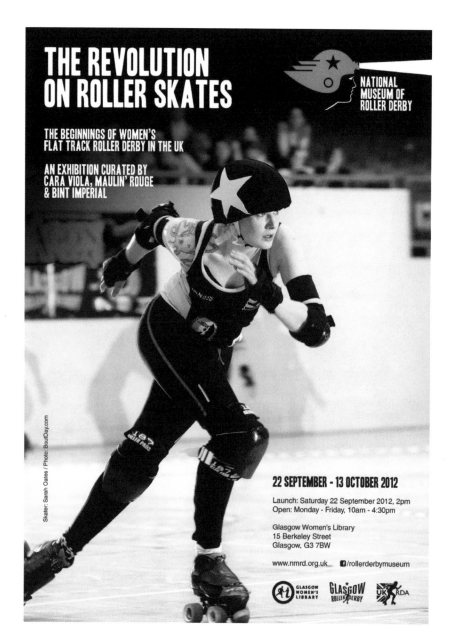

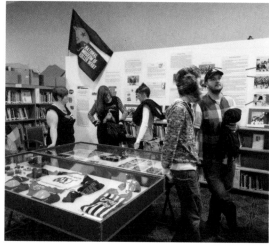

(40) (61) (62) (63) (64)

National Museum of Roller Derby, 2012
Poster design by Ellie Harrison for *The Revolution on Roller Skates* exhibition
Glasgow Women's Library, part of the *21 Revolutions* programme
September 2012

The first public exhibition at GWL of materials donated to the
new museum's collection. Curated by members of Glasgow
Roller Derby and Auld Reekie Roller Girls – Sharon McMeekin
(left), Cara Viola and Kirstie Meehan
Photo: Dave Mcalevy

The Artists

Sam Ainsley
This Land is your Land...

"My original idea was to use the names of all the women's memorials in Scotland, but I also wanted the text to hug the coastline of mainland Scotland as all old maps show (I couldn't fit text into the islands!).

Many of the memorials were inland, so I started with the Red Clyde and the Women's Rent Strike (in Glasgow), and by a process of word association, celebrated the qualities of all the women of Scotland. I didn't want to name names as so many would have had to be left out...

Most of all, I want to pay homage to everyone at Glasgow Women's Library who have sustained so many of us over the years; in particular, Sue John and Adele Patrick, without whom, as they say, none of this would have been possible."

About Sam Ainsley

Sam Ainsley has forged a long career within the visual arts sector as an artist and a teacher, co-founding the Master of Fine Art course at Glasgow School of Art.

She has exhibited in and curated independent exhibitions, and undertaken residencies in numerous institutions and arts organisations across the USA, Australasia, Europe and the UK.

Significant exhibitions include: *Atlas of Encounters*, Space Gallery, Chicago (2009); *The Red Room*, VCA Gallery, Melbourne (2001); and *Why I choose Red*, Centre for Contemporary Art, Glasgow (1987). More recent exhibitions include: *The New Scots at the RSA*, Edinburgh, (2008); *After Growth and Form*, Glasgow Print Studio (2011); and *Studio 58*, Glasgow School of Art (2012).

She is a respected and published spokeswoman for the visual arts, and her own artwork is in a number of national and international, public and private collections.

Claire Barclay
Untitled

The featured texts in the prints reappropriate a slogan that was used by the Social Purity Movement, which was aligned to temperance and women's suffrage groups in the late 1800s–early 1900s. Claire took inspiration from the Library's collection of *Jus Suffragii* magazines and suffragette memorabilia.

"I am interested in the notion of a 'blameless life', when compared to the moral codes which underlie contemporary society, and the sense of hypocrisy and guilt which seems to pervade. The phrase suggests a romanticised ideal of an innate feminine innocence, symbolised by the white flower, sometimes worn by suffragettes. Comparisons between feminine virtue and the purity of nature are outdated and sometimes complacent, but these groups also left a legacy of their struggle for progressive moral and social change which we still find inspiring."

About Claire Barclay

Claire Barclay lives in Glasgow, where she studied at the School of Art in the late 1980s and early 1990s. Since then she has exhibited widely, and is recognised for her large-scale sculptural installations.

In 2003, she represented Scotland at the Venice Biennale, with an installation at the Palazzo Giustinian Lolin. Her first retrospective exhibition took place at The Fruitmarket Gallery in Edinburgh, in 2009. She was a recipient of a Paul Hamlyn Award from 2007–2009, and more recently, exhibited *Shadow Spans* at the Whitechapel Art Gallery, in London, as a recipient of the 2010 Bloomberg Commission.

Her work explores themes such as the role of craft in contemporary art, contrasts between natural elements and man-made items, and the commodification of art as espoused by various lifestyle ideologies.

Ruth Barker
A Scarf for Glasgow Women's Library

The central panel of each scarf shows an image of the artist's hands, in an aesthetic suggesting the humble photocopy. Part of the beauty and strength of the Glasgow Women's Library's archive is the sheaves of photocopied notes and advertisements, revealing the historical significance of this simple tool for sharing information.

"The Library is a quiet space, and yet through our body language – particularly the way we use our hands – we are always eloquent. The immensely warm and welcoming embrace of the Library and its community is celebrated in the scarves' enveloping wrap."

About Ruth Barker
Ruth Barker is a Glasgow-based artist, originally from Leeds. She completed a BA (Hons) in Environmental Art, and a Master of Fine Art from Glasgow School of Art, and is currently undertaking a practice-based PhD at Newcastle University (2011–2014).

Ruth's work is primarily performance-based, and often involves fabric elements and costume. In her performances the retelling of ancient myths through original poetic composition becomes a gesture towards the ritual understanding of self, gender, and mortality. Her performance garments – usually developed with contemporary fashion designers – become complex ritual objects, containing the artist as she recalls her epic texts from memory.

Recent projects include performance commissions for: Cornerhouse, Manchester (2012); Glasgow International Festival of Visual Art (2012); and Cartel Gallery, London (2013). Upcoming projects are scheduled for Camden Arts Centre, London, and Glasgow Women's Library (both 2014).

Photo: Christina Kernohan
Glasgow Women's Library collection

Nicky Bird
Raging Dyke Network

Raging Dyke Network was a group of radical separatist lesbians active in the late 1990s. It spanned across 52 locations in the UK, Europe, Canada and USA. At the network's centre was an activist in Norwich, who donated materials – including personal letters and 'zines – to the Lesbian Archive housed at the Glasgow Women's Library in 2000.

The series of fine-art postcards aims to represent the network's scale and make visible a history often overlooked, without revealing the personal and political content that belonged to a group that identified itself in terms of its separatist gender politics. Nicky worked closely with Library volunteer Alice Andrews in the production of this work.

About Nicky Bird
Nicky Bird's work investigates the contemporary relevance of found photographs, their archives and specific sites. She explores this through photography, bookworks and online media. In varying ways, she creates artworks that make visible the process of collaboration with people that have significant connections to a hidden history.

This preoccupation with the social role of photography, memory, and genealogy emerged from her practice-led PhD (1999) at the University of Leeds. Her work is featured in *Seduced by Art: Photography Past and Present,* a major National Gallery touring show. Solo shows include: *Archaeology of the Ordinary,* The Peter Potter Gallery, Haddington (2011); and *Beneath the Surface/Hidden Place,* Stills, Edinburgh (2008), which also toured across Scotland (2009–10). She has undertaken residencies at Glasgow Women's Library (2009–10) and Hospitalfield House, Arbroath (2003). Nicky is also a part-time PhD Coordinator at the Glasgow School of Art.

Karla Black
Necessity

This edition consists of fifty small sculptures that sit like greetings cards and, when owned as single objects, should be placed on already existing domestic furniture, such as a desk, table, mantelpiece or shelf. They are made of sugar paper that has been smeared with peach, white and yellow body paint.

About Karla Black
Karla Black makes large-scale sculptural installations, using a combination of art and everyday materials.

She graduated from the Sculpture Department at Glasgow School of Art in 1999, and from the Master of Fine Art course in 2004. In 2011, she represented Scotland at the 54th Venice Biennale, and was nominated for the Turner Prize. Other significant solo exhibitions include: Institute of Contemporary Art, University of Pennsylvania, Philadelphia (2013); Galerie Gisela Capitain, Cologne (2013); Gallery of Modern Art, Glasgow (2012); Dallas Museum of Art (2012); Modern Art, Oxford (2009); and Inverleith House, Edinburgh (2009).

Photo: Ronnie Black

Ashley Cook
We Want

For this work, inspiration was taken from the suffragette collection at the Library, specifically the quote 'We want what men have, it may not be a lot but we want it just the same', a phrase from a suffragette postcard, and the imagery is drawn from the card game *Panko!*

The central image is a photo Ashley took of fellow artist Janie Nicoll, in 1996, for a suite of screen-prints called *It ain't easy to keep the one you love satisfied*. Other images are of Lady Justice, and various paradise-like images symbolising the search for a utopian ideal. The text in the work is repeated as a mantra, showing endurance and determination. The title also leaves room for further interpretation, including the longing that can be part of the female psyche.

About Ashley Cook

Ashley Cook graduated from Glasgow School of Art with a BA (Hons) in 1986, and Postgraduate Printmaking in 1987, and has since continued to practice as a professional artist. She has work in a number of prestigious collections, including the Scottish Arts Council, BBC, Kelvingrove Museum & Art Gallery, Glasgow, The Vaasa Museum, Finland and Galeria OtraVez, Los Angeles.

She creates narrative works with a mixture of found images and her own autographic and photographic images; iconography which she reuses, redevelops and manipulates continuously. She uses an intense palette of colour opposites that create a dreamlike and sometimes nocturnal quality to her work.

Photo: Ashley Cook

Delphine Dallison
Grassroots

"I drew my inspiration from the collection of badges in the Glasgow Women's Library Archive. When I first looked through the collection, I was struck to discover that it contained not only badges related to the feminist issues the Library has supported over the years, but also to a much wider range of political causes, from 'Free Nelson Mandela' to 'Abseil against Clause 28', denoting the richness and variety of political activism which the Library has championed in past years.

To accompany the print, I also wanted to create a new edition of badges that reflected the variety of causes supported by women currently working at the Library. I contacted all staff and volunteers, and as a result of their fantastic response, I was able to create an edition of twenty badges which once again demonstrates how political activism permeates all avenues of life, beyond what people would normally see as feminist issues."

About Delphine Dallison

Delphine Dallison is an up-and-coming artist, with an interest in sculpture, handmade publications and prints, 3D installations, and participatory practice in the public sphere. In her work, she explores themes linked with gender and sexuality, drawing inspiration from her personal experience as a bisexual and gender queer individual. She has been pursuing a keen interest in the intersections of art, history and science, as well as exploring how to make information from public archives more accessible to the general public.

Delphine graduated with a BA (Hons) in Sculpture and Environmental Art in 2013, from Glasgow School of Art. Recently, she has exhibited at House for an Art Lover and CCA, Glasgow, as well as at the Central Academy of Fine Arts in Beijing. In 2011, she was one of the performing artists at *100 Performances to the Hole*, SOMArts, San Francisco, and, more recently, a number of her video works have been selected for screenings in Glasgow and Edinburgh.

Kate Davis
Not Just the Perfect Moments

In this work, as is the case with much of Kate's practice, photography and drawing are brought into close relation, and both are questioned as techniques for representing, and caring for the past. The British artist Jo Spence (1934–92), whose significant autobiographical text, *Putting Myself in the Picture*, is the focus of this print, often asked who owned images, and especially images of the body. Kate reinstates such questioning here, by treating Spence's publication as the subject, and Glasgow Women's Library as the subject's stage.

"What we need to do with our own pictures and with our own self-image, if you like, is to shift the emphasis back to a point where we understand that everything we do as women has a validity – not just the perfect moments."
Jo Spence, *Spare Rib Reader*, 1968.

About Kate Davis

Born in New Zealand, Kate Davis lives and works in Glasgow. Questioning how to bear witness to the complexities of the past, Kate's artwork is an attempt to reconsider, reclaim and reinvent what certain histories could look, sound and feel like. This has often involved responding to the aesthetic and political ambiguities of historical art works and their reception. Informed by successive waves of feminist art and theory, she works across a range of media, including drawing, installation, bookworks and film/video.

Kate has presented solo exhibitions at The Drawing Room, London (2012); GoMA, Glasgow (2011); Galerie Kamm, Berlin (2011); Museo de la Ciudad and La Galeria de Comercio, Mexico (2010); CCA, Glasgow (with Faith Wilding) (2010); Tate Britain, London (2007); Kunsthalle, Basel (2006); and Sorcha Dallas, Glasgow (2008) amongst others. Current and forthcoming projects (all 2013–14) include a solo exhibition at Temporary Gallery, Cologne, and group exhibitions at Tate Britain, London; Abron Arts Center, New York; Art Stations Foundation, Poznan, Poland; and the Scottish National Gallery of Modern Art, Edinburgh.

Photo: Enzo Di Cosmo

Helen de Main
21 Spare Ribs

Helen de Main's series of prints are inspired by Glasgow Women's Library's *Spare Rib* collection, a feminist magazine that ran from 1972–1993.

"Whilst looking through the archive of these magazines, I found the issue from January 1980; the month that I was born. Leafing through the magazine, I was struck by a number of issues that still seemed pertinent today, over three decades later.

The texts in each of the works are drawn directly from the January edition of the magazine throughout its 21-year history, and relate to a wide range of feminist and political topics covered in the magazine, as well as more personal and poetic stories.

I was also attracted to the strong visual identity of the magazine; the colours of each print directly reference those used in the corresponding issue."

About Helen de Main
Helen de Main lives and works in Glasgow. She gained a BA (Hons) in Sculpture from Sheffield Hallam University in 2002, and a Masters in Fine Art from Glasgow School of Art in 2008.

Working in sculpture and printmaking, her work looks at ideas associated with public space, architecture and development, and the relation these have to power and control, often incorporating fragments of text culled from different forms of media.

She has shown widely in the UK and internationally. Recent exhibitions include: *Dreams, Ideas, Actions*, Glasgow Project Room (2013); *The Medium is the Message: Words in Printmaking Since the 1960s*, Glasgow Print Studio (2012); *PETROSPHERE* and *Art Lending Library*, both part of Glasgow International Festival of Visual Art (2012); and *Between Here & Somewhere Else*, Overgaden Institute for Contemporary Art, Copenhagen, Denmark (2010); Al Hoash Palestinian Art Court, Jerusalem; Al Khaf Gallery, Bethlehem (2010); and Sakakini Cultural Centre, Ramallah (2010).

Photo: Rosie Healey
Glasgow Women's Library collection

Fiona Dean
To the Dear Love of Comrades: In Memory of Flora Murray

Flora Murray was born in Dumfries and Galloway in 1869. She was a medical doctor and an active and prominent member of the Women's Social and Political Union. With her colleague and long-term companion, Louisa Garrett Anderson, she established the Women's Hospital Corps in Paris in 1914, and the Endell Street Military Hospital, London, run and staffed by women, recognised militant suffragists.

Much of Flora's history is 'hidden', tucked away in archives, newspapers, and periodicals which have all played a part in trying to build up a 'lost' picture of Flora and her life and achievements. The print, presented as a kind of open sketchbook, reflects drawings made directly of the sometimes concrete, sometimes sketchy imagery and objects of her life.

About Fiona Dean
Fiona Dean is an artist and researcher based in Glasgow. Her visual work is concerned with landscapes and objects and their relationships: in particular, narratives revealed through their histories – factual and fictional.

An Academician of the Royal Scottish Academy, Fiona studied Sculpture at Glasgow School of Art, and undertook her PhD at the University of Stirling. She has exhibited and taught widely, both nationally and internationally, undertaking residencies at Guestatelier Hollufgård, Denmark, and Centrum Rzeźby Polskiej, Poland, as well as in Russia and the USA. She has received a number of awards, including the Churchill Memorial Trust Travelling Fellowship, a Wingate Scholarship, and British Council and European Culture Foundation funding. Fiona recently received an RSA Gillies Award to continue her research around Flora Murray.

Kate Gibson
Homespun

Homespun is a homage to the dedicated homemakers of the 1950s. It's a modern-day domestic sticker-bombing campaign, where completed chores are rewarded with stickers to be collected like coupons or co-op stamps.

"My inspiration from the archive was drawn from home, lifestyle and craft magazines from the 1950s and '60s. In particular, the craft magazines often contained distinctive transfers for needlework, printed on utilitarian substrates. They also contained crochet and knitting patterns, technical illustrations and domestic product ads that provided a rich source of ideas."

About Kate Gibson
Kate is a graphic artist based in Glasgow. Her work combines analogue and digital collage, use of found materials, screen-printing and typography. In particular, her work is concerned with the interplay of different contexts for symbols and typographic characters, working with the reuse, reappropriation and decay of materials.

She has undertaken a wide range of projects, including site-specific installations, illustration, and print and web work for commercial clients, museums and charities.

Photo: Kate Gibson

Ellie Harrison
National Museum of Roller Derby

Rather than produce 'an edition', Ellie chose to develop an outreach project; an experiment in audience development. On 14th June, 2012, she launched *The National Museum of Roller Derby (NMRD)* at Glasgow Women's Library, making GWL the UK's first official archive for the exciting, all-female, full-contact sport of Women's Flat Track Roller Derby.

Working closely alongside the Glasgow Roller Derby league, Ellie's aim is that the NMRD will attract a strong and revolutionary young audience to the Library. Examining the essence of a contemporary grassroots organisation – captured in Women's Flat Track Roller Derby Association mantra 'by the skaters, for the skaters' – this ongoing project aims to broker a lasting partnership between Roller Girls all over the country and the important shared heritage contained within the Library's archive. (www.nmrd.org.uk)

About Ellie Harrison

Ellie Harrison was born in London in 1979, and now lives and works in Glasgow. In 2011, she was shortlisted for the Converse/Dazed Emerging Artists Award, with the Whitechapel Gallery in London. She studied Fine Art at Nottingham Trent University, Goldsmiths College, London and Glasgow School of Art, where she completed the Master of Fine Art programme in 2010.

She describes her practice as an ongoing attempt to strike a balance among the roles of 'artist', 'activist' and 'administrator'. She uses skills and strategies drawn from each of these perspectives to create fun and engaging work, in and out of art-world contexts, which aims to expose and challenge the systems which control and rule over our lives.

She is coordinator of the Bring Back British Rail campaign, an agent for The Artists' Bond, and a member of the Scottish Artists Union and the University and College Union.

In 2013, she was appointed Lecturer in Contemporary Art Practices at Duncan of Jordanstone College of Art & Design, Dundee.

Photo: Christina Kernohan
Glasgow Women's Library collection

Elspeth Lamb
Timepiece

"The object that sparked off the research for the banner and edition *Timepiece* was the small Victorian fob watch in the Library's collection.

The small flower, that appeared to be a yellow rose at the centre of the watch, intrigued me, and I discovered that the yellow rose was the symbol of the American suffragists. Further research into the British suffragette movement led to the idea of making a banner, as it is thought that the Women's Social and Political Union was the first campaigning body to use colour and design to create a corporate identity.

This banner is dedicated to the memory of Sylvia Pankhurst, who was not only a militant agitator for the suffragette movement, but also a gifted artist."

About Elspeth Lamb

Elspeth Lamb studied at Glasgow School of Art, Manchester Metropolitan University, and the Tamarind Institute of Lithography, University of New Mexico, USA, her main specialism being printmaking.

She is an RSA Academician, a member of the Society of Scottish Artists and Royal Glasgow Institute, and has taught several workshops in lithography at the Joan Miro Foundation in Mallorca, Spain. She has won a number awards for her work, which is also included in major collections such as the V&A, Japanese Consular Collection, British Council, MAG Collection and Joan Miró Foundation Collection, and is represented in galleries and museums in the UK and abroad.

For 21 years, she taught at Edinburgh College of Art, latterly as Head of Printmaking, and she has been a Visiting Lecturer at many colleges in the UK. She chose to give up all academic teaching commitments in 1999 to pursue her artistic career. Her most recent residencies have been in Bulgaria, Canada and Newfoundland, and she exhibits regularly at home and abroad.

Shauna McMullan
165 Stars, Found in GWL Lending Library

Shauna McMullan combed the GWL lending library, collecting the hand-drawn inscriptions left in the margins of the pages; specifically, the asterisks and stars found in the hundreds of donated volumes.

Past readers have left traces of their journeys through these texts, stopping and interrupting the pace, to inscribe discrete marks. These marks describe what has been seen to be essential, and act as points of connection between the absent, previous reader and us. The handwritten mark 'acts as a conduit between the mind and the surface of the paper' (Ingold, T. (2007) *Lines: A Brief History*, London, Routledge).

The resulting artwork brings together and permanently fixes the complete collection of stars found in the lending library. Placed on a blue ground, the 165 stars create a new constellation, which is the product of many hands.

About Shauna McMullan

Shauna McMullan studied Fine Art in Cheltenham, followed by a Masters Degree at Glasgow School of Art, and The School of the Art Institute of Chicago. She has received a number of awards, including a Scottish Arts Council Scholarship at the British School in Rome, and residencies at the NIFCA (Nordic Institute for Contemporary Art) in the Faroe Islands, the Triangle Artist Workshop in Karachi, Pakistan and Tramway, Glasgow. Her work has been shown nationally and internationally at major museums, as well as through permanent public commissions.

Shauna has experience in the realisation of large scale permanent public art works. Commissioners include The Met Office, Exeter; The Scottish Parliament, Edinburgh; The Toyota Museum of Modern Art, Toyota, Japan; and Glasgow Women's Library.

She currently works as a part-time lecturer in the Department of Sculpture and Environmental Art at Glasgow School of Art.

Jacki Parry
Women in the City

The focus for *Women in the City* is provided by the five geographical locations of the Library, since its inception in Garnethill to its permanent home in Bridgeton. Street names have been replaced with those of women whose contribution to the life of the city is acknowledged in the walking tours initiated by the Library. Where a street already has a woman's name it has been left in.

In the spirit of recent work by Maria Pia Ercolini in Rome, and Habiba Sarabi, Governor of Bamian, Afghanistan, we should call for the naming of streets in new areas of our towns and cities to reflect the presence of women.

About Jacki Parry
Jacki Parry was born in Australia, and has lived in the UK since 1965. Following a period of teaching and travelling in Europe and Asia, she moved to Glasgow, where she was one of the founder members of Glasgow Print Studio in 1972.

She studied papermaking in Barcelona with Laurence Barker, and in Shiroishi, Japan, with Tadao Endo, after which she established The Paper Workshop (Glasgow) in 1985. Jacki has exhibited and lectured internationally, and her work is represented in collections in the UK and abroad, including the Scottish National Gallery of Modern Art; Edinburgh, The Hunterian, University of Glasgow, Glasgow; British Council, London; and National Gallery of Art, Washington D.C., USA (Paper Conservation Collection). In 2013, she presented a solo exhibition of her work at the Dovecot Gallery, Edinburgh.

Photo: Jean Donaldson
Glasgow Women's Library collection

Ciara Phillips
Advice-giver

Ciara's work was made in response to items found the Library's poster archive. *Don't call me Girl!* by the Chicago Women's Graphics Collective (c.1975), and *It's even worse in Europe* by the Guerrilla Girls (1989), although not cited directly, express an attitude that Ciara brings to bear on her own work. The *Advice-giver* – a toucan that she photographed in 2012, in a city greenhouse in Zürich – suggests that we 'Give a damn', and refers to poster works by one of her admired artists and educators, Corita Kent (1918–86).

About Ciara Phillips
Born in Ottawa, Canada, and currently based in Glasgow, Ciara graduated from Queen's University, Kingston, in 2000, with a Bachelor in Fine Art, and from Glasgow School of Art in 2004, with a Masters in Fine Art.

Screen-printing is at the core of Ciara's practice; printing on paper, textiles and other materials, to form 2D works and installations.

Recent exhibitions include: *There should be new rules next week,* Dundee Contemporary Arts (2013); *And more,* Inverleith House, Edinburgh (2013); *Pull everything out,* with Corita Kent at Spike Island, Bristol (2012); *Start with a practical Idea,* Gregor Staiger, Zürich (2012); and *Zwischenraum: Space Between,* Der Kunstverein, Hamburg (2010). She has upcoming exhibitions at The Showroom, London, and Neues Museum, Nürnberg. She was Artist-in-Residence at Drawing Room, London (2013), and at St John's College, Oxford (2014).

In 2010, Ciara started *Poster Club*, a collaborative artist's project. *Poster Club* has exhibited together at Glasgow Print Studio (2011); Eastside Projects, Birmingham (2011); and Platform, Glasgow (2013).

Lucy Skaer
Cheiron in Type

On her 33rd birthday, Virginia and Leonard Woolf decided to buy Hogarth House, a printing press, and a bulldog that they would name John. It is not known what happened to the bulldog, but in 1917 a hand press and tray of type were delivered to the Woolfs at Hogarth House. Initially thought of as a hobby or therapy to keep Virginia's mind from her work, it soon became key in allowing the pair to publish their own, and their peers', work without being subjected to editor's changes and economic decisions. For Virginia, it also changed her approach to language, as she began to see words as physical entities in themselves.

Cheiron in Type is a photograph of a damaged copy of *Cheiron* by R.C. Trevelyan, published by the Hogarth Press, and printed in 1927. The book is cast into a block with melted-down tin type.

About Lucy Skaer
Lucy Skaer was born in Cambridge, and is currently based in Glasgow where she completed a BA (Hons) at Glasgow School of Art. Lucy has a diverse practice, incorporating almost all forms of production: sculptures, drawings, videos, films and prints, often combined in installations.

In 1997, Lucy co-founded the collaborative group Henry VIII's Wives, and also worked at Transmission Gallery, Glasgow, where she had her first solo show in 2000. In 2003, she was shortlisted for the Becks Futures art prize, and exhibited at the first Scottish presentation at the Venice Biennale, where she also presented in 2007. Her solo presentations include: *Exit, Voice and Loyalty, Tramway, Glasgow (2013); A Proposal for Mount Stuart,* Isle of Bute (2013); *Film for an Abandoned Projector,* Lyric Picture House, Leeds (2011); a mid-career retrospective at the Fruitmarket Gallery, Edinburgh (2008); *The Siege* at Chisenhale Gallery (2008); and a major show at Kunsthalle, Basel (2009), for which she was nominated for the Turner Prize.

Photo: Isla Leaver-Yap

Corin Sworn
Arms!

"A friend suggested that I read *Landscape for a Good Woman*, by the sociologist Carol Steedman. Glasgow Women's Library was the only public library in the city with it in their holdings. So, off I went to borrow that copy.

Steedman examines her own upbringing in working-class London, in order to point out the inadequacies of various theoretical lenses used to study marginal figures. In reflection of her work, *Arms!* plays with layering, to suggest the loss of the specific in amassing the multiple."

About Corin Sworn

Corin Sworn completed a BA in Psychology at the University of British Columbia, Vancouver, in 1999; a Bachelor of Fine Arts at the Institute of Art & Design, Vancouver, in 2002; and a Master of Fine Arts at The Glasgow School of Art, in 2009. She lives and works in Glasgow.

Recent solo exhibitions include: *The Rag Papers*, Chisenhale Gallery, London (2013); Neuer Aachener Kunstverein (2013); Contemporary Art Gallery, Vancouver (2011), Timespan Museum and Arts Centre, Helmsdale, Scotland (2011); *Art Now*, Tate Britain (2011); Tramway (2010); and Washington Garcia for Glasgow International (2010). In 2013 she represented Scotland at the Venice Biennale.

Corin creates atmospheric installations that weave fiction and history through film and objects.

She is represented by Kendall Koppe Gallery, Glasgow, and Blanket Contemporary Inc., Vancouver.

Photo: Luke Fowler

Sharon Thomas
Mary Barbour Monument

"*Mary Barbour Monument* is a limited edition print and research project, developed between 2011 and 2012, triggered from a recent body of work called *Herstory Portrait*, that catalogues powerful women in contemporary Scottish society.

By way of a media campaign, launched on the Centenary of International Women's Day, 2011, as well as research conducted in Glasgow through local people, community groups and Caledonian University Archive's, *Mary Barbour Monument* proposes a city marker to celebrate one of the most influential and powerful women in Glasgow's history. Mary Barbour led the successful and historic 1915 Rent Strike in Glasgow, and was the first female Baillie and Magistrate, so should be remembered and heralded."

About Sharon Thomas

Sharon Thomas is an artist working in Glasgow, with her recent career based between New York and Rome.

A central theme within Sharon's work is that of the role of artist as author, analyst and social dandy; questioning social constructs, their consequential rituals and art's role within them. Using imaginary material, excerpts from her personal history, and the 'real' history of art, Sharon creates fictional narratives that throw light onto these subjects, where institutional power has to dance with the lone lay voice of the individual maker.

Recent exhibitions include: *Mother/mother*, Air Gallery, DUMBO, New York (2009); *(E)merge*, Washington DC, USA (2011); and *Loop*, Tramway, Glasgow (2011). Solo shows include: *Herstory Portrait*, Paisley Museum, Paisley (2012); *Tales of Shiney-Shiney*, The North Wall Arts Centre, Oxford (2009); and *Apotropaic*, Museet fur Religiøs Kunst, Denmark (2009).

Photo: Rosie Healey
Glasgow Women's Library collection

Amanda Thomson
Moneses Uniflora

"The inspiration for the work came from finding a memorial to Mary McCallum Webster in Culbin Forest, and seeing it as part of the *Mapping Memorials to Women in Scotland* project, developed by the Library.

Moneses Uniflora consists of a print and a bookwork. The title refers to the Latin name for the one-flowered wintergreen, which in the UK is a plant found in only a few places in the North-East of Scotland. The wintergreens were the favourite flowers of Mary McCallum Webster, a self-taught botanist who died in 1986, and who wrote *The Flora of Morayshire*.

Moneses Uniflora, in a sense, is a homage to Mary McCallum Webster and women like her: often unknown and overlooked, but rare or special, and worthy of bringing to notice. The collecting and valuing of women's stories and histories is at the heart of Glasgow Women's Library, and is why it is such an important resource."

About Amanda Thomson

Amanda Thomson has a first-class BA (Hons) from Glasgow School of Art, and completed a Master of Fine Arts at the School of the Art Institute of Chicago in 2008.

Her creative practice is idea- and research-led, and fuses traditional and digital printmaking techniques, photography, bookmaking, video, three-dimensional work and installation. As part of current research, her practice has expanded to include walking. Amanda's work is often about how we are located (and locate ourselves) in the world, notions of space and place, and absence or subtle presence.

Recent solo exhibitions include: *A Wheen o' Timmer*, Bakery Gallery, Iowa, USA (2010); *A Bridal o' Craws*, Tent Gallery, Edinburgh College of Art (2010); *Several Forests*, Academy Gallery, Elgin, Morayshire (2010); and *Present/passed*, An Tuireann Arts Centre, Portree, Isle of Skye (2005). She has just completed an Arts practice-led, interdisciplinary PhD.

Photo: Rosie Healey
Glasgow Women's Library collection

Sarah Wright
Horses

"*Horses* takes the Glasgow Women's Library's vast collection of 'zines as its starting point. These modest and seemingly ephemeral objects had a sense of immediacy; an urgency of production that could only happen in the bedroom of a young artist, writer, activist etc., with a do-it-yourself attitude to printing and self-publishing. Their use of photocopying as a means of quick reproduction, prolific use of collage and appropriated imagery resonated closely with methods I often employ in my own work. Rather than working with one 'zine in particular, I used these characteristics to produce a series of prints in a newspaper format.

Horses uses a group of images and motifs that have been circulating within my recent work; photographs are printed, photocopied, scanned, and then reprinted. Painted marks become printed marks and screen-printed shapes mirror previous pages. I'm interested in how these images can move across 'states' in a non-linear fashion, like a Jacob's Ladder toy, setting in motion a process of transferrals from image to object and back."

About Sarah Wright
Sarah Wright graduated in Painting and Printmaking in 2009 from Glasgow School of Art. Working predominantly in printmaking, Sarah has shown widely in Glasgow, including: *Print Process*, The Glue Factory (2013); *Featured Artist*, Glasgow Print Studio (2013); *Costume: Written Clothing*, Tramway (2013); *Showcase: Six by Six*, Glasgow Print Studio (2011); *Black & White*, David Dale Gallery (2010); *Brigadoon*, Southside Studios, Glasgow (2009); and *Drawn Together*, Pentagon Gallery (2009).

The Writers

Karen Campbell
The Colour of Queens

"From the outset, I knew I wanted to write about the suffragettes, as it's such a pivotal point in women's history. I went looking for a banner, sash or something connected to the Women's Social and Political Union. But when I found this brooch, I knew it would be perfect. As I delved into the history, I remembered being told about the colours of the suffragette movement – purple, green and white – and how jewellery like this was worn almost as a secret code.

As I wrote the story, I began to think about the actual craft of making the brooch too, and that led me to incorporate Glasgow School of Art.

The brooch was great at opening up memories for me, but also for leading me to research in more detail things such as when the Art School began admitting women, and how this brought different social classes of women together, in some cases perhaps for the first time."

About Karen Campbell

Karen Campbell was brought up in Glasgow and now lives in Galloway. She writes contemporary fiction, and is a graduate of Glasgow University's Creative Writing Masters degree course.

Before turning to writing, she was a police officer with Strathclyde Police, and has published four novels with Hodder & Stoughton, focusing on the people behind the uniform: *The Twilight Time* (2009); *After the Fire* (2009); *Shadowplay* (2010); and *Proof of Life* (2011).

Using personal insights and experiences gained from her time in the police force, Karen deftly explores modern Glasgow in all its many contradictions, creating an authentic and fascinating depiction of the city.

Her most recent novel, *This is where I am*, a story about a Somali refugee living in Glasgow, was published by Bloomsbury Circus in 2013, and featured on BBC Radio 4's *Book at Bedtime*.

Photo: Rosie Healey
Glasgow Women's Library collection

Anne Donovan
Lassie wi a Yella Coatie

"I started to look through suffragette magazines in the Library and found a letter from 1908, about women in the 'fatal trades', and the terrible conditions of those who worked in the dye trade. Yellow was a particularly dangerous dye as it contained lead. There was a description of the women coming out of their work covered in yellow dust, and the idea of the contrast between the bright and cheerful colour and its hidden danger began to haunt me.

I did more research on different 'fatal trades'. Men as well as women suffered terribly, but the effect on women could sometimes be particularly horrible, as chemicals often caused miscarriages and affected the unborn child. The narrator is a man – something I didn't intend in a story for the Women's Library! – but his voice came, and he was the only one who could tell the story. It was a hard story to write, but sadder still is that this is not something which only happened in the past; all over the world, workers are still dying from the effects of their working conditions."

About Anne Donovan

Anne Donovan is the author of the short story collection, *Hieroglyphics and Other Stories* (2001), and the novels *Buddha Da* (2003) *and Being Emily* (2008); all published by Canongate. Her short story *All That Glisters* won the Macallan/*Scotland on Sunday* Short Story Award, while *Buddha Da* was shortlisted for several awards including the Orange Prize for Fiction, was nominated for the International IMPAC Dublin Literary Award, and won Le Prince Maurice Award in Mauritius. Other stories have been published in anthologies, newspapers, magazines, and online journals. She has also been commissioned to write stories for various organisations, including BBC Radio and the charity Artlink.

Photo: Christina Kernohan
Glasgow Women's Library collection

Margaret Elphinstone
We Thought We Were Going to Change the World

"Looking through the Library's archive, I was inspired to write about my own recollections of second wave feminism. It was a strange experience, examining material that had been so familiar to me at one time, but which I hadn't really looked at in thirty years, and is no longer part of public consciousness in the same way.

Inevitably, looking back at one's youth provokes a degree of nostalgia, but it was interesting to analyse just how much the 1960s' to the 1980s' feminist movement shaped my personal outlook, and indeed, that of my generation. As I leafed through books and magazines in the archive I was struck by how dated their aesthetic now seems. This led me to analyse the aesthetic context of second wave feminism, and how far it reflected what we were trying to express at that time."

About Margaret Elphinstone
Margaret Elphinstone is the author of eight novels, including: *The Gathering Night* (2009); *The Sea Road* (2000); *Hy Brasil* (2002); *Voyageurs* (2003); and *Light* (2006), all published by Canongate; as well as poetry, short stories, literary criticism and two books on organic gardening.

Her fiction is mostly historical, and is characterised by her portrayal of people on journeys to places on the edge – islands, frontiers – where cultures and ideas meet and evolve.

She was closely involved in the feminist movement from the 1960s to the 1980s, and in the Women's Peace movement in the 1980s. She grew up in the south of England, and has lived in Shetland, Galloway, Edinburgh, Glasgow and Moray. She is an Emeritus Professor at the University of Strathclyde.

She has two daughters and five grandchildren, and lives in Galloway with her partner.

Vicki Feaver
Time-Piece

"My poem 'Time-Piece' is about an anti-suffragette clock. What really interested me is that my initial response was to assume it was made to encourage men to take a role in looking after their babies, and in support of women's suffrage. I was really surprised and disappointed to find out that it was the opposite: a piece of anti-suffragette propaganda.

It intrigued me that the clock is evidence of the absurd lengths anti-suffragists went to, in their attempts to frighten men about the possible outcomes of women possessing the vote. Yet, ironically, its message, 'VOTE FOR WOMEN', intended to have the opposite effect, is, in Britain 100 years later, taken for granted. Women have the vote and nominally equal rights. Women have the chance to work in all the areas that men do. Some men are not ashamed to help with the care of children and housework. It's a change brought about partly by brave and pioneering women, but it's also partly due to the effects of time: the hands moving round the face of a clock."

About Vicki Feaver
Vicki Feaver moved from West Sussex to South Lanarkshire in 2000. Previously, she taught creative writing at the University of Chichester, where she is now Emeritus Professor.

She has published three collections of poetry: *Close Relatives* (Secker, 1981); *The Handless Maiden* (Cape, 1994), which won a Heineman Prize and was shortlisted for the Forward Prize; and *The Book of Blood* (Cape, 2006), shortlisted for the Forward Prize and Costa Award. Her poem 'Judith' won the Forward Prize for the Best Single Poem. She has also received a Hawthornden Fellowship, an Arts Council Award, and a Cholmondeley Award.

A central concern of her work is female creativity and its suppression. She uses myths and fairy stories to explore the sexuality and ferocity of women, as well as their nurturing qualities.

Photo: Christina Kernohan
Glasgow Women's Library collection

Helen FitzGerald
Parts Beyond the Skies

"Before I went into the Library, I'd been reading *The Floating Brothel*, about women convicts sent as 'cargo' to Australia in 1789. I'd also been listening to the debate about the poor conditions in Cornton Vale Prison, in Scotland. It made me wonder how much has changed for women in the criminal justice system in the last 200 years.

In the archives, I found a weathered cookery book, the kind my mum passed on to me, with recipes like lentil soup that make you feel safe, happy and at home.

Combine these ideas, and I found myself writing a story about women being transported from Cornton Vale to service workers at an asteroid mine in space. My character takes the recipe book her gran gave her, hoping the warmth and familiarity of it will help her cope in this bizarre and terrifying new environment.

Sounds weird and awful? Yes. Almost as terrible as what happened to those women 200 years ago."

About Helen FitzGerald
Born in Melbourne, Australia, and one of thirteen children, Helen FitzGerald moved to Glasgow in 1991. She works part-time as a criminal justice social worker. She writes emotional, darkly comic and heartbreaking crime fiction for both adults and young adults.

Her adult thrillers include: *Dead Lovely* (Faber and Faber, 2008); *My Last Confession* (Faber and Faber, 2009); *Bloody Women* and *The Devil's Staircase* (both Polygon, 2009); and *The Donor* (Faber and Faber, 2011). Her books have been translated into numerous languages. Her most recent books are the young adult thriller *Deviant* (Soho Teen) and *The Cry* (Faber and Faber), both published in 2013.

Janice Galloway
Woman's Realm

"I got my sex education – at least that of it not learned on the job – from girls' mags. Glasgow Women's Library has an interesting stack of these. Rereading reminded me of one reason why I did not have a properly settled relationship till I was fifty. With regard to that chap? Reader, I married him."

About Janice Galloway

Janice Galloway is author of three novels, three short story collections, two memoir/true novels, and several extended literary works with sculptor Anne Bevan. Her collaborative works include opera libretti, art installation texts, videography texts, song cycles and photographic commentary.

All made up (Granta, 2011) won the Scottish Mortgage Investment Trust Book of the Year, in 2012. It is the second volume of Janice's memoirs, revealing how the awkward child introduced in *This is not about me* (Granta, 2008) evolved through her teenage years, living with her mother and domineering older sister. She is working on a new novel set in Naples that is mostly about boys.

She has undertaken a number of research fellowships and writer in residences, including at four Scottish prisons and the British Library.

She lives in Lanarkshire, Scotland.

Photo: James McNaught

Muriel Gray
Guidance

"I was inspired by so many things I saw in Glasgow Women's Library, but I happened to pick up this pamphlet that was *Guidance for Marriage*, probably dating from the 1950s, maybe a little earlier, full of things that women and men would find preposterous now (for example, about how the woman should make the man comfortable when he comes home), but I went away and I thought about it, and I looked into the history of the Marriage Guidance Council. I now understand that there was a reason for these messages, essentially because war tore families apart, tore society apart. What they were trying to do, in the best altruistic way, was to try and find a way of rebuilding the way that a loving family operates. Those key values of 'Be kind to each other' have translated into today's equal partnerships and gay marriages; into marriage, love and commitment framed in law; a kind of formalised kindness, gentleness, caring and stability.

I've been aware of the Glasgow Women's Library for years and years, and it's just the most brilliant resource. I value their education programmes and support for women, especially around literacy; and for women accessing data and archives it is absolutely outstanding!"

About Muriel Gray

Muriel Gray is an author, broadcaster and businesswoman. Her diverse roles range from Assistant Head of Design at the National Museum of Antiquities in Edinburgh to member of the punk group The Von Trapp Family.

With her trademark bleached hair, sharp wit and opinionated comment, she became familiar as the post-punk presenter of a range of television programmes, including *The Media Show* (1987–89) and *The Tube* (1982). Known for her strongly held views, she writes regularly for various newspapers.

By the late 1990s, Muriel had reinvented herself as a mother and successful horror writer, with books including; *The Trickster* (St Martin's Press, 1994), *Furnace* (Harper Collins, 1997) and *The Ancient* (Harper Collins, 2001). In 2013 Muriel was appointed Chair of Glasgow School of Art's Board of Governors.

Jen Hadfield
Infestation: A Memoir of Pests

"As a remote contributor, I asked librarians at Glasgow Women's Library to mail me a care-package of books that they thought might appeal to me, including – as I remember – titles that might explore foraging for wild food, women in science and oral storytelling. That was an exciting parcel! In a spell of fine weather, I took books a couple at a time onto the hill behind my house. I loved what I came to think of as the 'hippie book', *Living on the Earth*, with its store of truly useful advice on how to build kilns, bake cylindrical loaves of bread in empty tin cans, and create stoves from oil drums. I was particularly interested in the pages that dealt with pests great and small, and it put me in mind of how my indomitable 106-year-old grandmother, and other 'older' ladies I've known, have a special hatred of mice. For many women of a certain generation, a mouse in the house was a practical indictment on their moral cleanliness. To put it in context: my gran has camped often and with relative equanimity in the company of bears, but I've seen her crouch in her nightie in the kitchen with a cast-iron frying pan in her hand, waiting for a mouse to venture out from inside a cupboard. I wanted to write something that would poke at our special horror of vermin..."

About Jen Hadfield

Jen Hadfield was born in Cheshire, and is a poet and visual artist. She studied English Language and Literature at the University of Edinburgh and is a graduate of Glasgow University's Creative Writing Masters degree course.

She is the author of two poetry collections, *Almanacs* (2005) and *Nigh-No-Place* (2008) both published by Bloodaxe Books. Many of the poems in *Nigh-No-Place* are inspired by the landscape of Shetland, where she lives, and also by her travels across Canada. It was shortlisted for the Forward Poetry Prize (Best Poetry Collection of the Year), and won the 2008 TS Eliot Prize. In 2012 she won the Edwin Morgan International Poetry Prize. Her third poetry collection is *Byssus* (Picador, 2014).

Jackie Kay
Ingrid McClements' Papers; Model House, Glasgow and *Undercoat, Model House, Glasgow*

"I was surprised to come across Ingrid McClements' papers. Ingrid was a friend of mine, and finding her in the Library was an extraordinary experience. It made me think that the conversation with the dead can continue in some way, through their interests, through what they have left behind. The archive then becomes something that can seem as if it brings the dead back to life; I could imagine, without much effort at all, Ingrid reading *Off our Backs* [a widely circulated feminist newsletter] in her lunch hour. It made me think of the importance of keeping things, of passing your beliefs down. I wrote the poem 'Ingrid McClements' Papers' thinking of her son and daughter, and also of the children they might have, and how those children might come to get to know their absent grandmother in the presence of Glasgow Women's Library.

Secondly, I was moved by the model house. It made me think of how we carry homes within us, from far and wide.

I was particularly struck, too, by the expression on the women's faces when painting the undercoat of the house, seen in the photographs of the process. They looked so joyous; as if they had, in the making of the model house, got something essential back. It made me think of how archives can bring memories to life. And in that way, all three of the poems are connected. I wanted to write two poems about the model house: the one an undercoat of the other, and to use the language that the women might use themselves of the objects in the house; and in the other to try and explore the themes behind the house, the recovery of memory the way in which one's homeland can take on a visionary, imaginary power."

About Jackie Kay

Jackie Kay was born and brought up in Scotland. *The Adoption Papers* (Bloodaxe, 1991) won the Forward Prize, a Saltire prize and a Scottish Arts Council Prize. *Darling* (Bloodaxe, 2007) was a Poetry Book Society choice. *Fiere* (Picador, 2011), her most recent collection of poems, was shortlisted for the Costa award. Her novel *Trumpet* (Picador, 1999) won the *Guardian* Fiction Award, and was shortlisted for the IMPAC award. *Red Dust Road*, (Picador, 2010) won the Scottish Book of the Year Award and the London Book Award, and was also shortlisted for the JR Ackerley prize. She was awarded an MBE in 2006, and made a fellow of the Royal Society of Literature in 2002. Her book of stories *Wish I was here* (Picador, 2011) won the Decibel British Book Award.

She also writes for children and her book *Red Cherry Red* (Bloomsbury, 2007) won the Clype award. She writes extensively for stage and television. In 2013, *Reality, Reality,* was published by Picador, and her production of *The Maw Broon Monologues* was staged at the Tron Theatre, Glasgow. She is Professor of Creative Writing at Newcastle University.

Photo: Denise Else

A. L. Kennedy
Stitches

"When I looked through the material – and possibly even before – I knew that I wanted to focus on one of the areas of crime which can still be ignored or minimised, because it happens primarily to women. Violence and sexual violence to women, or the threats of those types of violence, are utterly inexcusable and it's the sign of a civilised and mature country when they are seen as such, and prosecuted as such. When I saw the knitting patterns I knew I wanted to combine knitting – something that is also very much associated with women – with a history of domestic violence. I wanted to blend something that's to do with care and comfort and physicality with something which is physically brutal, but also 'domestic', as if that somehow sets it on a smaller, unimportant scale; as if being mugged by a stranger on the street is less horrifying than being mugged in your own home, by someone you have to live with, and who spends time near your children."

About A. L. Kennedy

A. L. Kennedy is the author of novels, collections of short stories, non-fiction books, stage plays, television scripts, a motion-picture screenplay, and numerous journalistic pieces.

She has won a number of awards, nationally and internationally, including the Encore Award, the Austrian State Prize for International Literature, a Lannan Literary Award and the Costa Prize. She holds honorary D.Litt. degrees from the University of Glasgow and the University of St Andrews.

Her most recent novel, *The Blue Book* (Jonathan Cape, 2011), is an extraordinary story of love, loss and the act of deception, and in 2013, *On Writing* was published by Jonathan Cape, bringing together extracts from her popular blog, alongside essays on character, voice, writers' workshops and writers' health.

She also performs as a stand-up comedian at the Edinburgh Fringe, comedy clubs and literary festivals.

Photo: Campbell Mitchell

Kirsty Logan
This is Liberty

"I saw the cover of LungLeg's album *Maid to Minx*, featuring a badass lady wrestler in a skull-and-crossbones cape, and I remembered Graham Rawle's book *Woman's World*, a novel made entirely from cut-out words. Why write a regular short story, I thought, when I could use this chance to do something a bit different? I decided to 'write' a story about a female prizefighter from cut-out words: somewhere between fiction and visual art.

I spent a joyful few days immersed in the Library's archives, photocopying pages from various 1950s' artefacts: women's fashion magazines, girls' annuals and traditional Scottish recipe books.

Next, I cut out many, many words and began sorting them into categories, then gave up on the organizing and jumped right into trying to make a story. The final product was four sheets of A4, made entirely of 1950s' magazines, telling the story of a female fighter. I'm not a badass lady wrestler, but if I were I'd like to think I'd be like the one in the story."

About Kirsty Logan

Kirsty Logan writes fiction, edits literary magazines, teaches creative writing, writes a column, reviews books and performs regularly at events around Glasgow and beyond.

Her short fiction has been published in around eighty anthologies and literary magazines, and broadcast on BBC Radio 4.

Her first novel, *Rust and Stardust,* is a dark fairy tale about grief, love and growing up, and was shortlisted for the 2012 Dundee Book Prize. Her short story collection, *The Rental Heart and Other Fairytales,* will be published in 2014, by Salt. She is currently working on a second novel, *The Gracekeeper,* about a circus boat in a flooded world.

She has a semi-colon tattooed on her toe, and lives in Glasgow.

Laura Marney
Mango

"I have taken as my inspiration for my piece the novel *The Poisonwood Bible* by Barbara Kingsolver, and the poem 'Meadowsweet' by Kathleen Jamie.

There is some dispute regarding the death toll in the Democratic Republic of Congo from the ongoing wars. Some estimates are as low as 2.5 million and some are as high as 7 million. Who to believe? And did I just say 'as low as 2.5 million?'

Stalin said: 'The death of one man is a tragedy, the death of millions is a statistic'. So, sticking with story and anecdote, I have written a monologue from the point of view of a young woman who lives in war-torn North Kivu, in the Democratic Republic of Congo. To reinforce the universality of her situation, I've decided to render her voice as that of a Glaswegian woman."

About Laura Marney

Laura Marney is the author of four novels: *No Wonder I take a Drink* (Black Swan, 2004), *Nobody loves a Ginger Baby* (Black Swan, 2005), *Only Strange People go to Church* (Black Swan, 2006) and *My Best Friend has Issues* (Saraband, 2012). She was awarded a writer's bursary from Scottish Arts Council, in order to concentrate on writing her second novel. She has had short stories and plays published in magazines and broadcast on radio. Originating from Glasgow, her tales are dotted with the vibrant language of the city. Although her books are not all set in Glasgow, they are filled with the spirit of the place.

Laura graduated from the Creative Writing Master's degree course, run by Glasgow and Strathclyde Universities, and currently holds a part-time post at Glasgow University. She is poised to publish her fifth novel in Spring 2014.

Heather Middleton
Jigsaw of Doom

"My inspiration was girls' annuals in the Library's collection, particularly the comic strips. The collection includes annuals dating from the 1960s, similar to the ones I read second-hand as a child, alongside my subscriptions to contemporary weeklies such as *Jinty*, *Misty*, *Spellbound* and *Tammy*. I remember enjoying both the continuities and the differences.

'Jigsaw of Doom' is my affectionate take on the ludicrous plot set-ups typical of girls' comics, their predictability (captions often plonkingly recap exactly what is shown in the panel), masochism, outrageous comeuppance, and cruelty, often more mental than physical.

I tried to recreate the characteristic duotone colour scheme, inking, and typeface of such comics, as well as the uneven saturation of ink on newsprint. The comic was conceived in small thumbnails then scripted, before being pencilled and inked, using a traditional dip pen and India ink, and coloured and captioned in Photoshop. I took timer photographs of myself enacting all the poses as source material."

About Heather Middleton

Heather Middleton is a cartoonist and illustrator. At university she studied both Art History and English, as she didn't want to choose between words and images. She loves the gigantic, stretchy medium of comics, which can hold everything from a one-panel gag to an analysis of Middle-Eastern politics.

Her 'zines include *Honeypears* and an autobiographical irregular monthly comic, *Period*. She is a regular contributor to the Glasgow-based *Team Girl Comic* anthology. Her work has been exhibited in *Comic Book Queens* at Spike Island, *Between the Covers: Women's Magazines and their Readers* at London Women's Library, and *Telling Stories* at Glasgow's Market Gallery. Recently, she toured an illustrated lecture, about the history of women in the comics industry, round Wigtown Book Festival and other venues.

Photo: Rosie Healey
Glasgow Women's Library collection

Alison Miller
An Innocuous Tale of Love and Romance

"I visited the Library a few times for this project, getting a sense of what was on the shelves and in the archives. What struck me very forcibly was how many of the writers and women, connected with publishing and political action, are friends of mine, or known to me personally: *Grit and Diamonds, Hens in the Hay, Stramullion, The Poetry Cure, Trumpet*; Usha Brown, Anne-Marie McGeoch, Cynthia Fuller, Julia Darling, Jackie Kay, and many more... My first effort was a poem that highlighted these connections, but I wasn't satisfied with it.

A short story then began to insinuate itself into my head. If I tell you its source, it will spoil the story! Let me just say that the piece takes as inspiration an image and a book that I spotted in the Library lending collection. Both are iconic in the history of twentieth-century feminism. Imagine these icons turning up in Orkney in the early 1970s, into the life of a teenage girl. That is the basis of the story."

About Alison Miller
Alison Miller was born and grew up in Orkney and, after attending Aberdeen University, lived in Glasgow for many years. In 2003, she completed the Creative Writing Master's degree from Glasgow and Strathclyde Universities. Her first novel, *Demo*, published in 2006 by Penguin, was shortlisted for the Saltire First Book award. She has had stories anthologised and broadcast on BBC Radio 4.

She has worked extensively with community groups, the Workers' Educational Association, and Glasgow's Centre for Women's Health.

In 2012, she was appointed Reader in Residence at Orkney Library and Archive, and has moved back to Orkney, where she is finishing her latest novel.

Photo: Rosie Healey
Glasgow Women's Library collection

Denise Mina
Ernest Hemingway's Third Wife

"This story came from two visits: one to the Library and one to Geneva.

It struck me how lucky I was to live in Glasgow, near a lot of other women like me, and most women can't assume other people cherish women's unique and hidden history. For me, the Library is a constant reminder that I'm not alone, and I don't need to say 'sorry' every five minutes. There were others before, there will be others after, and we could raise an army if we needed to. Get in!"

About Denise Mina
Denise Mina was born in Glasgow. She writes crime fiction and graphic novels. Her ten novels include: the *Garnethill Trilogy* (Transworld, 1998–2011); *Sanctum* (Orion, 2012); the *Paddy Meehan* books (Orion, 2011–12); and the *Alex Morrow* series (Orion, 2010–13). Her graphic novels include: *Hellblazer* (2006–7); *A Sickness in the Family* (2010); and an adaptation of *The Girl with the Dragon Tattoo* (2012–13), all published by DC Comics. She writes plays and short stories too.

With Glasgow as her backdrop, Denise's writing is violent, graphic and harrowing, offset by strong, compassionate female characters and an irrepressibly dry wit.

She has won a number of awards, including the Crime Writers' Association John Creasy Dagger for the best first crime novel, for *Garnethill*, and the Theakston's Old Peculier Crime Novel of the Year 2012, for *The End of the Wasp Season*.

Donna Moore
The Mouse's Umbrella

"There is so much wonderful and fascinating history in the archive boxes at the Library that it was a tough choice. In the end, I picked a Victorian umbrella stand, slightly the worse for wear, given to the suffragettes in Duke Street Prison by a governor who was sympathetic to their cause. When Duke Street Prison was being demolished in the 1950s, a social worker that used to visit the prison was walking past and saw the umbrella stand poking out of a skip. She rescued it, and eventually it found its way to the Library.

I immersed myself in the collection to get background information on the Cat and Mouse Act, force-feeding and life in prison at that time, as well as stories of some of the brave women who fought for my right to vote. Most of the stories are of middle- and upper-class women, but working-class women did play a big part in the suffrage movement, and I wanted to show both sides. Florence Crossman isn't a real person, but the story of what happens to her is based on an amalgam of several suffragette histories. Florence Crossman is my grandmother's name. She, too, was a feisty, brave woman, and would have approved of the actions of the character in the story."

About Donna Moore
Donna Moore is the author of *Go to Helena Handbasket* (Wildside Press, 2007), a spoof private-eye novel that won the Lefty Award in 2007, for the most humorous crime fiction novel, and *Old Dogs* (Max Crime, 2010), a caper set in Glasgow and featuring two elderly con artists, and nominated for both the Lefty and the Last Laugh Awards in 2011. She is currently writing a screenplay. Donna teaches creative writing and is Writer in Virtual Residence for the Kuspuk School District in the Alaskan Bush. She completed a Masters degree in Community Learning and Development in 2012, and now works as the Adult Literacy and Numeracy Development Worker at Glasgow Women's Library. Online, she runs the blog *Big Beat from Badsville*, focusing primarily on Scottish crime fiction.

Elizabeth Reeder
everyday wintergreen

"My short story 'everyday wintergreen' emerged from discussions with the artist Amanda Thomson about a memorial in Culbin Forest, dedicated to a female botanist, Mary McCallum Webster. Having found the book *The Women of Moray* at the Library, as well as Webster's book on *Flora and Fauna*, Amanda and I also visited the Elgin Museum, and searched out some of her notes and pressed flowers.

We walked through Culbin Forest, near Forres, looking for Webster's memorial and also searched for, and found, the wintergreen flowers that had been her favourite, both common and rare. The story takes Mary McCallum Webster's life as a starting point, but is definitely fiction, and moves to consider these everyday and common objects, and people that might just be, if you pay attention, extraordinary."

About Elizabeth Reeder
Elizabeth Reeder is originally from Chicago and has lived in Glasgow for over fifteen years. She writes fiction, lyrical essays, poems, cross-over pieces, as well as some travel writing and writing for radio. In 2012, she published two novels, *Fremont* (Kohl) and *Ramshackle* (Freight Books).

She finds the process of writing continually fascinating, and is a firm believer in muscular, crafted writing that is clear and simply complex, in a way that invites the reader in. Recently, she's been exploring families, civic responsibility, illness and our responses to change and crisis.

She has an MSc from the University of Edinburgh in Modernism, Gender and Writing, and a PhD in English Literature (Creative Writing) from the University of Glasgow, where she now teaches on the Creative Writing Programme. She is currently writing her third novel.

Leela Soma
Boxed In

'*Boxed In*' is a short story set in a small village in South India. It follows the life of a young girl, Devi, who works in a Safety Matches factory— a cottage industry that still exists in India. The story was inspired by reading about Annie Besant in the books at the Glasgow Women's Library, and her fight for improving the conditions of work of the young girls at the Bryant May factory in 1888. A hundred odd years on, the same exploitation of children continues in India, despite many Government laws against child labour. Has Devi's life improved now? Read the story to find out!

About Leela Soma
Leela Soma writes short stories, novels, and poetry. She lives in Glasgow, where she worked as a Principal Teacher of Modern Studies.

Her first novel *Twice Born* (You Write On, 2008) won the Margaret Thomson Davis Trophy for Best New Writer 2007. Her second novel, *Bombay Baby* (Dahlia Publishing, 2011) is a tale of identity, motherhood, sibling rivalry and family secrets. An e-book of short stories has been published by The Pot Hole Press in 2013.

She is a member of the Milngavie Book, Art and Music Festival Committee, and the Scottish Writers' Centre Committee. Her articles, poems and short stories have been published in a number of magazines and journals, including *Gutter*.

Her work reflects her experiences as a first generation Indo-Scot.

Zoë Strachan
Anyone Who Had a Heart

"Zoë and me, Louise and I, have collaborated on short stories and a play before and knew that we wanted our *21 Revolutions* contribution to be a joint piece of work. The *Girls' Questions Answered* leaflet spoke to us of a coming of age that had to be faced coyly and alone. We imagined a young girl approaching puberty in the highly gendered world of the 1970s, and discovering that her sexuality was more fluid than the world around her suggested it should be.

In the 1970s, girls and boys hung posters of their pop idols up on their bedroom walls. Susan's friends are obsessed with Donny Osmond and David Essex, but Susan's pin-up is Dusty Springfield.

We employed the cut-up technique made famous by William Burroughs, taking a collage of extracts from *Girls' Questions Answered*, interviews with Dusty in the *NME* (1968) and the *Evening Standard* (1970), and adding our own narrative. The title comes, of course, from one of Dusty Springfield's most popular recordings, 'Anyone who had a Heart', written by Burt Bacharach."

About Zoë Strachan
Zoë Strachan is the author of three novels: *Ever fallen in Love* (Sandstone, 2011); *Spin Cycle* (Picador, 2004); and *Negative Space* (Picador, 2002). She also writes short stories, plays, essays and libretti, most recently for *The Lady from the Sea*, an opera composed by Craig Armstrong, and based on the play by Ibsen.

Ever fallen in Love is a visceral story about what happens when you fall in love with someone you shouldn't have. Like much of Zoë's work, it is concerned with memory, and the ways in which people tell and retell their stories, as they try to make sense of their lives. It was shortlisted for the Scottish Mortgage Investment Trust Book Awards and the Green Carnation Prize, and nominated for the London Book Awards.

Zoë is proud to be one of the Board of Directors of Glasgow Women's Library.

Photo: Rosie Healey
Glasgow Women's Library collection

Louise Welsh
Anyone Who Had a Heart

About Louise Welsh

Louise Welsh is the author of five novels: *The Cutting Room* (Canongate, 2002); *Tamburlaine must die* (Canongate, 2004); *The Bullet Trick* (Canongate, 2006); *Naming the Bones* (Canongate, 2010); and *The Girl on the Stairs* (John Murray, 2012). Her new book, *A Lovely Way to Burn* will be published by John Murray in April, 2014. She has written many short stories and articles, and presented over twenty features for BBC Radio. She has also written libretti for opera, including *Ghost Patrol* (music by Stuart MacRae), the production of which won a Southbank Award and was shortlisted for an Olivier Award (2013).

Louise was Writer in Residence at The University of Glasgow and Glasgow School of Art between 2010 and 2012. She has received many awards and international fellowships, most recently an honorary fellowship from the University of Iowa's International Writing Programme.

She lives in Glasgow with the writer Zoë Strachan.

Photo: Steve Lindridge, idealimages.co.uk

Zoë Wicomb
Writing Lesson

"'Writing Lesson', as a tribute to the Glasgow Women's Library, references the celebration of women's writing and publishing. In the archives of the Library I found *A Plain Cookery Book for the Working Classes* with a recipe for toast water, which I include in my story, and also use to establish self-reflexivity. Other references to books in the library include Lily Briscoe's tree, which she moves at the dinner party in *To the Lighthouse*, Virginia Woolf (1927) and Toni Morrison's *Jazz* (2004): an adaptation of the last lines, which I cite at the end of my story."

About Zoë Wicomb

Zoë Wicomb is a South-African writer of fiction and criticism. Her works include *You can't get lost in Cape Town* (Virago/The Feminist Press, 1987); *David's Story* (The Feminist Press, 2002); *Playing in the Light* (New Press, 2006); and *The One That Got Away* (New Press, NY/Five Leaves Publications, 2011). Her forthcoming novel, *October*, will be published in early 2014 (New Press).

Zoë is Emeritus Professor in the Department of English Studies at the University of Strathclyde, and, in 2013, was awarded the inaugural Windham-Campbell Fiction Prize.

Photo: Rosie Healey
Glasgow Women's Library collection

The Essay Contributors

Dr Fiona Bradley

Dr Lesley McDowell

Fiona Bradley has an MA in art history from Cambridge University and an MA and PhD from the Courtauld Institute, London, where her research was in surrealism and blasphemy. She started her professional career at Tate Gallery Liverpool, where she made exhibitions with, among others, Rachel Whiteread, Andreas Gursky, Paula Rego and Susan Hiller, and the Hayward Gallery, London, where she co-curated Douglas Gordon's major solo exhibition 'what have I done'. She has been Director of The Fruitmarket Gallery in Edinburgh since 2003, where she has curated exhibitions and produced important publications with Scottish and international artists including Louise Bourgeois, Ellen Gallagher, Cai Guo-Qiang, Fred Sandback, Eva Hesse, Bill Bollinger, Callum Innes, Christine Borland, Tony Swain, Martin Creed, Claire Barclay, Lucy Skaer and Gabriel Orozco. She was a member of the Turner Prize and the Paul Hamlyn Award juries in 2007, and in 2011 was the curator for Scotland's contribution to the Venice Biennale.

Photo: Sally Jubb

Lesley McDowell is an author and literary critic based in Glasgow. After completing a PhD on James Joyce and Feminist Theory at the University of Glasgow, she taught in the English Literature Department at St Andrews University, before turning to full-time literary journalism. She has reviewed for many newspapers, including the *Glasgow Herald*, *The Scotsman*, the *Independent on Sunday*, *The Guardian* and the *Times Literary Supplement*. Her first book, *The Picnic*, was published in 2007 by Black and White publishing, and her second, *Between the Sheets: The Literary Liaisons of Nine 20th Century Women Writers*, a feminist take on some of the most notorious literary partnerships, was published in 2010 in the UK and the US by Gerald Duckworth & Co Ltd. She has won two writers' awards from Creative Scotland, and has been shortlisted in *The Scotsman* and Orange Short Story Awards and The Scottish Mortgage and Investment awards. Her latest book, *Unfashioned Creatures* (Saraband, 2013), is a historical novel about Isabella Baxter Booth, the Scottish childhood friend of Mary Shelley.

Photo: Bob McDevitt

Dr Adele Patrick

Adele studied at Glasgow School of Art in the 1980s. She taught Gender, Art and Culture Studies in the Historical and Critical Studies Department at the GSA and gained a PhD in Media Studies in 2004 at the University of Stirling. Her research focus was on 'feminine excess' and the convergence of femininity, feminism, class and race. She has been involved in research and academic and community learning and teaching on gender for over 20 years. Adele co-founded Women in Profile (in 1987) and subsequently Glasgow Women's Library (in 1991) and is currently GWL's Lifelong Learning and Creative Development Manager. She has been active in a wide range of feminist and women's projects, contributes to publications and regularly speaks at national and international conferences on art, gender, equalities, learning and libraries. She is a Fellow of the Royal Society of Arts.

Photo: Jean Donaldson
Glasgow Women's Library collection

Glasgow Women's Library Collection and *21 Revolutions* Sources

The Glasgow Women's Library lending, museum and archive collections are unlike any other. The richness and variety of the material is reflective of both the diversity of donors and the many women who find support, inspiration, friendship and widened horizons on their visits.

The archive and museum collections comprise local, national and international holdings, from records of national organisations, such as the publications of the Equal Opportunities Commission and the Scottish Abortion Campaign collection, to personal papers of activists. Housed within hundreds of archive boxes are a variety of items including letters, diaries, manuscripts, posters, pamphlets, newsletters, journals, artworks, postcards, badges, jewellery, banners, oral history recordings, t-shirts and other artefacts and ephemera.

Every book, archive or museum item has been donated by individuals or groups; entrusting the Library with its safekeeping and knowing that it will be valued and used. Second wave feminism distilled the idea that many aspects of women's lives have been lost and neglected in traditional historical records and institutions; that, generally, women's role in history is not taught, their achievements not remembered and their contributions to culture and creativity not collected. Glasgow Women's Library is the sole library and archive in Scotland with the specific aim of addressing this inequality, focussing on women's contributions and role in culture and celebrating women's many achievements.

All are welcome to visit Glasgow Women's Library and browse the shelves or handle the objects in its care, which range from suffragette jewellery to roller derby bout programmes, cookery books and *Vogue* knitting patterns. The lending library complements and gives further depth to the works to be found in the mainstream libraries, comprising as it does thousands of texts by women that have the potential to change women's lives. The team at the Library seek to record the memories behind many of the items that are donated, whether a badge or pamphlet, poster or academic manuscript. We do this through oral and video history gathering, ensuring the context of many of the items and their broader historical significance is captured.

The collections are used outside the GWL space in exhibitions and workshops with local communities, with women's and other groups and in collaborations with partner organisations across Scotland.

Although we are focusing on a few different categories in relation to sources used by artists and writers in this publication, this is just a taste of what the lending library, archive and museum collections have to offer. The lending library is home to thousands of books reflecting the breadth, strength and diversity of women's lives and achievements, covering over twenty main subject areas, including Women in an International Context, Women and Politics, and Women and Religion, Spirituality and Philosophy. The artists and writers involved in the *21 Revolutions* project sourced material in broadly the following thematic areas: the suffragette movement, fine art and literature, history and social history, second wave feminism, activism, autobiography and biography, craft, cookery and textiles, sexuality and the Lesbian Archive collection, popular culture and the National Museum of Roller Derby collection[1]

1. Each object in this section is numbered from one to sixty four. Specific numbers then appear next to each of the works by artists and writers, correlating to objects in this section and denoting where that artist or writer has used the object in their research process and as a source of inspiration.

The Suffragette Movement

The British suffragette campaigns are a gateway into understanding women's rights achieved in the late nineteenth, twentieth and early twenty first centuries. In newspapers, ephemera, postcards and artefacts our collection records landmarks of the suffrage movement: Emily Wilding Davis and her martyrdom at Ascot; the Gude Cause march in Edinburgh (and its centennial re-enactment in 2009); Emmeline Pankhurst's rousing visits to Glasgow Green. The strength of the collection lies in ephemera and the prosaic; a piece of suffragette jewellery with its colour coded message of solidarity; *Panko!*, a card game played by the light of gas lamps that has a dash of grim humour; *Jus Suffragii*, a suffragist newsletter bringing news from across the globe.[2] GWL's suffragette and anti-suffragette artefacts and ephemera provided fuel for the imagination for several of the *21 Revolutions* writers and artists and are among the most consistently popular of our museum and archive collections.

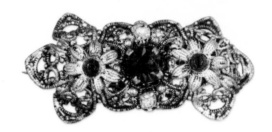

Suffragette Brooch (1)
c.1900s

Artefact

The three colours adopted by the suffragettes are used in the design of this brooch – green (hope), purple (dignity) and white, here represented by silver (purity).

The Suffragette Movement: (2)
An Intimate Account of Persons and Ideals
by E. Sylvia Pankhurst, 1977

Book

This is a fascinating memoir of the Pankhursts, one of the most extraordinary British political families of the last hundred years. It chronicles how the women of Britain won the vote, and tells of Sylvia Pankhurst's harrowing personal experiences of imprisonment; hunger, thirst and sleep strikes; and forcible feeding.

Copyright: Virago, an imprint of Little, Brown Book Group

2. The artist Claire Barclay, who used this as a source, drew our attention to a review she discovered in *Jus Suffragii* of Virginia Woolf's *A Room of One's Own*

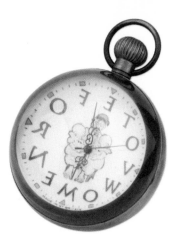

Anti-suffragette Clock (3)

c.1900s

Artefact

An anti-suffragette clock satirising the argument that men would have to take on childcare if women were granted the right to vote.

Umbrella Stand (5)

c.1900s

Artefact

This umbrella stand, donated by a supporter of Glasgow Women's Library, was rescued from outside Duke Street Prison, Glasgow, and is reputed to have been painted in the suffragette colours by imprisoned suffragettes for the (pro-suffrage) Governor's office.

Photo: Tian Khee Siong

Traitors to the Masculine Cause:
the Men's Campaign for Women's Rights (4)

by Sylvia Strauss, 1982

Book

The male campaigns for women's rights were part of a humanitarian movement that embraced all oppressed groups, and these male feminists made women's rights a criterion for judging humankind's progress. In the larger context, they were dissidents against patriarchal authority in government, religion, economics and the family itself.

Copyright: Sylvia Strauss, London, Greenwood 1982

Jus Suffragii (6)

1928

Publication

The International Women's suffrage Alliance, *Jus Suffragii* was an American monthly publication that was distributed in Britain and beyond. Founded in 1909, it was packed with news and comments from across the world and continued printing under this title until 1939. In 1949, the publication was rebranded as *International Women's News* and remained in print until 1991.

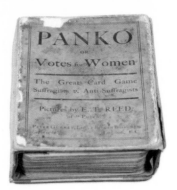

Panko! (7)

1911

Artefact

A satirical card game featuring male politicians against the suffrage cause alongside suffragettes Christabel and Emmeline Pankhurst, as well as a lone female piper.

The Woman Worker (9)

1908

Publication

Set up by Mary MacArthur, a suffragette and part of the Trade Union Movement, this monthly British publication examined issues affecting the working woman, including the dangers faced by those working in dye making factories.

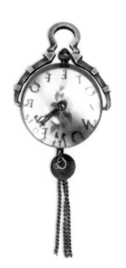

Suffragette Pocket Watch (8)

c.1900s

Artefact

The yellow roses in the centrepiece of this pocket watch were adopted by the American suffragettes to promote their cause. Yellow roses can also symbolise friendship.

Fine Art and Literature

Glasgow Women's Library benefits from donations of monographs, catalogues and related publications from artists, collectors and galleries. For example, in 2010 Faith Wilding and *21 Revolutions* contributor Kate Davis collaborated on *The Long Loch: where do we go from here?* [3] GWL provided a pop-up library resource at the exhibition augmented with a wide range of specially sourced feminist (art) texts. Subsequently, these new texts were generously donated by the artists to the GWL Art collection. [4] Biographies of women artists, catalogues and feminist art theory form the basis of the Art section of the lending and reference library collection, while a small body of paintings, drawings, ceramics and fine art and agit-prop prints are housed in the archive alongside each of the *21 Revolutions* prints.

Women's literature is at the heart of the Library's lending collection. The Library holds many 'classics' by writers including Virginia Woolf, Jane Austen and Elizabeth Gaskell, 'rediscovered classics' published by Virago, and feminist fiction published by The Women's Press. Classic works of feminist fiction, such as *The Women's Room* by Marilyn French, *The Color Purple* by Alice Walker and *The Handmaid's Tale* by Margaret Atwood, remain perennially popular and thought provoking. Work by writers such as Jackie Kay, Janice Galloway, Liz Lochhead and Jessie Kesson reflect the diversity and richness of Scottish women's writing. The Library's literature section is extremely well used including in the GWL Learning team's development of bibliotherapy for women and the Library's broader *Reading for Wellbeing* work.

Georgia O'Keefe: Art and Letters ⑩
by Jack Cowart and Juan Hamilton, 1987

Book

One of the most significant artists of the 20th century, Georgia O'Keeffe (1887-1986) was devoted to creating imagery that expressed what she called 'the wideness and wonder of the world as I live in it.' The imagery of her work is now considered integral to the history of American Modernism.

Copyright: Board of Trustees, National Gallery of Art, Washington, 1987

It's Even Worse in Europe ⑪
Guerrilla Girls, 1986

Poster

The self-styled 'Conscience of the Art World', this US based group critiqued the guardians of art and associated institutions for their lack of acknowledgement of artists who were women and/or people of colour.

Copyright: Guerrilla Girls

3. At Glasgow's Centre for Contemporary Arts, for the Glasgow International Festival of Visual Arts.

4. These texts, nominated by a wide range of international contributors, were developed by Wilding and Davis into a reading list, book group programme and an online resource, *Feminist Lines of Flight*, accessible on the GWL website.

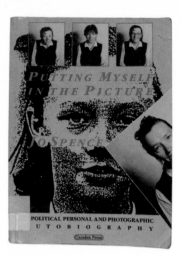

Putting Myself in the Picture: A Political, Personal and Photographic Autobiography
by Jo Spence, 1986

(12)

Book

Jo Spence (1932-1992) was a British photographer, socialist and feminist. This book is based on her 'Review of Work', a retrospective exhibition in 1985 which covered her career from high street photographer to her very personal experience as a breast cancer patient. This book very much embodies Jo's belief that photography should be used by everyone for enlightenment and self-knowledge – for putting themselves in the picture.

Copyright: Terry Dennett

The Dinner Party: From Creation to Preservation
by Judy Chicago, 2007

(13)

Book

Judy Chicago pioneered feminist art and art education in California in the early 1970s. Her monumental work of art *The Dinner Party*, conceived as a symbolic history of women in Western civilisation, was first exhibited in 1979 and since then has attracted over one million visitors.

Copyright: Judy Chicago, 2007

The Poisonwood Bible
by Barbara Kingsolver, 1998

(14)

Book

This critically acclaimed novel tells the remarkable but tragic story of the wife and four daughters of a fierce evangelical Baptist, who takes his family and mission to the Belgian Congo in 1959.

Copyright: Barbara Kingsolver, 1998. Used by permission of Faber and Faber

To the Lighthouse
by Virginia Woolf, 1927

(15)

Book

Considered to be one of the greatest literary achievements of the 20th century, this is the most autobiographical of Woolf's novels. Through her fascinating character Mrs Ramsay, Woolf explores adult relationships, marriage and the changing class-structure in the period spanning the Great War.

Copyright: Used by permission The Random House Group Limited

Jazz ⑯

by Toni Morrison, 1992

Book

Evoking the world of black Harlem in the 1920s and the birth of jazz, this tale of an ageing man who kills his young lover is an exploration of love, obsession and tragedy. Toni Morrison was the first African-American to win the Nobel Prize for Literature, and has also won the Pulitzer prize.

Copyright: Toni Morrison, 1992. Used by permission The Random House Group Limited

Herland ⑰

by Charlotte Perkins Gilman, 1979

Book

This utopian novel from 1915, written by feminist Charlotte Perkins Gilman, describes an isolated society composed entirely of women. It first appeared as a serial in *Forerunner*, a magazine edited and written by Gilman, and was not published in book form until 1979.

Copyright: The Women's Press. Used by permission of Quartet Books

Egalia's Daughter ⑱

by Gerd Brantenberg, 1985

Book

This is Brantenberg's most famous novel, first published in 1977. In the land of Egalia, gender roles are topsy-turvy as 'wim' wield the power and 'menwim' light the home fires. The novel poses the provocative question of whether the culprit in gender subjugation is gender itself or power, no matter who wields it.

Copyright: Gerd Brantenberg, 1985. Used by permission of Pluto Press, London

The Golden Notebook ⑲

by Doris Lessing, 1962

Book

This landmark novel is a powerful account of a woman searching for her personal, political and professional identity amid the trauma of emotional rejection and sexual betrayal. Often described as the 'bible' of Women's Liberation, it is also a political tract and a story of mental breakdown.

Copyright: Doris Lessing, 1962. Used by permission of HarperCollins Publishers Ltd

The Color Purple ⟨20⟩
by Alice Walker, 1983

Book

Set in America's Deep South between the wars, this novel won the Pulitzer
Prize in 1983. It tells the powerful and moving story of Celie, a young black
woman with a tragic, abusive past who learns how to survive, how to let go
of the past, and ultimately how to love.

Copyright: Alice Walker, 1983. Used by permission of Quartet Books.
This Women's Press edition is now out of print

The Complete Shorter Fiction of Virginia Woolf ⟨21⟩
edited by Susan Dick, 1985

Book

Woolf's forty-six short stories, or 'sketches' as she called them,
demonstrate her fondness for experimenting with narrative forms and
voices. The pieces range from tales with traditional plot lines to denser
interior monologues. This was the first compilation of her short stories.

Copyright: Used by permission of The Random House Group

History and Social History

History and Social History are a significant flank of the Library's lending, reference and archive collections. This broad category describes the mass of texts to be found within our lending library and archive that chart women's cultural and social lives and experiences. Alongside the secondary sources that range from the academic to those created by community and women's groups, books, educational resources and videos we have a wide range of archive and museum artefacts from photographs of munitions factory workers to marriage guidance and sexual health pamphlets. We also house specific organisations' records, including those of the Family Planning Association, all mapping the diverse histories and lives of women.

Red Skirts on Clydeside (22)

1985

Video

Red Skirts on Clydeside, a documentary made by the Sheffield Film Co-Operative, surveys the history of the Govan Rent Strikes of 1915.

Reproduced with thanks to Chrissie Stansfield and Christine Bellamy

She Was Aye Workin': Memories of Tenement (23)
Women in Glasgow and Edinburgh
by Helen Clark and Elizabeth Carnegie, 2003

Book

This book explores the previously hidden lives of the women who held families together and made ends meet in Scotland's crowded urban tenements. It is an eloquent tribute to women's resilience, self-sacrifice and management skills in the face of difficult conditions and relentless poverty.

Copyright: Helen Clark and Elizabeth Carnegie, 2003. Used by permission of White Cockade Publishing

Up Oor Close: Memories of Domestic Life in Glasgow Tenements 1910-1945

(24)

by Jean Faley, 1990

Book

This book brings to light the routines and rituals of tenement living, from housework and shopping to childbirth and death. It highlights the ceaseless labour and ingenuity of women, and the good neighbourliness which was a key to survival in hard times.

Copyright: Jean Faley, 1990. Used by permission of White Cockade Publishing

The Hidden History of Glasgow's Women: The Thenew Factor

(25)

by Elspeth King, 1993

Book

Starting from city's earliest beginnings right up to the 20 century, this book reclaims women's rich and diverse contribution to Glasgow's history. Elspeth King shows us Glasgow through the eyes of, among others, the suffragettes, falsely accused witches and striking factory-workers.

Copyright: Elspeth King, 1993. Used by permission of Mainstream Publishing

Mapping Memorials to Women in Scotland

(26)

2010

Website

This joint project between Glasgow Women's Library and Women's History Scotland aims to capture monuments to women across Scotland, ranging from street names and plaques to statues and buildings.

womenofscotland.org.uk

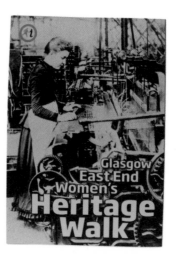

Glasgow Women's Library Heritage Walk Map (one of a series)

(27)

2007–2013

Map and booklet

GWL's Women's History Detectives group uncover, record and create resources that chart the stories of women who are part of Glasgow's history. Their fascinating heritage walks are a popular part of GWL's events programme.

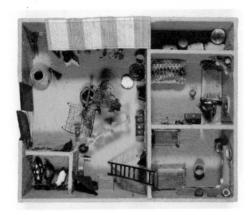

Model House

2008

Artefact

Glasgow Women's Library and artist Sadia Gul Ibrahim worked with a group of South Asian women to recreate a composite model of the homes they left behind when they migrated to Scotland. This piece is used as an outreach learning and reminiscence tool by Glasgow Women's Library.

Photo: Tian Khee Siong

(28)

Women of Moray

by Susan Bennett et al, 2012

Book

This book captures the tales of over seventy inspirational women from Moray, including the botanist Mary McCallum Webster (1906–1985), whose rich and diverse lives have made an impact on history in Scotland and abroad.

Copyright: Used by permission of Luath Press

(30)

Landscape for a Good Woman: A Story of Two Lives

by Carol Steedman, 1986

Book

Written by sociologist Carolyn Steedman, this book is partly autobiographical. Focusing on her own and her mother's working class childhoods, she tries to find a place for their stories in history, politics, psychoanalysis and feminism.

Copyright: Carol Steedman, 1986. Used by permission of Virago, an imprint of Little, Brown Book Group

(29)

Living on the Earth

by Alicia Bay Laurel, 1970

Book

This book sold out its first run of 10,000 copies in six weeks, and eventually made it on to the *New York Times* Bestseller List. Although not strictly reflective of 'social history' this book exemplifies a strand of feminism-infused utopian texts that has historical significance. A handbook for those who wish to literally 'live off the land', it is packed full of practical advice on things such as how to make soap, carve wood and build shelters, and is beautifully illustrated throughout.

Copyright: Alicia Bay Laurel, 1970

(31)

A Plaque in memory of Flora Murray ⓷②

Undated

Plaque

The memorial to this inspirational suffragette who established the Women's Hospital Corps in Paris, 1914 outlining her life and achievements, can be found at Dalton Church in Dumfries and Galloway.

Screenshot of memorial record to Flora Murray on *Mapping Memorials to Women in Scotland* at womenofscotland.org.uk

Memorial to Mary McCallum Webster ⓷③

2003

Stone Memorial

This stone marks the area that Mary's ashes were scattered in Culbin Forest, by her request. Her passion for the area's flora and fauna is captured in this touching memorial erected by The Moray Field Club.

Photo: Amanda Thomson, Mapping Memorials to Women in Scotland, womenofscotland.org.uk

Second Wave Feminism

The Library has extensive material in its lending collection documenting the period of second wave feminism and the great volume of writing that was generated at this time. Following the first wave of feminism, which focussed largely on women's suffrage, the second wave from the 1960s on foregrounded a diversity of issues affecting women's lives. Amongst the key texts from this period in the Library's collection are *No Turning Back: Writings From the Women's Liberation Movement 1975–1980*, *The Female Eunuch* by Germaine Greer and *The Feminine Mystique* by Betty Friedan. The archive collection also has a wide selection of influential magazines from the time, including an almost complete collection of *Spare Rib* and its Scottish counterpart, *Harpies and Quines*. Our collection spans the wide range of feminist perspectives including international movements, Marxist Feminist and Black Feminist texts.

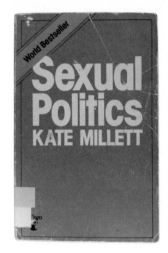

Sexual Politics (34)
by Kate Millett, 1969

Book

With the publication of this book, Kate Millett was recognised as a founder member of the struggle for women's rights. Controversial at the time of its publication, it examines male domination and patriarchal bias in every sphere of life: employment, education, family life, religion and sex.

Copyright: Kate Millett, 1969, 1970. Used by permission of Virago, an imprint of Little, Brown Book Group

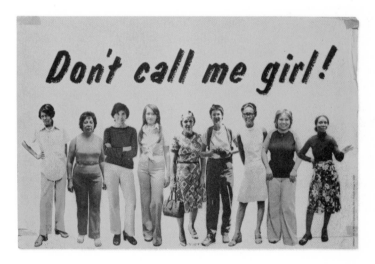

Don't Call Me Girl (35)
Chicago Women's Graphics Collective, 1974

Poster

Representative of the US second wave women's liberation movement, the Collective came together to create eye-catching posters containing feminist demands and messages.

Photo: Tian Khee Siong

Copyright: Chicago Women's Graphics Collective, cwluherstory.org

I expected to find in Spruill's work information about various groups of women in American society. I found instead that it was another work solely about white women and that both the title and blurb were misleading. A more accurate title would have been *White Women's Life and Work in the Southern Colonies*. Certainly, if I or any author sent a manuscript to an American publisher that focused exclusively on the life and work of black women in the south, also called *Women's Life and Work in the Southern Colonies*, the title would be automatically deemed misleading and unacceptable. The force that allows white feminist authors to make no reference to racial identity in their books about "women" that are in actuality about white women is the same one that would compel any author writing exclusively on black women to refer explicitly to their racial identity. That force is racism. In a racially imperialist nation such as ours, it is the dominant race that reserves for itself the luxury of dismissing racial identity while the oppressed race is made daily aware of their racial identity. It is the dominant race that can make it seem that their experience is representative.

In America, white racist ideology has always allowed white women to assume that the word woman is synonymous with white woman, for women of other races are always perceived as Others, as de-humanized beings who do not fall under the

Ain't I a Woman: Black Women and Feminism
(36)

by bell hooks, 1982

Book (detail of marginalia)

Marginalia appears in many of GWL's donated texts. Here, marginalia features in a key book by Gloria Jean Watkins, better known by her pen name bell hooks, an American author, feminist, and social activist. This book examines the impact of sexism on black women during slavery, the historic devaluation of black womanhood, racism within the women's movement, and black women's involvement with feminism.

Copyright: Gloria Watkins, 1981. Used by permission of Pluto Press, London

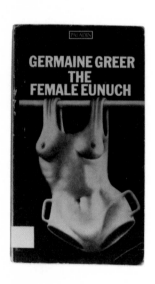

The Female Eunuch
(37)

by Germaine Greer, 1970

Book

A worldwide bestseller, this book is a landmark in the history of the women's movement. Drawing liberally from history, literature and popular culture, Greer gives a searing examination of women's oppression. Greer uses humour, boldness, and uncensored language to present a direct and candid description of female sexuality.

Copyright: Germaine Greer, 1970. Used by permission of HarperCollins Publishers Ltd.

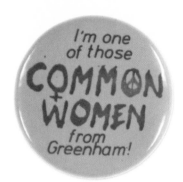

Badges
(38)

c.1970s – c.2000s

Ephemera

Greenham Common Women's Peace Camp was established in 1981 outside the military base at Greenham Common, Berkshire in opposition to the nuclear warheads that were being sited there. Many women visited the peace camp and wore these badges in solidarity with the women who were permanently living there.

Activism

The Library's eclectic collection of activist material includes placards, banners, posters, pamphlets and an extensive badge collection. The wide range of campaigns covered reflects the multiple registers on which women have been and continue to be active, from Peace campaigning to Wages for Housework. Many of these chart the early campaign roots of organisations that have now become culturally embedded, such as those that address violence against women and campaigns for equal pay. Many of these artefacts and texts are handmade and unique, representing women's very personal engagement with and dedication to their chosen causes.

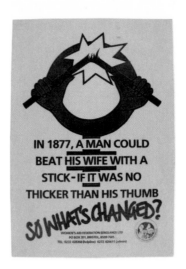

Women's Aid Federation of England (39)
1991

Poster

Activism surrounding, and definitions of, violence against women from the early second wave of feminism in Britain was to have an impact on legislation. As late as 1991, when this poster was created, rape within marriage in England had only recently been decriminalised. Rape within marriage in Scotland was decriminalised in 1982.

Reproduced with thanks to the Women's Aid Federation of England

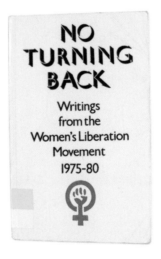

No Turning Back: Writings from the Women's (40)
Liberation Movement 1975-1980
by The Feminist Anthology Collective, 1981

Book

This book brings together a broad cross-section of writings from the women's liberation movement in the UK, covering issues including sex, class, violence against women, health and culture.

Copyright: Feminist Anthology Collective, 1981.
Used by permission of Quartet Books. This Women's Press edition is now out of print.

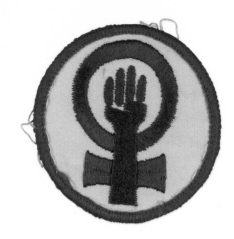

Campaign Ephemera (41)

c.1970s – c.2000s

Ephemera

Women have played a pivotal role in many social campaigns rooted in the
late twentieth century, such as the anti-apartheid movement, Campaign for
Nuclear Disarmament and LGBT issues.

Badges (42)

(c.1970s – c.2000s)

Ephemera

This badge, produced in it's thousands, was worn by people supporting the
campaign to end violence against women.

Autobiography and Biography

Women's lives, in all their diversity, fascinate and inspire, and the Library has an extensive range of biographical texts. Amongst the shelves you can explore the lives of iconic historical figures such as Joan of Arc and anarchist Emma Goldman, or well-known writers such as Maya Angelou, Sylvia Plath and Naomi Mitchison. Particularly striking are the 'unsung heroines': you will find fascinating stories of lesser-known women, such as Dolly Shepherd, a pioneering Edwardian parachutist, or Sheila Stewart, a Scottish story-teller and traveller. The archive collection houses personal papers and ephemeral materials relating to inspirational women including Jackie Forster and Ingrid McClements.

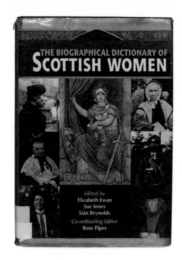

The Biographical Dictionary of Scottish Women (43)
edited by Elizabeth Ewan, Sue Innes, Sian Reynolds and Rose Pipes, 2007

Book

Written by a team of 280 scholars, this book tells the stories of women famous and infamous, extraordinary and ordinary. It enables a new perspective on Scottish life and demands a rethinking of what is meant by Scottish national identity.

Copyright: Used by permission of Edinburgh University Press

Film of Ingrid McClements (44)
by Jan Nimmo, 2006

Video

One of a series of filmed interviews with Library users by Jan Nimmo commissioned as part of GWL's *Documenting 109* project.

Copyright: Jan Nimmo, Glasgow Women's Library collection

Feelings are facts: a life

(45)

by Yvonne Rainer, 2006

Book

In this memoir dancer, choreographer and film-maker Yvonne Rainer traces her personal and artistic coming of age, from her Californian childhood to her artistic accomplishments in the New York dance world, and her involvement in feminism and the anti-war movement in the 1970s and 1980s. Rainer visited GWL to talk about her life and this book in October 2010.

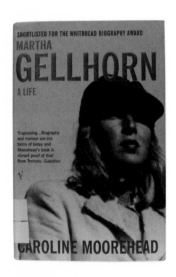

Martha Gellhorn: a Life

(46)

by Caroline Moorhead, 2003

Book

This book looks at the life of pioneering American war journalist and traveller Martha Gellhorn. Her despatches from the front made her a legend, and her journalism tracked many of the flashpoints of the 20th century. Much to her understandable resentment, Martha Gellhorn was often described as Ernest Hemingway's 'third wife' – which completely undermined her own incredible professional and personal achievements.

Craft, Cookery and Textiles

Traditionally regarded as the domain of women, 'domestic' crafts and activities are illustrated in a wealth of primary sources housed by GWL: knitting patterns, cookery books, sewing templates and craft ephemera. Feminist interpretations of these activities on the Library shelves are wide-ranging, from those that aim to celebrate and restore the value of these neglected and frequently derided fields of creativity to critiques of them as forms of subjugation and enforced femininity. The *21 Revolutions* artists' and writers' responses to these artefacts and texts are similarly wide-ranging.

Needlewoman and Needlecraft
c.1940s

Pattern books

Needlewoman and Needlecraft were sewing pattern books published from the 1940s to 1970s and are amongst a wide range of craft ephemera to be found in the GWL collection.

Copyright: Coats PLC

Woolcraft 48
c.1940s

Pattern books

A wide range of knitting pattern books, used (principally by women) to create home-made versions of cutting edge fashion garments are held in the GWL collection.

Copyright: Coats PLC

Scottish Women's Rural Institute (SWRI) Cookery Book
1947

Book

SWRI cookbooks were a popular annual publication produced to fundraise for local chapters as well as promoting the production (by women) of nutritious and economical meals.

Copyright: Scottish Women's Rural Institute

A Plain Cookery Book for the Working Classes
Charles Elme Francatelli, 1852, republished 1977

Book

Concerns about the diet and domestic management of the rising urban working class can be clearly identified in this 19th century publication.

Sexuality and the
Lesbian Archive Collection

Issues around women's sexuality have been core in feminist discourse and so it is no surprise that a library, archive and museum reflecting the diversity of women's lives contains materials representing the trajectory of such political and social debates. GWL's history spans a pivotal period between a palpable, institutional backlash against pro-equalities gains during the late 1980s and 1990s (such as Section 28) and the gradual growth in pro-equalities support leading to, amongst other things, the passing into law of Equal Marriage. In 1995 the UK's National Lesbian Archive and Information Centre, set up in 1984 and containing the largest collection of materials relating to lesbian lives, relocated to GWL, having lost its funding and premises in London. This vast collection contains materials dating back to the inter-war years and is accessed by people from all over the world.

Sex in Marriage (51)
c.1950s

Pamphlet

This widely circulated information pamphlet was produced and distributed to married couples across the United Kingdom.

Reproduced with thanks to Relate, formerly the National Marriage Guidance Council

Girls Questions Answered (52)
c.1950s

Pamphlet

The anxieties and concerns of the emergent female 'teenager' are illustrated in this pamphlet produced by the National Marriage Guidance Council.

Reproduced with thanks to Relate, formerly the National Marriage Guidance Council

Dusty Springfield sweet pea seeds
(53)
c.1990s

Ephermera

These seeds were sold to raise funds for cancer research, in memory of
Dusty Springfield. Dusty Springfield, an habituée of the famed lesbian
nightclub The Gateways, is one of the figures that regularly features in the
Lesbian Archive collection, for example in a lesbian fan's donated scrap book
album.

Copyright: With thanks to Unwins

Raging Dykes Network
(54)
c.1990s

Newsletter

The Raging Dykes were part of the radical lesbian separatist movement and
their newsletter was a key method of keeping in contact with members from
across the world.

Popular Culture

Popular culture is an underrepresented territory in many museum and archive collections. Women's interest in and production and consumption of popular culture is further marginalised, traditionally seen as not being of historical interest or significance. GWL actively sources and showcases ephemeral and often overlooked popular cultural texts and artefacts, from badges to fan t-shirts, fanzines to women's magazines, dime novels and music (in the form of song sheets or recordings) that help illuminate the diverse tastes, passions and relationships of women to the media and its impact in the formation of identities. The Library also houses a wide-ranging collection of academic texts and auto/biographies covering the territories of film, music and broader popular culture.

Girl
1952

Annual

Girls' annuals were widely consumed by girls of all classes from the 1950s and still are today. These publications 'annually' sold around Christmas time.

Copyright: IPC Media

Diana
1975

Annual

This DC Thomson publication ran from 1963 until 1976. Its content included comics with a focus on stories with underlying moral messages.

Copyright: DC Thomson 2014

Sixteen (57)

1967

Annual

Sixteen was aimed at the mature teenager and aimed to educate young women about the adult world, with articles on careers and childbirth featuring alongside hair and beauty tips.

Copyright: HarperCollins

Riot Girl Essex, Yummi Hussi #9, Poppy Violet no. 2 (59)

c.1990s–2001

'Zines

These 'zines or handmade magazines have their roots in the Riot Girrrl movement of the 1990s in Britain and the US which was influenced by feminism and punk and was an alternative to mainstream (popular) culture.

Copyright: Yummi Hussi Publications *(Yummi Hussi #9)*, and the rest Glasgow Women's Library collection

Maid to Minx (58)

LungLeg, 1999

Record

LungLeg were a Glasgow based all-women, Riot Girrrl inspired band that formed in 1994 and disbanded in 1999.

Cover: Southern Cross Records

Spare Rib (60)

1980

Magazine

An iconic British publication from the early second wave women's liberation movement, which ran from 1972 until 1993, *Spare Rib* captured the concerns and demands raised by this pioneering social movement.

Copyright: *Spare Rib*

National Museum of Roller Derby Collection

The sport of Women's Flat Track Roller Derby exploded across the UK from around 2006. The first pioneering leagues, London Rollergirls, Birmingham Blitz Dames, London Rockin' Rollers and Glasgow Roller Girls founded in 2006 and 2007, have expanded to around 90 leagues in all corners of the country.

The National Museum of Roller Derby was established in 2012 by Ellie Harrison as her contribution to the *21 Revolutions* project. Her aim was to initate the UK's first permanent collection of ephemera and memorabilia relating to this new and exciting all-female, full-contact sport. Materials (such as bout programmes, merchandise, press cuttings etc.) are donated by Roller Derby Leagues all over the country to form the basis of a national collection, which aims to document and preserve for posterity the fast-and-furious first years of Women's Flat Track Roller Derby in the UK and beyond.

Carrie on Skating 61
2009

Ephermera

A love of puns characterises the literature produced by the roller derby community, richly illustrated in the Museum's bout programme collection.

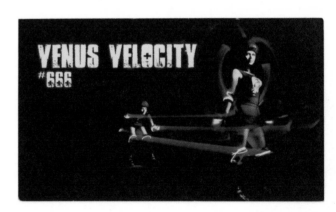

Player card 62
Undated

Artefact

Fans can collect cards that showcase their favourite players.

Copyright: Glasgow Roller Derby

Wristband (63)

Undated

Artefact

These bands are restricted to skaters or the crew at bouts. Crew roles can range from being match officials, merchandise sellers or first aid contacts.

Copyright: Glasgow Roller Derby

Roller derby helmet (64)

c.2012

Artefact

Artist Ellie Harrison donated her helmet to the Museum. It is customised with stickers from other British teams, including the Sheffield Steelers and the London Rockin' Roller Girls. Ellie Harrison created the sticker of the GWL logo as part of her contribution to *21 Revolutions*.

Photo: Tian Khee Siong

21 Revolutions:

Exhibitions, readings and events

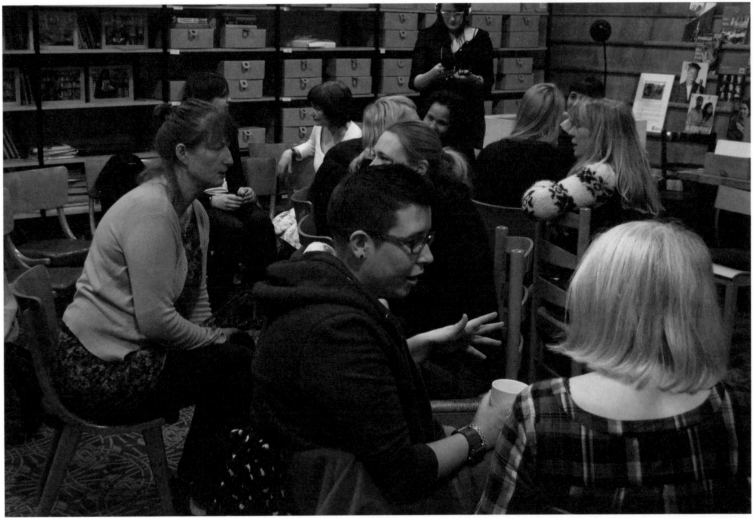

Inaugural gathering for the 21 artists and 21 writers commissioned to create new work for *21 Revolutions*, January 2012.

From January 2012 until the launch of this publication, Glasgow Women's Library programmed exhibitions, readings, screenings, podcasts and other events and activities as part of the wider *21 Revolutions* project.

The programme involved many of the artists and writers and drew upon the Learning and Collections team and archive and library resources at GWL. An overarching aim of the *21 Revolutions* project was to raise awareness of the Library's work and its collections and this programme was aimed at and attracted thousands of visitors and diverse audiences to GWL and to outreach venues in Glasgow and Edinburgh.

One of each of the new artworks was added to the GWL collection, and the remaining editions were made available for private and public collectors at exhibitions and through our website. Several works are now in public collections. The exhibitions and new writing were widely and positively reviewed. Podcasts featuring the writers reading their contributions to *21 Revolutions* and talking about their inspiration for creating the work began to be released monthly from 21st September 2012 (the 21st anniversary of the launch of Glasgow Women's Library) via the GWL website and on iTunes. The *21 Revolutions* artworks, writing and sources continue to be used in Glasgow Women's Library's art, literature and learning programmes.

Inaugural gathering for the 21 artists and 21 writers commissioned to create new work for *21 Revolutions*, January 2012.

Writer Kirsty Logan reading her *21 Revolutions* piece 'This is Liberty', at *Two Decades of Changing Minds* event, Glasgow Women's Library, June 2012. Photo: Jean Donaldson, Glasgow Women's Library collection.

Participants at *21 Revolutions* gallery talk and tour led by Kate Davis and Helen de Main, Intermedia Gallery, Centre for Contemporary Art, Glasgow, September 2012.

January 2012
Networking gathering for *21 Revolutions* commissioned artists and writers at Glasgow Women's Library.

January 2012 (ongoing until September 2012)
Research process involving artists and writers exploring the Glasgow Women's Library collections and meeting with the staff team.

22nd March 2012
The first of two public previews of *21 Revolutions* artworks and writing. Entitled *Two Decades of Changing Minds*, these events at Glasgow Women's Library offered opportunity for artists and writers to meet and share work with the public. Writers Margaret Elphinestone, Anne Donovan and Karen Campbell premiered their *21 Revolutions* pieces whilst work by artists Ellie Harrison, Claire Barclay and Ashley Cook was shown for the first time.

June 2012 (ongoing)
Launch and distribution of National Museum of Roller Derby (NMRD) merchandise designed by *21 Revolutions* artist Ellie Harrison.

14th June 2012
The second public preview of *21 Revolutions* artworks and writing. At this *Two Decades of Changing Minds* event Ellie Harrison launched the National Museum of Roller Derby, and work by Kate Davis and Delphine Dallison was exhibited. Writers Vicki Feaver, Kirsty Logan and Laura Marney premiered their work.

August 2012
Ellie Harrison recruited the NMRD curatorial and archive team including roller derby participants and archivists Cara Viola, Maulin' Rouge and Bint Imperial who worked with GWL Archivists to encourage and manage donations to the GWL's NMRD collection.

25th and 26th August 2012
Ellie Harrison and the NMRD team along with other GWL volunteers helped distribute and sell NMRD promotional and merchandising materials, and conducted outreach oral history gathering at the Glasgow Roller Derby bout, *Chaos on the Clyde*, Kelvinhall, Glasgow.

21st September – 13th October 2012
21 Revolutions exhibition at Intermedia Gallery, Centre for Contemporary Art, Glasgow.

22nd September 2012
The launch of *21 Revolutions* exhibition of writers work and related sources at Glasgow Women's Library. Simultaneous launch of *The Revolution on Roller Skates: the beginnings of women's flat track roller derby in the UK* exhibition curated by Cara Viola, Maulin' Rouge and Bint Imperial (GWL National Museum of Roller Derby collection volunteers), Glasgow Women's Library, 15 Berkeley Street, Glasgow.

Detail of *21 Revolutions* exhibition, Royal Scottish Academy, September 2013
Photo: Tian Khee Siong.

Adele Patrick (right) accepts the Arts & Business Scotland 'Enterprising Museum of the Year' 2013 Award for *21 Revolutions* from Joanne Orr, CEO, Museums Galleries Scotland.
Photo: A&B Scotland

26th September 2012
The first *21 Revolutions* public readings event at the cinema, Centre for Contemporary Art, launching work by writers Denise Mina, Elizabeth Reeder and Leela Soma.

29th September 2012
21 Revolutions Gallery tour and talk led by artists Kate Davis and Helen de Main, Intermedia Gallery, Centre for Contemporary Art, Glasgow.

3rd October 2012
The second *21 Revolutions* public readings event at the cinema, Centre for Contemporary Art, launching work by writers Anne Donovan, Alison Miller and Laura Marney.

6th October 2012
21 Revolutions Gallery tour and talk led by artists Jacki Parry and Fiona Dean, Intermedia Gallery, Centre for Contemporary Art, Glasgow.

13th October 2012
The third *21 Revolutions* public reading event at the cinema, Centre for Contemporary Art, launching work by writers Heather Middleton and Karen Campbell and a screening of the film of Ellie Harrison's launch of the National Museum of Roller Derby.

27th November 2012
21 Revolutions outreach event at Bridgeton Community Learning Campus: readings by writers Karen Campbell and Anne Donovan and a talk by artist Jacki Parry about her work, *Women in the City*.

4th February – 4th March 2013
Exhibition of a selection of artworks at Bar Gandolfi, Glasgow.

19th July – 8th September 2013
21 Revolutions exhibition at Royal Scottish Academy, Edinburgh.

22nd August 2013
Writers Zoë Strachan and Louise Welsh premiere their *21 Revolutions* piece 'Anyone Who Had a Heart' at Word Power bookshop, Edinburgh as part of the Edinburgh Book Festival Fringe.

30th October 2013
Glasgow Women's Library wins the Arts & Business Scotland 'Enterprising Museum of the Year' Award for *21 Revolutions*.

Acknowledgements and thanks

The publishers would like to thank the following people for their contributions to this publication: all the participating artists and writers, Fiona Bradley, Lesley McDowell, all the Glasgow Women's Library staff, interns and volunteers involved its production, in particular contributing artist and volunteer Delphine Dallison, Alice Andrews, Zoë Strachan, Genevieve Wong, Elizabeth Rogerson, Linda Woodburn, Belle McMahon, Helen MacDonald, Syma Ahmed, Laura Dolan, Gabrielle Macbeth, Jena Connolly, Keisha Ann Stewart, Jenni Clapham and Carrie Hicks and the Glashow Women's Library collection team, Lindsey Short, Laura Stevens and Wendy Kirk. Thanks to Samina Shariff, Humaira Iqbal and Asia Ahmed for their help in translating 'Model House' by Jackie Kay, to Ron Grosset and Publishing Scotland and to Sue John who was involved in all aspects of the publication and programme.

Thanks too to the photographers who worked with GWL on this publication: Tian Khee Siong, Alan Dimmick, Syma Ahmed, Adele Patrick, Sue John and Delphine Dallison and Alice Andrews who produced photographs of library, museum and archive items. Christina Kernohan, Laura Dolan, Jean Donaldson and Rosie Healey who created the artists' and writers' portraits. A big thank you also to all the individual backers that supported the production of *21 Revolutions* through our Kickstarter campaign; in particular, Sue John, Anabel Marsh, Joyce and Patrick Moore, Christine Patrick, Linda and Neil Patrick, Helene Dallison and Jude Barber.

For more information about the *21 Revolutions* project, the Glasgow Women's Library collections, the limited edition prints, merchandise and our broader programmes visit www.womenslibrary.org.uk

The proceeds from the sale of this publication support the ongoing work of Glasgow Women's Library.

Prints from the *21 Revolutions* project can be found in the collections at Glasgow Women's Library and Glasgow Museums.